Breakthr...

GHOST PHOTOGRAPHY

of

HAUNTED HISTORIC VIRGINIA

FEATURING HOMES OF THE VIRGINIAN PRESIDENTS

Tim Scullion

SCHIFFER
PUBLISHING

4880 Lower Valley Road • Atglen, PA 19310

Thanks to my wife and family
for putting up with all of my late-night jaunts.

Edited by Kim Grandizio
Cover design by Molly Shields

Type set in Avenir/Times

ISBN: 978-0-7643-6192-0
Printed in China

Published by Schiffer Publishing, Ltd.
4880 Lower Valley Road
Atglen, PA 19310
Phone: (610) 593-1777; Fax: (610) 593-2002
E-mail: Info@schifferbooks.com
Web: www.redfeathermbs.com

For our complete selection of fine books on this and related subjects, please visit our website at www.schifferbooks.com. You may also write for a free catalog.

Schiffer Publishing's titles are available at special discounts for bulk purchases for sales promotions or premiums. Special editions, including personalized covers, corporate imprints, and excerpts, can be created in large quantities for special needs. For more information, contact the publisher.

We are always looking for people to write books on new and related subjects. If you have an idea for a book, please contact us at proposals@schifferbooks.com.

TO MY READERS

This book is dedicated to all of thos who have to see something before they believe it. This book is a look into a world we cannot see with the naked eye. The advanced electronics of the digital camera have become the eyes through which we can see evidence of the paranormal! Most ghosts, apparitions, phantoms, wraiths, or whatever you choose to call them, have an appearance like nothing you have ever imagined—are you ready for proof of an alternate realty?

The boundaries which divide Life from Death are at best shadowy and vague. Who shall say where the one ends, and where the other begins? (Edgar Allan Poe) Perhaps that ephemeral boundary may blur a little more as you progress through this book, and you may feel compelled to ask:

"WHERE ARE THE DEAD? ARE THEY STILL AMONGST US, POSSESSED OF THAT UNDEFINED, MYSTERIOUS EXISTENCE WHICH THE ANCIENT WORLD ATTRIBUTES TO THE GHOSTS OF THE DEPARTED?"

—Charles Lindley Wood (1839–1934)
Lord Halifax's Ghost Book: A Collection of True Stories, first published in 1936

The dead are within the pages of this book, waiting for you to discover this undefined paradigm. Perhaps even Lord Halifax himself exists in this netherworld, casting out hints of his presence to those who are unaware. Now you will learn what becomes of those caught between this world and the next—and what they really look like . . .

—*Tim Scullion*

CONTENTS

ABOUT THE AUTHOR

Tim Scullion has a bachelor's and a master's degree in education from the College of William and Mary. Tim is a published author and photographer who has was nominated by the Library of Virginia for nonfiction book of the year in 2016 for the first book in the Breakthrough Ghost Photography series, *Haunted Historic Colonial Williamsburg, Virginia with Breakthrough Ghost Photography*. He has been featured on television shows in Virginia and radio shows across the country, including *Coast to Coast with George Noory* (now starring in the History Channel's series *Ancient Aliens*); *Darkness Radio* with Dave Schrader (now starring in the paranormal television series *The Hans Holzer Files*); *The Ghost Host* with Sophia Temperilli; KCMO Talk Radio 710 AM in Kansas City with former newscaster Wendy Garrett; on *Dark Waters Radio* with Shawn Graham; *Ghost Chronicles International* with host Ronald Kolek; *Phenomena Encountered Podcast* with hosts Daniel Klaus and Denise Garcia; *Ghostly Hour* on KCOR with David Cook, simulcast in the UK and Las Vegas; *The 'X' Zone Radio* with Rob McConnell; *Nocturnal Frequency Radio* with host Steve Genier; *Strange Planet Productions* with Richard Syrett; and many others. Tim has also been featured presenter at the Maryland Paranormal Conference, the Psychic Studies Institute in Kansas City, and other paranormal groups in the United States. He has had worldwide distribution of his work by the University of Virginia in its book *Hard Times Companion*, Volume 3, a book that examines ways for victims of life-changing events to cope with their reality. Among his other works is a novel called *Nick*, which removes all of the commercial trappings of Christmas and takes the reader to a place where giving oneself is the real meaning of the holiday. Learn about St. Nicholas—not the red-suited Santa that gives children toys—but the spirit of giving. He has also written a successful series of four books on advanced lead guitar, called Shred Tech, with sales around the world. As a photographer, he specializes in fine-art photography, work that preempted the idea for this series of books—to do something that has not been done before: a comprehensive photographic study of the paranormal in one specific area—Colonial Williamsburg, and then to expand that across the country!

INTRODUCTION

The photos you are about to view are an amazing look into an alternate reality. I continue to learn, and I continue to be amazed by what I discover in this netherworld that most people do not want to admit exists. I found the hypothesis of physicist Janusz Slawinski intriguing: Based on the two scientific facts that all living creatures give off photons of light, and that when a living organism dies it emits a "death flash" of electromagnetivity that can be up to a thousand times stronger than the standing rate of emission, he concluded that our mind is an electromagnetic conscious that survives the death of the physical body. As I processed that I wondered why our physical brain would have or even need this; wouldn't this center of awareness or consciousness exist somewhere within the structures of the human brain? I had to learn more, and that's when I discovered the work of Dr. Johnjoe McFadden.

To answer the above question, no, researchers can find no region or structure in the human brain that houses the consciousness. Rene Decartes, in his fundamental statement of existence, wrote, "I think, therefore I am"; but where, and what is the "I"? According to Dr. McFadden, the brain's central processing unit (cpu) that binds together all of the thousands of nerve signals that come in at one time is an electromagnetic field. Without this binding field that makes sense of everything and how it relates to the "I", all of this information would be like pieces of a jigsaw puzzle scattered on a table. This electromagnetic field binds all of the nerve signals (from all of the senses) together to produce a complete picture, and creates a synchronous firing of neurons to induce a physical reaction, if necessary. Of course, this is a simplified explanation for what our conscious is, but the idea is that what makes us conscious, living, breathing, beings is something separate from the human body: The "I" is an electromagnetic ghost! Can you imagine what this means for mental illness? Would you treat the physical brain or the electromagnetic soul? What are the implications for creating artificial intelligence? On the one hand, things just got a lot more complicated, but on the other, Professor McFadden may have provided a rational explanation for the photos in this book.

Besides the possibility, or perhaps probability that we possess an electromagnetic consciousness, I have set out to find and use scientific research to prove the inimitable link between light and life. Why? Because if life is to truly continue after the death of the flesh and blood body, then it must be connected to energy—electromagnetic energy, of which the wavelengths of both visible and invisible light are an integral part. The fact that people who see ghosts, or have taken photos of ghosts as I do, are seeing/photographing a hologram of light, often just white light, just adds to this postulation that light and life are inexorably linked. So if we have, as physicist Janus Slawinski theorizes, an electromagnetic consciousness, then it would be an intelligent energy—and energy cannot be destroyed, it can only change form. So if all of our thoughts, memories, personality—yes, our consciousness—are tied to energy, then we cannot die, but live on in a different kind of

paradigm. So I was absolutely fascinated to find research that establishes that link as a scientific fact.

So if ghosts give off photons of light, enabling them to appear as semi-transparent apparitions of their former human bodies, do human beings give off photons of light? The answer is an unmitigated Yes! Kobayashi, Kikuchi, and Okamura (July 16, 2009) were able to successfully photograph the light given off by the human body—although our eyes are not sensitive enough to see it. Ponder that for a minute; scientists were able to successfully prove that the human body emits light, and even though we can't see it, the camera can! Now is it that much of a stretch to believe that the camera can capture something else that the naked eye cannot see—ghosts? Our electromagnetic consciousness, or ghost, or soul, or spirit emits light at such low levels— most of the time—that the naked eye cannot see it, but the camera can.

But even more astounding connections have been found between living organisms and light, and I just want to highlight some of the discoveries collected by writer Dan Eden in his article "Is DNA the next Internet?," with the even more intriguing subtitle "Are humans really beings of light?" Russian scientist, Pjotr Garjajev used a laser beam to intercept the transmission of ultraviolet photons from DNA molecules. He then transferred this light message from one organism (a frog embryo) to another organism's DNA (a salamander embryo), with the end result that the salamander embryo developed into a frog! Can you imagine the implications of being able to change the whole development of an organism with just a coded message of light— especially if scientists start to experiment with human embryos? This same scientist suggested ultraviolet light communication may not only occur within every organism, but may occur

between organisms—communication that is invisible to the human eye that may explain telepathy and ESP. It may also explain how flocks of birds and droves of fish are able to rapidly synchronize their movements with such amazing fluidity.

In another little-known but stunning discovery, Dr. Fritz-Albert Popp, a theoretical biophysicist at the University of Marburg in Germany, found that the human body uses photons of ultraviolet light to switch on the body's processes. At different frequencies, they perform different functions. In addition, he may have inadvertently discovered both the cause and cure for cancer all the way back in 1970: he found that compounds (or chemicals) that entered the human body that cause cancer have the ability to absorb the cell's ultraviolet photon signals and scramble them. The rogue chemical sends out a different frequency of light, causing cells to mutate. All the way back in 1970 we had a way to determine if a chemical causes cancer, and it had to do with coded messages of light! He even discovered an extract from the mistletoe plant that would return the mutant cell's scrambled signals back to normal light frequencies—actually curing numerous cases of cancer. Dr. Popp would later exclaim, "We now know, today, that man is essentially a being of light."

It seems that everything from the smallest cellular processes to even higher thinking, including communication with other organisms, and consciousness itself has been scientifically connected to light. For every second that passes about 100,000 chemical reactions occur in each cell in the body—and every one of those reactions require a photon of light. Where do we get the photons for all of these processes? When we eat plant foods, we are actually eating light—ultraviolet light stored from the sun via photosynthesis in the molecules

of the plant. A tiny super computer within the cell—the DNA—is able to take these stored photons and convert them into signals to direct each of those 100,000 reactions within the cell. A student under Dr. Popp discovered that when you use a certain chemical to unravel DNA, it gives off light. He then discovered that the DNA uses that stored ultraviolet light to send out a range of frequencies of light—each linked to certain intercellular processes.

But the body uses light emissions outside of individual cells as well—to repair wounds; however they had to be low intensity signals because these communications took place on an intracellular, albeit quantum level. Higher intensities would generate too much "noise" to be effective. There is a strange relationship between a creature's complexity and the amount of photons emitted by it: You would think the more complex, the more light released—but just the opposite is true. So humans, at the top of the evolutionary scale, release the least amount of photons; perhaps that's why ghosts are so hard to see or photograph. Dr. Popp not only studied healthy human light emissions, but also those that had cancer and other terminal illnesses. He found that these people were losing their internal means of communication within their own body because the light frequencies were scrambled, their rhythms were off—they were literally losing their light—along with their life.

Building on all of Fritz Popp's discoveries, Stuart Hameroff and Roger Penrose wrote a groundbreaking paper with a convoluted title that essentially describes the brain as a quantum computer that uses a system of cytoskeletal microtubules between the brain's neurons (cells). These microtubules have a crystal-like lattice structure, with a hollow inner core—ideal for the transmission of photons of ultraviolet light. In less esoteric terms, our brain is a super computer with a fiberoptic network for the transmission of thoughts—our thoughts are in essence coded messages of ultraviolet light. Taking it a step further, the two scientists believe that this crystal-like lattice structure is the seat of human consciousness, and what we once believed to be a metaphoric reference to our "inner light" is no longer symbolic, but a literal reference to our consciousness, our thoughts, our DNA, and quite literally the control of every cellular function that we have. We are truly, as Dr. Fritz Popp stated, "beings of light."

Being that all of these inner light functions are so dependent on ultraviolet light, you would think that ghosts would only appear in UV light. But given the number of people who have witnessed a "lady in white," do they only appear in white light? (That said, did you know that white light is actually a combination of all the colors in the visible light spectrum?) From all of the thousands of photographs I've taken, I've discovered that ghosts will appear in different colors of light, but in many cases it seems as if they are using the surrounding ambient light, giving their appearance the shades of color from their surroundings. The most frequent appearance is white, with shades of ultraviolet as well as infrared light, but there are exceptions. The full-bodied apparitions that I have captured outside any home or building will usually appear in full color, including their clothing. Faces in the windows will usually take on the color of their ambient surroundings, but again there are always exceptions. I feel compelled to return to the Peyton Randolph House to show you some of my best examples of ghosts showing up in just one color of the visible light spectrum, and neither color was part of the surrounding ambient light. If you have seen the color of the Peyton Randolph House during the daylight, it has a dark reddish brown color which at

night is quite foreboding of the paranormal presences within, and the lights reflecting in its windows have an amber color. So to assume the surrounding ambient colors, a ghost would be in amber and red, which they often have appeared in. But when I captured two ghosts in the same window, different windowpanes, one in blue and the other in green, I knew that color wasn't necessarily a rule, so perhaps it's a choice. I just wonder what the colors had to do with the people these ghosts once were— was it just a favorite color, or does it go deeper than that?

This series of books, more than anything, has been a personal odyssey to discover the answer to the age-old question: Is there life after death? Have people made up ghost stories for thousands of years just to entertain each other, or was it a bona-fide experience? I believe the photographs answer that question in a way that I never imagined. Had you come to me a few years before and told me that this is what I would be doing, I would have told you that you were crazy! Now I have discovered that ghosts are everywhere; a house doesn't have to be historic or really old to have one or more ghosts. I have found them in the desert, in cornfields, in the parking lots of shopping centers, in new houses, even in the water. Come with me on my journey into the unknown to look at the faces of those who choose to stay behind, for whatever reason, and who try to make their presence known to those still in the world they once inhabited.

JAMESTOWN

More than 500 Victims of Famine, Plague, and Indolence

In 1607 Jamestown became the first *permanent* English settlement in America, and one could call it a dark comedy of errors if there hadn't been so much starvation, disease, and death associated with the venture. The first attempt at an English colony began when Sir Walter Raleigh sent an expedition of 115 English settlers to Roanoke Island in 1587, which would disappear just a few short years later. Ironically the *Powhatan* (word for the *president*, or leader of a confederation of Native American tribes in Virginia, and *not the first name* of the leader), may have erased any trace of the "lost colony" by slaughtering the Chesapeake tribe just one year before, because it is believed that the English colony was assimilated by the Chesapeakes in order to survive when ships failed to arrive from England with needed supplies. To the ill-equipped group of Englishmen who later came to America, the use of the adjective *permanent* to describe their colony has a hollow, fleeting sound that betrays the conditions they endured, because for many, their stay was anything but permanent.

The problem in Jamestown began over in England when the Virginia Company (the company that sponsored the settlement) recruited people to voyage to America. Out of the 105 men and boys chosen, about one half were craftsmen, artisans, or just laborers, but the other half were *gentlemen*—men who had never worked in their lives. They lived off their family's fortunes and investments, they did not have to work for a living, and quite frankly, it was beneath them. They were under the impression that they would journey to this "paradise," subdue the indigenous people, profit from this land of plenty (like the Spaniards), and become wealthy beyond their wildest expectations. John Rolfe, who married Pocahontas, wrote an insiders view of the prevailing disposition of the colonists in 1620: "I speake on my owne experience for these 11 yeres, I never amongst so few, have seene so many falsehearted, envious and malicious people . . ." These well-educated, self-serving gentlemen, who knew nothing about work, let alone survival in a world and a climate totally alien to them, nevertheless forced their way into leadership roles that would lead to a disastrous beginning for the Jamestown experiment:

On May 13, the ships arrived at their final destination, and one of the highborn, connected gentlemen was elected president of the upstart colony: John Wingfield. Despite what everyone thought, Wingfield was a poor leader with no forethought, who was later accused of hoarding food supplies when they began to run short. Under his direction upon arriving, the colonists at once threw themselves into building a settlement, without a thought towards learning ways to live off the land. Game, fish, shellfish, and edible plants were abundant in the New World, and yet the colonists consumed the food supplies brought over on the ship—sans consideration as to what they would eat when the supplies

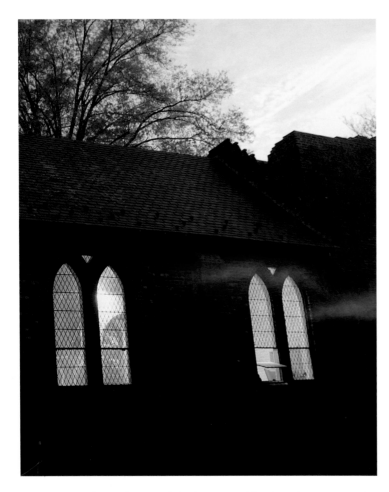

This was the clearest of several rather unhappy looking floating phantom faces that I captured just seconds later.

This shot was taken at the side of the Jamestown Church, and you can see the wispy white wraiths streaking from the window right after they turned the TV on to play the prerecorded Jamestown Story. (The church was locked up for the evening and the park employees had left!)

Here are three residents that showed up in the church's small, diamond-shaped windows, curious to see what I was doing on their island.

ran out. (They arrived at the beginning of the growing season, and forethought and good leadership would have had them planting gardens or even farms, as well as exploring their options for native plants, game, and the abundant fish and seafood in the river right next to the settlement.) So by midsummer, their supplies were critically short, and Wingfield was stripped of the presidency because the colonists felt he was culpable in taking and hiding extra food for himself. Another Wingfield folly was his refusal to fortify the settlement against a possible attack by the Powhatan people—until a surprise assault convinced him otherwise. Finally, any wells that the colonists dug from the part of the island that is a marsh would yield brackish water (part salt water/part fresh water). So for the first few months they drank ale; but when the ale supplies ran out they began to consume the island's bad water. All of this happened right when the oppressive heat of the Tidewater summer was at its peak. As if the water's salt content wasn't enough to sicken the island's inhabitants, keep in mind that it was loaded with bacteria, and they became victims of disease accompanied by "Burning fevers." When Captain Newport returned in January 1608, just seven and a half months later, 67 out of 105 colonists had died, most from starvation in a land of plenty!

Two very similar looking faces—could they be brothers?

Beards are indicative of early-seventeenth-century settlers. Could these two have been victims of the early mismanagement of the colony—starving in a land of plenty?

Just days after Newport's return, all but three of Jamestown homes burned down, including the triangular palisade. As for leadership, one inept leader was replaced with another: the council placed the presidency in the hands of the incapable John Ratcliffe, who was in charge until September 1608. When the time came to elect a new president, the council finally realized that being a well-born gentleman does not mean leadership skills are innate. So they elected Captain John Smith to lead the colony for the next twelve months, and he proved himself a capable leader, with perhaps a penchant for hyperbole—of his own accomplishments and exploits. There was not a shy bone in Smith's body, and he was not afraid to let everyone know about his achievements, much to the chagrin and disgust of the gentlemen who thought they were his

An older woman with the eyes either closed or darkened from sickness or death . . .

The eyes are usually the first facial detail that I notice; in this case they are devoid of detail. In addition, she has a very thin appearance—did this woman starve to death?

This woman looks young and healthy; perhaps her hair is a really light blond instead of the white appearance you see (in dark surroundings, yellow appears to be white). Could this be the young Ambler woman who kept waiting for the return of her groom from the Revolutionary War?

"betters." His solution for the laziness of the well-born was to organize them into companies and drill them daily on the use of weapons and defending the fort. Smith got the colony through the winter of 1608–1609 without starvation, but an unintentional explosion (some think this is highly suspect—recall John Rolfe's assessment of the people of Jamestown) of gunpowder gravely wounded him. Smith's enemies used this as a reason to oust and replace him with another incompetent leader; Smith would depart the following October and never return to Jamestown.

Perhaps it's better that Smith left when he did, because the highborn were about to lead the colony straight down the road to perdition. A decision by the London-based Virginia Company was about to set up the colony for major disaster during the winter of 1609–1610. They selected five hundred men, women, and children to set sail for Virginia on board nine ships in May, unbeknownst to the colony. During their stormy voyage across the Atlantic, an outbreak of a plague killed dozens, and a hurricane hit the convoy and sank one ship (losing all aboard) and wrecked another carrying new leadership for the colony. Seven ships arrived at Jamestown in August, carrying four hundred new mouths to feed with the growing season just about over. All of the new arrivals were in poor health from the difficult voyage and too weak to prepare for the coming winter. The winter of 1609–1610 was given the moniker "the starving time" by the colonists; out of five hundred colonists, only sixty survived! One man was even executed for killing and eating his wife.

The newly designated leader, Sir Thomas Gates, and the wrecked ship *Sea Venture's* other survivors spent that same winter in Bermuda. Their boat was irreparable, and so they used the timber they cut on the island to build two small boats called *pinnaces* to sail to Jamestown. They arrived in May after famine and disease had decimated the colonists, and Gates believed that the colony should be abandoned. He had loaded up the survivors and begun sailing down the James River when they got word that Lord De la Warr had just sailed into the Chesapeake. The English noble's arrival was just in time to prevent Jamestown from becoming another lost colony—not an intriguing disappearance like the Roanoke Colony that is enveloped in mystery and conjecture, but a gruesome tale of starvation, disease, and death that is enveloped in incompetence, mismanagement, and indolence. So in just three years, the Jamestown colony experienced more than five hundred deaths, many in a prolonged condition of hunger, pain, and disease. That said, perhaps you may agree with me that the upstart colony has all the earmarks of a haunting!

Samuel Argall would take Pocahontas, the Powhatan's (leader's) daughter, hostage in 1613, keeping the indigenous people from attacking the English colonists. According to her tribe's oral history (the Mataponi), Pocahontas was already married at that time and had a son. According to written history, she accepted Christianity and would later marry John Rolfe, a planter, in 1614. Jamestown would become a successful colony when the colonists discovered that tobacco was the colony's "gold"; a renewable cash crop that turned disaster into success: John Rolfe was able to successfully plant and harvest a variety of tobacco from the Spanish West Indies (1614), and use the curing techniques of the Native Americans to produce Virginia's first viable tobacco product (the tobacco species native to Virginia had a biting, harsh taste,

whereas the plant taken from the Spanish West Indies had a sweet scent). In 1619, America's first representative form of government began at the statehouse in the tiny island capital. A surprise uprising of the Powhatan's confederation in 1622 killed about one third (347) of the colonists on the Virginia Peninsula, although Jamestown got wind of the impending attack (a Christianized Native American by the name of Chanco informed the settlement) and was not destroyed. Another "plague" followed in 1623, reducing the number of English colonists down to about three hundred. This is just an abbreviated account of Jamestown's beginning history; for a more expanded reading of Jamestown's early history read *Jamestown and the Founding of the Nation* by Warren M. Billings, professor of history at the University of New Orleans and one-time Jamestown resident.

Jamestown would continue as the capital of England's first and largest colony in the New World until 1699, when it burned for the third time (I have come across some accounts that say fourth). At that time it was decided that the capital would be better placed further inland at a place called Middle Plantation. Jamestown was a small, marshy island with no room for expansion and no fresh water, just stagnant water full of mosquitos that helped to spread disease. The new site, quickly renamed Williamsburg in honor of the reigning English monarch, was the solution to the problems with the site chosen by the first English colonists, and it would remain Virginia's capital from 1699 until 1780, when then governor Thomas Jefferson would again move the capital even further inland to Richmond.

All that remained of Jamestown by 1716 was a church, a courthouse, and several brick houses. Some estimate that a few years later the Ambler family acquired most of the island and built a Georgian style mansion; Richard Ambler would farm the island as well as run the ferry that crossed the James River. Just like Jamestown, the Ambler Mansion would burn down three times before the family deserted the island: in 1781, Benedict Arnold, the well-known American traitor, would sail up the James River, burning quite a few plantation homes, including the Ambler Mansion. (You will read more about this later, with Arnold's stop at the Berkeley Plantation.) The Amblers rebuilt the home, only to see it burn a second time during the Civil War. Finally, in the 1890s flames consumed the plantation home a third time, and the family abandoned the property without rebuilding, succumbing to what many say is a curse on the island. You can see the derelict ruins of this once magnificent mansion if you visit Jamestown Island today, and just maybe catch sight of the phantom of a young woman who walks from the mansion to the river, still waiting after more than two centuries for the return of her love: Lydia Ambler fell in love with Alexander Maupin, a young soldier for the Continental Army who hastily married Lydia in August 1776 before his departure to fight the British. Alexander's fate is a mystery, but his ever-faithful bride would daily go out to the banks of the James River and wait for the return of her groom. No one knows how long she kept this exercise in futility up, but she pined away for her lover until she took her own life. Suicide is never the answer, because the sadness continues, as does the pointless walks to the banks of the James, but more than one park official has seen Lydia walking between the abandoned ruins of her home and the banks of the James River. One psychic who visited the derelict shell of the Ambler House got the profound impression that the house should have never been built;

I can only wonder if that impression came from the more than 500 souls who lost their life while trying to make a tiny footprint on the continent of North America, all with the hope that just maybe they could find a better life.

THE GHOSTS AT THE CHURCH

Other than the Visitor Center, an archaearium, and a few park maintenance buildings, the only complete structure on the island is the rebuilt church with the historic church tower. You can see some of the original foundations, as well as the ruins of the former Ambler plantation home, a monument, and a statue of Captain John Smith, but no 17-century buildings have survived. I wandered around the island on a warm winter evening to see what I could photograph, going towards the Ambler Mansion ruins in hopes of seeing and photographing the ghost of Lydia Ambler. I would have no luck at the Ambler Mansion; in fact, I found nothing paranormal until I walked back to the church, now closed and locked. The ornate window glowed from the interior lights, left on for the evening, but all the park employees had gone home. All was quiet at the church for about the first ten minutes, and then I captured a large white mist coming from the right side of the church. At the same time, the television was turned on inside the church—although no one was inside—and it began to play the prerecorded Jamestown story. I knew at once that the ghosts from Jamestown's past had turned the television on. They then began to show up in several photographs to let me know they were there; no longer suffering the pangs of hunger, typhoid, dysentery, or whatever other misery they endured, but nevertheless still on the island of their demise. I can't say that I was frightened; if anything, I was intrigued about the encounter and was hopeful that I would get more faces that perished in the island's wretched past. I can only wonder if the poor woman that was killed and eaten by her husband, or perhaps even the sordid soul that killed, boiled, salted, and ate his wife was part of that cast of characters floating in the mist by the old church!

The range of characters I captured on the tiny island was amazing, and I had to pick and choose which ones to include in this book. Several captures were quite intriguing, including what appears to be a group of people lying on the ground with a multitude of smaller phantom faces surrounding them—perhaps an inside look into the starving times? Another photo that was more titillating than intriguing had me wondering what befell a young blonde woman sans clothing; was she one of the many victims of the James River, swallowed by one of its rip currents and then spit out once her life force was taken? Could this be Lydia Ambler, and were her clothes ripped off by the current, or was this a careless victim of skinny-dipping, who went out just a little too far in the shallows and inadvertently stepped off the edge into one of the river's suck-holes? The last compelling curiosity I shall save until the epilogue because of the suggested nature of the apparition, the existence of which is more frightening and thought provoking than the collection of earthbound ghosts I have captured on this haunted, marshy English foothold onto North America.[1]

The appearance of this young nude woman was a complete shock to me—why would a ghost show up naked? Could she have been one of the many drowning victims of the James River? Did she drown while skinny-dipping or were her clothes torn off by a fast-moving current from a storm? Could this be a drowning victim from nearby Jamestown Beach, or is this perhaps the suicidal young Lydia Ambler, who according to rumor drowned herself in the James River when her husband did not return from the war?

This photo was not a surprise—one of the original settlers of Jamestown Island—perhaps long before the English even thought of coming here!

This looks like a group of bodies that are laid out, with several faces that are fairly clear, and a bunch of others that you can barely make out; my guess is that they are victims of the starving times that died so fast the living could not keep up with the burials.

THOMAS NELSON HOUSE

Still Possessed? Denying Wraiths Exist Can Solicit a Wrathful Response

He put the American Revolutionary War effort above his own welfare and possessions; assuming that Cornwallis had taken over his home as his headquarters (Cornwallis always commandeered the best home for himself), he had his men turn the cannons and aim them directly at his own house! In fact, there is a great story that goes with this fact: The Marquis de Lafayette asked him to observe the first round of cannon fire into the city of Yorktown from the artillery battery of Captain Thomas Machin. Lafayette asked him where to direct the cannon, knowing that as a longtime resident, he knew the city inside and out. (At the time, Yorktown was about the size of Williamsburg, with about 3,000 residents—more than ten times larger than it is today.) "Over there, to that house," he pointed. "It is mine," he explained, "the best one in the town. There you will be almost certain to find Lord Cornwallis . . ." If that wasn't enough, he reportedly offered a reward to any gunner who hit his house. Only three cannonballs hit the Georgian manor, with one crashing through the wall, striking a hidden staircase where a British soldier was hiding, killing him. The other two are embedded in the brick façade— and you can still see them today! This legacy is what comes to my mind when recalling one of the greatest Revolutionary War heroes that you probably have never heard of:

There were actually three Thomas Nelsons—all from the same elite family in Yorktown—but Thomas Jr. is the one most remembered because of his self-sacrificing role in the Revolutionary War. Construction on the Nelson House began in 1711 but was not completed for some years later, a rather ostentatious home on the Yorktown bluff overlooking the York River. Nelson's grandfather, Thomas Nelson, was a successful merchant who arrived in 1705. He had a son he named Thomas (not Jr.!), but not much information is given about him. Thomas' brother, William Nelson, inherited both his father's business and his father's business acumen, setting himself on a course to becoming a wealthy landowner and a powerful politician. William named his son Thomas Jr. to distinguish him from William's brother Thomas, although in reality he was Thomas III. Thomas Nelson Jr. inherited his father's wealth and propensity for shrewd business practices, and, like his father, became one of the most powerful politicians in Virginia. He served in the Continental Congress, signing the Declaration of Independence, the state legislature, and later as the governor of Virginia. As a military officer, he also had a strategic acuity coupled with a selflessness rarely seen in battle, commanding the Virginia militia (about 3,000 men) in the Battle of Yorktown. Now you know how that selflessness came out in battle, cementing his legacy in the hearts and minds of his fellow officers and soldiers. How many people do you know that, if they have or could have something of great value, would willingly destroy it for a cause that they believed in?

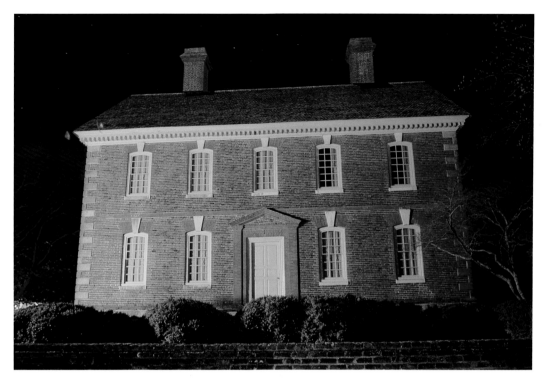

The Thomas Nelson House, the finest Georgian mansion in eighteenth-century Yorktown, sits on a bluff overlooking the York River.

Nelson's chronically ill health was attributed to his war efforts and exposure on the battlefield, particularly during the long siege of Yorktown, which lasted from June until October 1781. He died just six years later of an asthma attack. His home survived the cannon fire (the wall that was struck with the hidden staircase was repaired) and still stands today. But the British soldier, who had taken refuge in the secret stairway during the barrage of cannon fire, is possibly one of the many phantoms that inhabit this eighteenth-century house.

During the Civil War the home served as a military hospital for the Confederate wounded when Yorktown, including the Nelson family, was evacuated. After the Confederates abandoned their earthen works in Yorktown, retreating to Richmond (after a one-day battle in Williamsburg), the Union army stayed in Yorktown for the remainder of the war and the Nelson House served as a Union hospital. It was during this time period that the most seriously wounded Union soldiers were placed on the third floor (the attic) of the Nelson House, were many died.[2] The Nelsons kept the home in their family until the early 1900s, but as for the Union soldiers—well, that's a different story . . .

THE GROANS OF GHOSTS LONG GONE . . . AND THE SMELL OF PUTREFIED FLESH

If you recall in the stories of the Wren Building and the President's House on the campus of William and Mary, the most gravely wounded were always taken up to the top floor of the building and, in both cases, the deaths on those floors resulted in hauntings. The paranormal results for keeping a ward of dead and dying soldiers in this beautiful

The left side attic window was a treasure trove of spying spectres; many of these faces are likely from the Civil War, when the Nelson House became a makeshift hospital. The most seriously wounded were placed on the third floor, where many of them died!

Georgian mansion: Tales of the moans and groans of mortally wounded men who only had hours to live are sometimes heard emanating from the attic. Included in this paranormal barrage to the senses is the stench of rotting flesh and the occasional appearance of a man clad in blue with a bloodied face opening the third floor window crying out to anyone below about conditions on the third floor. There is a story told by a group of parents and children on one Halloween evening: As the group walked past the right side of the empty house, the attic window was flung open by a Union soldier with a bloodied face. They began to smell putrefied human flesh (If you have ever experienced that smell, you will never forget it!), heard the cries of pain from the dying, and heard the soldier yelling as they broke into a run, trying to escape this powerful paranormal sensory onslaught. So there is no shortage of possible explanations for who haunts this house—care to spend All Hallow's Eve at the Thomas Nelson House?

Most of the faces that I captured at the manse were from the third floor window, so I can only conclude that these are the faces of the Civil War soldiers that perished in the makeshift hospital. I also captured several faces in a basement window, one that I think strongly resembles a face from the third floor, as well as the clearest, most-distinct face I've ever captured here: a woman that appears to be wearing dark lipstick—perhaps from the twentieth century? Speaking of the twentieth century, there is one intriguing paranormal event that happened in the early 1900s that seemed to erase any doubt whether the home was haunted for the family that purchased the old Georgian manse from the Nelsons:

Although the Civil War soldiers seem to preside over the third floor of the Nelson House, the British soldier killed in the hidden staircase is not shy about making his presence known. In the early 1900s a Captain George Preston Blow from Illinois purchased and restored the Nelson Manse to all of its eighteenth-century glory, and began to entertain guests for luncheons and dinner parties. During one such luncheon held by Mrs. Blow, one of the female guests asked if the old manor was haunted. She related the story of the British soldier killed on the hidden staircase, but then stated matter-of-factly that neither she nor her

ended his life, and in the aftermath an eerie silence prevailed, seemingly slowing time to a crawl, where seconds seemed like minutes and minutes like hours in a heightened sense of awareness, and every soul in that dining room knew that ghost/soldier was right there with them. So if you would like to set off the ire of a ghost, just deny their existence . . . but be prepared for a violent response!

Several spectres also showed up in the basement window; could one of them be the British soldier killed on the hidden stairway by the canon from the American army—directed by Thomas Nelson himself towards his own house?

husband had witnessed any paranormal events that would convince them that the haunting legend had any veracity. As if her disclaimer had outraged the passive spirit, a secret panel in the dining room hiding a covert doorway pushed open with such an explosive force that it caused the whole room to tremble. The panel rammed a sideboard loaded with dishes, sending many to a shattering end on the floor.[3] It was quite evident that the British soldier answered the haunting question with the same explosive violence as the cannon fire that

Isn't it ironic that the largest, clearest wraith in this whole house is a woman, and not connected to any known ghost story!

COLE DIGGES HOUSE

Ghosts That Light Fires . . . & Suffocate the Living!

A young, wealthy woman left a party, boarded her waiting coach, and went off into the night, heading for her home, Bellfield Plantation. At some point near the end of her journey, something in the woods frightened the skittish horses so badly that they made a mad, uncontrolled dash away and plunged, coach and all, headlong into the quicksand of a nearby swamp. The screams of the young woman, the drivers, and the horses are heard to this day emanating from an area now taken up by the Naval Weapons Station, where official logs mention not only the screams but the partial sighting of a sinking coach right before it was enveloped by the murky quagmire of quicksand (the records going back to the 1920s). Although the historical records are just as murky as the swamp that swallowed them, the woman is believed to be Elizabeth Digges, daughter of Edward Digges, a former governor of the Virginia colony during the 1650s, and ancestor to Cole Digges.[4]

Both Yorktown and Cole Digges, the owner of this house, had their start in 1691. The Digges family and Yorktown owed their success to tobacco; Edward Digges, Cole's grandfather, produced a well-known type of "sweet-scented" tobacco named after his initials: "E. Dees." Although the Digges family owned plantations outside the city of Yorktown, Cole, a young merchant in his twenties, needed a place to stay in the city, where he had his business transactions. He purchased the lot in 1713, evidently tore down the original

home (built in 1699) belonging to ferryman Thomas Pate, and built a townhome worthy of a wealthy landowner and merchant in about 1720. At the time of his death in 1744, Cole owned two plantations, a warehouse, a wharf, other lots in Yorktown, and of course this townhome. In addition to growing tobacco on his two plantations and his mercantile activities, Digges served as a royally appointed member of the council of the governor of Virginia (Spotswood).

Before the National Park Service purchased this house, it was a rental home—and the ghosts of a man and woman from the eighteenth century have run off at least two of the families, if not more. This home was used as a place of business after the Digges family left: it was a general store, a bank, a hotel (a very small one), and a restaurant.[5] Whether the ghosts were married or related is unknown, but they both have been seen going about their eighteenth-century business as if the twenty-first century is not even here.

NOT JUST YOUR AVERAGE HAUNTING . . .

By an average haunting, I'm talking about the living just seeing apparitions or hearing noises that are paranormal in origin, as in the next two examples. The apparition of a man dressed in colonial clothing has been seen walking through the bedroom and out into the hallway before disappearing from sight. Likewise, a

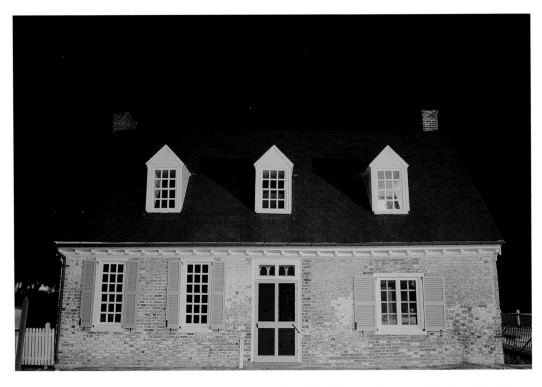

The much-less-ostentatious Cole Digges House sits nearby the Nelson House with its own collection of legacies and gathering of ghosts.

woman in a colonial dress has been seen walking into the kitchen before vanishing. But here is where you go outside the innocuous sightings and into the realm of a poltergeist: one of the renters had placed a log, kindling, and paper into the fireplace but decided not to light the fire before going to bed; when she got up the next morning, everything in the fireplace was burnt! Ghosts walking through rooms—I could live with that. But phantoms lighting fires is a little frightening, considering the potential! I say this in light of the house fire that I experienced several years ago, when all my peers in the paranormal field asked me right away about the origin of the fire. Although it was later ascertained by the fire marshal that a guest failed to extinguish her cigarette on the front porch, causing the fire, the concern expressed by the paranormal community is well founded because they are aware of a

ghost's ability to ignite fires. It makes you wonder just how many fires are paranormal in origin! (If you recall from my previous books, the ghosts at the Governor's Palace as well as the ones at the King's Arms Tavern have lit candles on multiple occasions.)

Evidently one resident family's German shepherd dogs manifested psychic abilities while at the Digges House: They would growl, and the hair on the back of their necks would stand up as they followed something invisible to human eyes as it came out of the ceiling and moved across the room. The dogs would get up and follow the invisible wraith but would stop at the doorway to the next room. Besides invisible strolls across the living-room ceiling, one or possibly both ghosts did something impossible (at least for the living): one

evening, the wife took off her slip and laid it across her purse; the next morning, the strap of her slip was inside the strap of her purse—a physical impossibility without damaging the garment or tearing the arm off the purse. It was as if the strap of the slip was sewn on while it was threaded through the handle of the purse; now the ghosts are getting metaphysical!

Perhaps one could tolerate all the above, but the next story gets downright bone-chilling for the same couple: When the husband was out of town on business, an invisible assailant tried to smother his wife! For lack of a better analogy, an unseen type of material enveloped her face, shoulder, and arm and made her feel like she was suffocating! The woman shrugged off the experience, saying that she hoped that with her next experience with the paranormal, she could communicate with the other side. I don't know about you, but if a ghost tried to smother me, I would be moving to the other side of town—not trying to communicate with my invisible attacker.

The following group of four faces resides in the Digges House. Which one do you think tries to suffocate the residents? Which one is the fire-starter?

AUGUSTINE MOORE HOUSE

The Last Victim of the Revolutionary War—White Eye

The Moore House's enduring legacy was that the terms for surrender of the British forces—effectively ending the Revolutionary War—were negotiated and signed in this house. I immediately thought that Washington, Lafayette, and Cornwallis all met in this house to haggle over the terms; I was wrong. Instead they sent officers under them to iron out the details of surrender, which, for me, took away some of the house's mystique. The house does have plenty of paranormal activity, including the last casualty of the Revolutionary War, who still haunts it, and those who have seen him have given him the unlikely moniker White Eye. But first let's look at the background history:

THE TREATY THAT ENDED THE REVOLUTIONARY WAR—SIGNED HERE!

Governor John Harvey originally owned the land in the 1630s, but Lawrence Smith II was the one who later constructed this home on his 500-acre farm ca. 1730 (by the way, when you have that much land, you call it a plantation and you give it a proper name; Smith called it Temple Run). The elder Smith died in 1754, and his son Robert took over the management of the family plantation. Financial problems forced the younger Smith to sell the plantation to his brother-in-law Augustine Moore in 1768. Moore became an apprentice to William Nelson at the age of fourteen and proved his business acumen well enough that he became a partner

in the business along with William's successor, Thomas Nelson Jr. In 1767 Moore inherited three plantations from his father, becoming a wealthy landowner. A year later, Moore purchased Temple Run from Robert Smith and settled his small family (a wife and one son: Augustine Moore Jr.) into the Smith family home. Augustine Moore became a "gentleman farmer" and continued this role until 1781, when General Cornwallis marched the British army into Yorktown. It is not known whether the Moores left for safety to Richmond during the siege of Yorktown, but son Augustine Moore Jr. must have stayed behind to manage the farm. None of the battles were fought on the grounds of the Moore Plantation, but only son Augustine Moore Jr. was shot and killed by a stray bullet while out working the fields, making him the last casualty of the Revolutionary War battle of Yorktown. He was only twenty years old when the fatal stray bullet struck him; he held on for several days in severe pain before finally succumbing to the wound.

Eighteenth-century warfare (even up to and including the Civil War, in the nineteenth century) was directed by drumbeats; specific drumbeats signaled certain commands to the soldiers. On the morning of October 17, 1781, a British drummer signaled to the allied American and French forces, which were devastating the British army with artillery fire, that they wanted a "parley" (the word came from the French word *parler*, meaning "to speak"). At the same time, a flag of truce

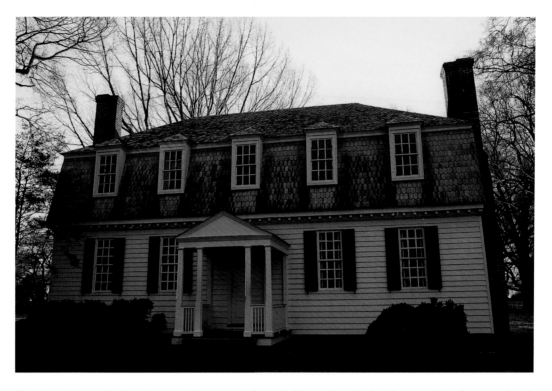

The Moore House: the Revolutionary War essentially ended here when the British unconditionally surrendered in 1781.

was raised; in essence, two signals to the Continental and French forces that the British were asking for a ceasefire. Two subordinate officers to the commander from each side hammered out the terms of surrender. The four men met at the neutral site of the Moore House in the afternoon and finally came up with something agreeable to both sides by about midnight. The Articles of Capitulation were fourteen terms directing how each side would act toward the other: British soldiers were marched off to prisoner-of-war camps in Frederick, Maryland, and Winchester, Virginia. One field officer would be assigned to accompany every group of fifty soldiers to make sure they were not mistreated and to deliver clothing and other necessities. All other British officers were released (or paroled) on the condition that they would no longer fight; they were free to go back to England,

New York, or any of the American posts still being held by British forces. Wounded and sick British soldiers would be cared for in American hospitals, and additional supplies would be procured from New York. The surrender ceremony itself was a sticking point—Washington insisted that the British would be denied customary honors, and was adamant that the British would be treated the same way the Americans were treated in Charleston, South Carolina, when the Continental garrison was captured in May 1780. By October 19, both Washington and Cornwallis signed the Articles of Capitulation, and the defeated redcoats began to march out of Yorktown and lay down their weapons; the American Revolution was over.

The iconic moment for American independence is the highlight of the Moore

House legacy; after the death of Augustine Moore in 1797, the house was passed to the son of his former business partner, Hugh Nelson, beginning a string of about fifty owners. The house suffered damage from a Union shell in the Civil War, and a lot of its siding was stripped by troops for firewood. After Confederate and Union forces left Yorktown for Williamsburg, the house remained abandoned and derelict till the centennial of the Revolutionary War's final major battle, when it was restored (1881). In 1931 the National Park Service began a second restoration, this time to its original colonial appearance—the first of its kind for the NPS.

WHITE EYE

Augustine Moore Jr. is not the only casualty of the Revolutionary War that haunts the Moore House: Yorktown merchant John Turner came out to the Moore property to watch the American and French forces decimate British forces with artillery shells just days before the British capitulation. The casual observer became a casualty when an errant projectile critically wounded him, and he died in the arms of his wife, who never recovered from the loss of her husband. Turner was buried in the Moore family graveyard, and his wife, Clara Turner, is said to have pined away for her husband and to have returned to the Moore House postmortem to haunt the place that caused her so much grief in life. According to author Daniel W. Barefoot, who has discovered lesser-known tales of the paranormal, two wounded soldiers who expired just as the British signed the capitulation papers are said to haunt the Moore House as well.[6]

Now that you know (perhaps) all of the paranormal possibilities, let's take a look at what visitors and park employees have witnessed. Park rangers and interpreters discover the most frequent manifestation of ghosts in the Moore House: indentations on the bed in the master bedroom—as if a person had been sleeping there, as well as indentations in a red velvet chair—as if a person had been sitting there. Many believe the culprit to be Augustine Moore Jr. Others have seen a woman peering out the second-story window—or sometimes just a wispy, ghostly white presence with a white eye: Perhaps Clara Turner is still waiting for her husband to return to her in death?

I was disappointed that a house with such a historical and haunting legacy did not have a stronger presence to photograph—but I was happy to learn that several witnesses have seen the apparition that I photographed—the ghost with the white eye peering from the upstairs gable window. I have captured two different ghosts in the Moore House; one with a pale face and a bluish tint to its eyes (perhaps Clara Turner?), and the other with a white eye and a white face that is kind of chilling to look at. Usually the ghosts do not have an all-white appearance that includes the eye, and they usually do not stare out from the side of their face, with just one eye visible, but who am I to say what's normal in the paranormal paradigm?[7]

Could this be Clara Turner, the woman you read about who mourns the death of her husband here at this house?

Could this be White Eye, the legendary ghost of Augustine Moore Jr., seen by many different people at the Moore House?

GRACE EPISCOPAL CHURCH

Did Cornwallis Lose the War Because He Desecrated This Church?

Is defiling a place of worship a good idea? Perhaps to Lord Cornwallis, commander of the English army, it was just another building when he desecrated the Yorktown church. The church pews were ripped out and the windows were all broken when Cornwallis used it as a "powder magazine" (a storage house for gunpowder and other supplies for the English army). Many in Yorktown would deem this supreme act of arrogance as the reason why Cornwallis lost the war. The bombardment on English positions in Yorktown from the French and American artillery got so bad that a large group of English and Hessian (hired German soldiers) troops tried to swim across the York River to escape its devastating effects, while Cornwallis is rumored to have cowered in a cave on its banks. As the desperate troops swam across the wide expanse of the York River, a squall came up and drowned most of them. At least that's the story that I was told; I would later find some historical records that contradict the prevailing narrative . . .

The Grace Episcopal Church has a long, storied history; it reminds me of the Wren Building on the campus of the College of William and Mary: It was burned down and rebuilt, and two different wars stopped all activity in each building. The original church was constructed and reconstructed on the grounds of the present-day Yorktown Coast Guard Training Center. In 1691 Yorktown's public buildings would be rebuilt, and a grid of half-acre lots were made up, with a rebuilt

church to be placed on its current site. Francis Nicolson was the governor then, and the man credited with laying out a similar grid for Williamsburg when it became the capital of Virginia in 1699. Nicolson promised twenty pounds sterling to erect a brick church on the new lot—the governor did not keep his promise, and the rector of the church wrote to the archbishop of Canterbury to complain. The city would eventually get its brick church, although the church was built with an exterior covering of "marl" over the brick, a substance like stucco that gets harder with age. Yorktown was at its most prosperous period at the height of the tobacco trade from 1750 to 1760, probably when the north wing, the bell tower, and the brick wall around the churchyard were added. The dark clouds of revolution would soon reverse the fortune of the Yorktown Anglican Church.

This period of prosperity was followed by a period of decay: When the Revolutionary War began, the new American government would no longer support the church. Essentially, the Anglican Church was an arm of the English government, and it imposed fines on people for their behavior, payable in tobacco, the currency of the day in colonial Virginia. Not only would the new government not support the Anglican Church with taxpayer money, but also it would demand that the church sell its silver and church bells and return that money to the government. In addition, "glebe lands," land used by the rectors of the church

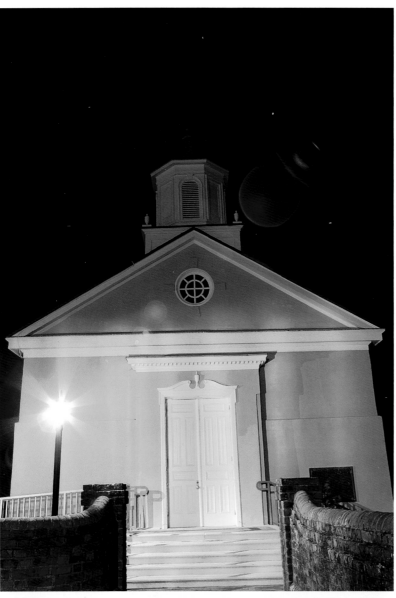

The front of Yorktown's Grace Episcopal Church, desecrated by Lord Cornwallis and the British army . . . and the reason many Yorktown residents believed he lost both the battle and the Revolutionary War.

Here are four residents of the church's graveyard looking inside the windows of the old house of worship from the graveyard.

for farming to create an additional income, were taken by the state. If that wasn't enough, during the Battle of Yorktown in 1781, Cornwallis began the desecration of the church that you read about in the first paragraph of this chapter, which many in Virginia believe led to his downfall. But that was not the end for the abuse this old building would endure:

Many Americans saw the Anglican Church, even after the Revolution, as a representation of English colonial rule, which is why attendance dropped precipitously; churches went into disrepair, and some were even burned down. The Anglican Church would become the Episcopal Church, but the new name did not bring about a change in attitude. In 1814 a new disaster struck the Yorktown community: fire ravaged the whole city, including the Episcopal Church. All that remained of the church was the burned-out shell, which would stand abandoned for many years. Rumor was that the English were responsible for the fire—English ships had been seen in the area right before the fire, and the War of 1812 was ongoing. The church remained an abandoned shell of marl—no windows, no roof, until 1848.

If you read my first book, you may recall a German professor of Greek and Latin who came to Williamsburg to teach at William and Mary. He stayed at the St. George Tucker House and is responsible for cutting, decorating, and displaying the first Christmas tree in America. This very same professor, Charles Minnigerode, felt a calling to the ministry, and he became an ordained Episcopal priest. So the man that introduced America to the Christmas tree was responsible for the rebuilding and rededication of the renamed "Grace" Episcopal Church. During the Civil War, Yorktown was likely evacuated, and Confederate troops were quartered in the church from time to time, using the large horizontal gravestones as mess tables. During the Union occupation, the church and its bell may have been damaged from the explosion of a powder magazine. The church, abandoned during the Civil War years, did not officially come back into use until 1870, and it has been in use ever since. Amazingly, this church has gone through extensive damage from three different wars, fire, years of neglect, and an explosion and yet still stands and is still a place where people worship today.[8]

Like its fellow Episcopal church in Williamsburg, I have discovered that both the living and dead attend this church. Since the windows of the church are perfectly aligned, you can look through one window and see through the other to the outside of the church. The ghosts that I captured were on the outside of the building, looking in from the opposite side. I went to the other side, hoping for the same effect, but to no avail. I found the cast of characters quite intriguing, especially a ghost that resembled Washington. No, I have no reason to believe that Washington would haunt this place, so I think that it's a coincidence that this ghost resembles the first president—but then again, what do I know?

CHAPTER 6

CORNWALLIS'S CAVE

The York River Gives Up Its Dead

The night I paid a visit to the cave named after the commander of the British army, it was a cold, windy, rainy night in early June, on the night of a full moon. Rumor has it that smugglers and pirates in the eighteenth century used this cave for nefarious purposes, possibly including the crew of Blackbeard the Pirate. This small, man-made cave has been carved into the rock of the Yorktown bluff, very close to the Yorktown beachfront. The two-roomed cave has a larger space that measures about twelve by eighteen feet, with a smaller, circular room off to the right. Today the entrance to the cave is blocked by iron bars, and to some with psychic abilities, it has a sense of fear, sadness, confusion, and anger. However, the use of this cave by Lord Cornwallis is up for debate:

As much as we would like to think of the commander of the British forces cowering in this rather small cave as the American and French forces showered them with cannon fire, most military experts think it was highly unlikely. Cornwallis, a member of English royalty, is reported to have headquartered at the finest home in Yorktown—the Thomas Nelson Jr. House. This is a brick home, but not a one-brick facade like homes that are built today: This home was built like a fortress (as were other well-made homes of that period), with walls that were two-feet thick. This house could withstand cannon fire, unless of course a window was hit. So it's up for debate whether Cornwallis left the Nelson House for the safety of the cave. Military experts say that the

British general could not have conducted the battle so removed from his forces, nor could he inspire his men to continue fighting when he was cowering in a cave. They say that Cornwallis had a "bombproof" bunker just a few hundred feet away at the Great Valley Road, but no trace of it has ever been found. So I will leave it up to you to determine whether you believe the military experts or the legend handed down by residents of Yorktown.

During the second siege of Yorktown, this time in the 1860s by the Union army, the Confederates used the cave until they abandoned the small town in the night and retreated to Williamsburg. From that point on, the historic city was in Union hands, and the cave was used as a munitions depot. A building was built around the cave to protect its contents; holes cut into the rock are all that is left of the now-collapsed building. After the Civil War, the cave remained in relative obscurity until the centennial celebration of the Yorktown victory in 1881. The owner of the cave charged tourists ten cents to see the famous Yorktown landmark. Then the small cavern returned to anonymity for almost another one hundred years. In the 1970s local legends indicate that the cave was used by a satanic cult, and some believe that the cave's new role as a place of devil worship resulted in the present-day paranormal activity.[9] Some claim to have heard voices coming out of the empty cave, and have placed the blame for the said paranormal activity squarely on the shoulders

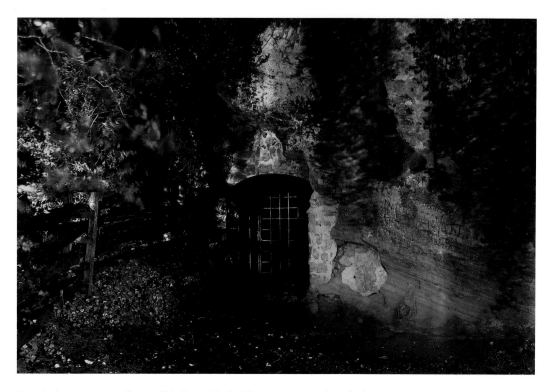

Here is the entrance to Cornwallis's Cave, blocked by an iron gate for all who wish to enter. I know the gate can't hold the ghosts inside; they can easily pass through solid objects. Perhaps something we can't see, feel, or understand holds them here.

of the Satanists, but after a photographic and psychic investigation, I beg to differ.

To clarify, I have never been a part of a psychic investigation, and as far as I knew, I was at the cave just to photograph whatever paranormal phenomena I could find. I went to Cornwallis's Cave to take advantage of the increase in paranormal activity on the night of the full moon. With the cold wind blowing off the York River, I was not sure if the chills down my back and the raised hairs on my arms were because I was not dressed warmly enough for the weather, or whether it was because of the unseen occupants of the cave. I was with a family member who is a reluctant psychic, and he was able to see with unusual clarity two of the cave's many residents:

If you recall the history of Yorktown's Grace Episcopal Church, Cornwallis's men desecrated the sanctuary during the British occupation of the sieged city. Windows were broken and pews were ripped out; the British used the building for storage. Members of the church were highly offended and felt that Cornwallis would have to answer for his transgressions to a higher power. Flash ahead and the scene in Yorktown has changed radically: Franco-American artillery fire is cutting down the British forces as well as just about every home in Yorktown to pieces; there is practically no place that is safe from the devastating effects of the cannons. Perhaps Cornwallis did end up cowering in the cave, but I believe that the first account of the next-to-last day before the British surrender is incorrect: A whole group of British

Could these two be the drowned Hessian soldiers from the Revolutionary War who somehow made it back to the cave postmortem?

Perhaps, just from the macabre look of the apparition on the left and the black-eyed people on the right, these apparitions have something to do with the occult worship that went on in this cave before the iron gates were installed to keep people out.

and Hessian troops decided to abandon their positions and swim across the York River to safety. As they tried to swim their way across, a squall seemed to come out of nowhere and drowned many of the hapless soldiers. However, I went through about ten more sources before coming up with something more historically accurate; this account comes from the government archives, written by Washington himself: On October 16, 1781, the night before the British capitulation, Lord Cornwallis hoped to ferry British forces across the York River to Gloucester with sixteen large boats sent over by Tarleton, entrenched at Gloucester Point. A violent storm broke out, forcing the boats down the river, ruining Cornwallis's plan.[10] According to American Dr. James Thacher, observing from the front lines of the Continental army, many British soldiers drowned during the storm. Yorktown residents felt that God had punished these men for desecrating their church, and that the British loss was inevitable. Flash ahead to the present day, and I am listening to a description of two individuals inside the cave.

Confusion . . . sadness . . . anger . . . regret; those are the overwhelming feelings coming from inside that cave that the psychic felt, but what he saw was even more vivid: A man is sitting down in the middle of the floor of the cave; he's soaking wet. He has no shoes on, and he seems to be wearing a uniform—but it's not the characteristic British redcoat. We would later discover through research that the unknown uniform was that of a hired Hessian (German) soldier. No words were transmitted (we do not understand German anyway), just overwhelming feelings. The psychic could see the man sitting on the ground better than he could see me! The man had auburn hair that was dripping wet, and he went from a sitting position to a fetal position—overwhelmed with confusion about where he was and why he was

there. As I looked into the blackness of the cave, I could see nothing, and all I could feel were the chills running up and down my spine. I'm trying to see with my mind's eye as he describes the scene of the drowned Hessian. I asked if there were any other soldiers that had drowned in the York River occupying the cave, and that's when he saw a second soldier . . .

This second occupant was a very large man—well over 6 feet tall. He had a dark, angry countenance and the clothing to match. In fact, everything that he wore was dark—was it really the color of his clothing or was it because he was malevolent? He wore a tricorner hat and a large British military overcoat that came to his knees. He had a very high collar (part of the coat or the shirt underneath?), an over-the-shoulders rain cape, and a wide leather sash over one shoulder, with a large metal medallion (bronze?). The Hessian soldier was in the center of the large room of the cave, whereas this rather ominous-looking bruiser stood to the far right—in front of if not in the smaller circular room of the cave. This man's anger was superseded only by his confusion, as if he did not comprehend either where he was or why he was there. To hear the description of this large intimidator of a man as I looked straight into the darkness where he was standing was a bit unnerving; what are the limitations of the dead? What can and can't they do? I wonder if size and strength of human body translates proportionately into the size and strength of our ghost? Both of the men had trouble "seeing" us—and of course I could not see them. What is this boundary of the senses that separates us from them? Why are only some people gifted—or should I say cursed—with the ability to see the other side?

In addition to the two soldiers, I was able to capture on camera other occupants of the

If you look closely at this photo, you will see apparitions of various animals, including deer, owls, a hawk, and a fox or coyote. I don't know if you have ever thought of this before, but it appears that humans do not have exclusive rights to the afterlife . .

cave looking at us—other soldiers who drowned in the York River trying to cross to safety? I was taken aback by an almost skeletal face with blond hair, as well as what appeared to be a man and a woman with blackened eyes—perhaps something to do with the satanic ceremonies held here in the past? Finally I photographed what appeared to be a whole group of animals of different species inside the cave, which created another perplexing conundrum. What do they have to do with the drowned British/Hessian troops or with the satanic observances held in the cave? One thing that I have learned about the Native American philosophy of the afterlife is that they believe that each person is accompanied by as many as nine different animal spirit guides that help him or her through their life's journey. Some Native American tribes believe that they can return to this world postmortem as an animal spirit. Is it possible that Native Americans cut this cave into the rock and later died here, and that their animal spirits now reside here? Unlike Native Americans, most Americans of European decent do not believe that the afterlife for humans will be shared with animals—although I know that some devoted pet owners may disagree with that statement. What's your philosophy of the afterlife? Does it include animals?

BERKELEY PLANTATION, BIRTHPLACE OF PRESIDENT WILLIAM HENRY HARRISON

Lightning Strikes Twice in the Same Family

According to author Kevin Kling, his family has a propensity for being struck by lightning.[11] Can a family have, as Kling suggests, a genetic predisposition for being struck by lightning? Every male in his family has been the victim of a lightning strike, and his mother took a hit from the television set. Along the same lines, is there a test that measures the body's conductivity? Kling stated that in junior high school, an instrument that determines the skin's conductivity (of electricity) measured both him and his brother; the siblings were the only two in the class to put the meter into the red. The problem is that no scientific study has been performed on the Kling family, or any other, to determine if such a predisposition exists—but the facts are compelling. If such a predisposition does exist, then I might make the compelling assertion that one of the aristocratic families of old Virginia had the very same condition that the Kling family has.

Let's just take a look at a few lightning facts before going on. The odds of a person getting struck by lightning in the United States in any year are 1 in 700,000 or 1 in 1,000,000—depending on which website you look at. The odds of getting struck in your lifetime are 1 in 3,000 or 1 in 5,000—again depending on which website you trust. Here is a scary fact that all the websites agree on: a single lightning bolt is 50,000°F, or, to put it in perspective, five times hotter than the surface of the sun.

With the thickness only about the size of a silver dollar, it packs quite a punch: a lightning bolt is anywhere from 1,000,000 to 1,000,000,000 volts and between 10,000 and 200,000 amps. About 20 percent of those struck are killed instantly, and that's no surprise, considering that lightning causes objects to explode and instantly turns any water to steam. This includes concrete, trees, asphalt, clothes, and parts of the human body. It's been known to blow (or shred) both clothes and shoes off people due to the sweat/water instantly vaporizing and creating a steam explosion. Given that Florida, Texas, and North Carolina are the top three states for lightning-induced deaths, and the proximity of southeastern Virginia to North Carolina, this part of Virginia is more dangerous than most parts of the country for someone to die as a result of a lightning strike.[12] According to the *Guinness Book of Records*, Roy Sullivan, a former Virginia park ranger, is the world record holder—having survived seven lightning strikes. Jim Caviezel, the actor playing Jesus in the film *The Passion of Christ*, was struck twice during filming (Caviezel was not seriously injured by either strike). My point is that people who have been struck multiple times can survive, making this story all the more intriguing. One man can survive being struck by lightning seven times, another man can survive two strikes, and yet different generations of the Harrison family were struck by lightning twice—and each time three adults died! What

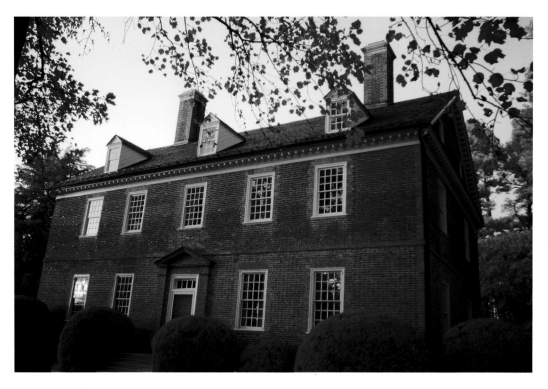

Berkeley Plantation, Birthplace of President William Henry Harrison and the site of the first Thanksgiving Celebration in America.

would you call that—coincidence, fate, or a genetic propensity to attract lightning? Here are two different stories of the Harrison family's legacy of lightning.

Sarah Harrison was the beautiful daughter of Benjamin Harrison II, a wealthy plantation owner along the lower James River (not Berkeley). In 1687 Sarah was seventeen, beautiful, and far more independent than most women in the seventeenth century. Sarah was the target of a number of eligible suitors, even though she never had a problem speaking her mind to any man—I guess that beauty and wealth trumped her independent personality. She signed a marriage contract with one of the suitors—a young man of twenty-two named William Roscoe, who was studying to be a lawyer. The contract stated in essence that Sarah would not marry any other man as long

as William was alive—*so help her God*. Just three short weeks later, she met the Reverend James Blair, and it was love at first sight. Blair was the well-educated rector of Bruton Parish Church, who would in just six years become the founder and lifelong president of the College of William and Mary. The problem was twofold: First of all, Blair was almost twice Sarah's age—thirty-one. What you need to keep in mind is that in the seventeenth and eighteenth centuries, most people did not live too long past the age of forty. Blair was just nine years from that milestone age and, because of that, was considered much too old for the vivacious seventeen-year-old Sarah. Second, Sarah had written her name on a contract promising to marry William Roscoe—*so help me God*. Considering how much the church was a part of every colonist's life, this would be a serious breach of promise!

Could these two be the same ghost, perhaps one of the young Harrison women killed by the lightning strike? Or are they sisters?

So Sarah broke her marriage contract with William Roscoe, who legend says died of a broken heart, and told her outraged parents of her plans to marry the older Blair. Though the Harrisons tried reasoning, then arguing, and then threatening their hardheaded daughter, Sarah went through with her plans to marry the charismatic preacher. It's not known if her parents even attended the ceremony, but in an amusing and fitting footnote to this story, Sarah refused to say the word "obey" in her marriage vows. Sarah Harrison married Rev. Dr. James Blair; end of story—right?

Wrong! Sarah's parents did not give up that easily: they began to seek to have the marriage annulled. But fate, or coincidence, or a genetic propensity intervened with the outcome of these efforts: Colonel Benjamin Harrison, his wife, Hannah, and his baby daughter all were riding in their carriage when a severe thunderstorm caught up with them. A bolt of lightning struck the three hapless Harrisons dead in their carriage before they could reach shelter, and their efforts to separate the two lovers was over—or was it?

The happy couple lived until Sarah's death in 1713 at the age of forty-two; the "old man" would outlive his younger lover by a full thirty years! Blair died in 1743 and was buried just six inches to the left of his beloved Sarah. Sarah was buried on the fringe of the Harrison family plot on Jamestown Island, about seven feet away from the nearest Harrison—her older sister. *Ripley's Believe It or Not!* was the first to publish this story and what happened: A sycamore sapling sprang up in that six inches of real estate that separated the two lovers, and was left to grow unimpeded between the two graves. If you have ever seen a full-grown sycamore, you may realize what happened next. The sapling grew unchecked, and it broke the connecting stones on both ends (that connected the two graves together) and pushed Sarah's tomb up and over a full seven feet to within just six inches of her older sister's grave. Ripley called the sycamore the "mother-in-law tree," because it accomplished what Mrs. Harrison could not: it separated Sarah from James Blair and brought her back to the Harrison family. The sycamore would die and would be cut down, but it left the tombs of

Could these two be the same ghost appearing in different windows at different times; one appearing with a mouth and one without?

the two lovers broken and separated, with a new sapling trying to grow in its place.

Whether you believe that the "mother-in-law tree" was the result of efforts of the Harrison family to separate their daughter from James Blair or not, the lightning strike, according to the legends recorded both by *Ripley's Believe It or Not* as well as L. B. Taylor Jr. in his book *The Ghosts of Williamsburg . . . and Nearby Environs*,[13] killed three members of the Harrison family (today you can also find this story on a number of websites). In my efforts to be thorough, I must add this to the story: Benjamin Harrison II, according to a Harrison genealogical website, died on January 30, 1712—twenty-five years after the marriage of James Blair and Sarah Harrison, and not immediately after attempting to have the marriage annulled. I'm not sure who is right; you be the judge . . .

The second incident where a lightning strike took the lives of three members of the Harrison clan happened at the Berkeley Plantation. The victims this time were Benjamin Harrison IV and two of his daughters (two daughters were reported dead in the newspaper; however, newer research indicates that perhaps only one daughter died). But let's back up for just a minute to get some background on Berkeley. Like the other two large plantations in Charles City (Westover and Shirley), this tract was a land grant by the Crown, ideally to be settled by one hundred colonists. In 1619 King James I gave the land to the Berkeley Company, and on December 14, 1619, Captain John Woodlief arrived from England with only thirty-eight colonists to settle what came to be known as Berkeley Hundred. Two years before the pilgrims of Plymouth Rock did so, the first celebration of a Thanksgiving in

These two ghosts appeared outside right next to me, and I just captured a partial face (cut off by the edge of the photograph), but it appears to be an eighteenth-century man with a white powdered wig—perhaps the elder Harrison killed by lightning when he struggled to put the upstairs window down?

America was observed at Berkeley Plantation. In 1622 the Native Americans attacked all the English settlements; the settlers who survived soon abandoned Berkeley. Benjamin Harrison III (the brother of Sarah Harrison Blair) purchased the property in 1691 and built a small house on it. His son, Benjamin Harrison IV, became the first college graduate (College of William and Mary) in the Harrison family and immediately began to increase his family's land holdings. In 1722 he married Anne Carter, daughter of Robert "King" Carter; this was a strategic marriage that, whether for love or for gain, netted Harrison profits from land that was his father-in-law's. Ultimately, this land would go to the couple's son Carter Henry Harrison, but in the meantime Harrison was able to afford to build a three-story brick mansion overlooking the James River in 1722. Harrison IV and wife, Anne Carter, had eight

children together, and at this point we turn back to the focus of this story.

One July afternoon in 1745, at the age of fifty-one, Benjamin Harrison IV began to go around his home and close all the windows and shutters because of an afternoon thunderstorm. This area of Virginia is accustomed to sweltering heat and humidity in the summer months, and as a result, windows and doors often swell and can be a problem when opening and closing. The patriarch had difficulty with one upstairs window and enlisted the help of two of his youngest daughters in getting the stubborn window closed. One of the daughters was carrying her little brother, who according to some writers was Benjamin Harrison V—clearly an impossibility since he was born in 1726 and would have been nineteen years old in 1745. The boy may have

been Nathaniel, born in 1742. As the father and two daughters struggled to get the window down, a bolt of lightning struck and killed all three; the youngest Harrison boy survived. For the second time, three members of the Harrison family fell victim to a single bolt of lightning. Again I ask, is this coincidence, fate, a genetic propensity, or perhaps a curse on the Harrison family?

Now with thoughts whirling around in your head about who might be haunting this eighteenth-century Georgian mansion, I'm going to touch on just a few other historical facts about Berkeley. Whether you are curious about the home's actual history or are interested solely in the paranormal possibilities, these stories and facts will add to the palette of possibilities: Benjamin Harrison V was at the College of William and Mary when his father and two sisters were fatally struck by lightning; he had to leave the college to help arrange for the funerals and to take over the management of the family's vast land holdings. He was elected to the House of Burgesses at the age of thirty-eight and would later show his meddle by refusing a bribe from the royal governor to accept an appointment on the executive council. Harrison stuck by his principles and would later attend the First Continental Congress in 1774. A year later he was helping Washington plan the future of the Continental army, and the following year he signed the Declaration of Independence. By 1777 Harrison was back in Virginia, serving both in the Virginia House of Burgesses and as a lieutenant in the Virginia militia, all of which made him a target of traitor Benedict Arnold. As a result, Arnold brought his force of 1,600 British soldiers up the James River, wreaking havoc on Virginian homes and plantations, particularly on the leaders of the rebellion. Harrison moved his family out of Berkeley before Arnold

arrived, and then went to Philadelphia to secure more troops and equipment for Virginia. Arnold destroyed a large portion of the mansion and Harrison's possessions, making sure that all the family's portraits were taken outside and burned (keep in mind that in an age before photography, a portrait was the only way to remember the appearance of a family member).[14] Of course, being the eighteenth century, anytime you have an army encampment, men are lost to mosquito-borne or waterborne pathogens such as typhus and malaria. How many British soldiers died on the property?

Fast forward now to the next major armed conflict: in 1862 the Union army, under the command of George McClellan, camped on the grounds of Berkeley—140,000 troops. The plantation, owned by the Stark family at the time, was empty—the family had fled to Richmond before the troops arrived. The Army of the Potomac was reeling from a beating it took in the Seven Days Battle for Richmond; thousands of the dead and dying were brought back in what seemed like a never-ending procession of carts. It had been the bloodiest week in American history, producing more **than 34,000 casualties (*19,000* Confederate—3,478 killed, 16,261 wounded, 875 captured/missing, and *15,000* Union—1,734 killed, 8,062 wounded, 6,053 captured/missing).**[15] Even though the Confederates lost more men, they saved Richmond from the enormous Union army and, if not for a few miscommunications, would have routed the entire Army of the Potomac. Fortunately, the Berkeley Plantation was not ransacked and burned by the federals, although the departing army did burn the docks on the James River.

Two interesting footnotes about the Union occupation of Berkeley: The song "Taps," a

military song most often heard at military funerals and played by a lone bugler, was composed on the grounds of Berkeley. The second anecdote revolves around a young Union drummer boy named John Jamieson, who was in the McClellan encampment. The drummer boy would one day become a successful businessman and return to buy the plantation he had camped on as a part of the massive Union army: in 1907, Jamieson purchased the old Georgian plantation home, by then in ruins, and 1,400 acres. How incredible is it that a young boy who stayed in a tent on the grounds of this eighteenth-century mansion was able to return forty-five years later and purchase it! Twenty years later, John's son Malcolm inherited Berkeley, and he began work to restore the property to its full Georgian glory. The Jamieson family still owns and operates Berkeley, trying to keep its legacy and history alive, and, along with that, the heritage of the paranormal. Berkeley was the home of our ninth president, William Henry Harrison, and the ancestral home of our twenty-third president and grandson of William Henry—yes, another Benjamin Harrison. But let's take a closer look at William, who was born and raised here:

PRESIDENT WILLIAM HENRY HARRISON, YOUNGEST SON OF BENJAMIN

William Henry Harrison was born at Berkeley Plantation in 1773, the youngest of seven children. In the eighteenth century, a family's home and property were willed to the eldest son, leaving the younger males to get a good education and become ambitious and independent enough to create their own wealth. William was tutored at home, spent three years at Hampden-Sydney College, then went to study medicine under Benjamin Rush, a Philadelphia physician who was as well known for his participation in politics, including signing the Declaration of Independence, as he was for his medical practice. William's father, Benjamin Harrison, died in 1791, leaving him short on funds, so William left his medical training for a career in the military, a life pursuit that he preferred. Not content to enter as an infantryman, Harrison used familial connections to the Washington and Lee families to secure a rank of ensign, the lowest officer's rank; however, the ambitious young officer was soon promoted to the rank of lieutenant, and then to aide de camp under General Mad Anthony Wayne. He won a citation for bravery in the Battle of Fallen Timbers against the Native Americans in 1794 and took over command of Fort Washington as a captain when Wayne died the next year.

Soon after, Harrison eloped with twenty-year-old Anna Symmes, against the wishes of her father, who was traveling at the time. Harrison would exploit his new wife's family connections with land speculators, and in 1798 he resigned from his commission. Although his father-in-law did not like his talentless (his words, not mine) son-in-law, he used his political connections to have Harrison appointed secretary of the Northwest Territory, and the following year he was elected as the territory's congressional delegate, reforming a law that allowed only large land purchases into a law that would enable poor settlers to purchase smaller plots of land on a payment plan. In 1800, President John Adams appointed Harrison governor of the Indiana Territories, comprising all or part of five midwestern states now. To his credit, he was an honest administrator who worked on improving roads and infrastructure. However, Harrison would push through treaty after treaty that exploited Native Americans, serving alcohol to dim their senses as they

47

would sign away millions of acres of land for next to nothing. After years of exploitation by Harrison with corrupt leaders, poverty, and alcohol, one Native American chief, Tecumseh, gathered a number of tribes together with British military assistance to rise up against the Harrison leadership. Harrison would personally command 950 men in the Battle of Tippecanoe (River), and his years away from a command would soon show. He let his men build too many campfires, which gave away their position, paving the way for a predawn surprise attack that resulted in the deaths of a number of men and officers. Harrison would ultimately rally his men and win the battle, but the public had mixed feelings about the victory—some just happy for the victory, others angry over the heavy loss of life due to lax leadership. Harrison would earn his nickname, Tippecanoe, or just Tip, as well as his presidential slogan, from this battle. He was appointed major general of the forces in the Northwest Territories, and although he would hold back from his orders till Oliver Hazard Perry's naval victory over the British fleet in Lake Erie, he would take back Detroit from the British as well as win a decisive victory over Tecumseh and the British forces at the Battle of Thames. Rather than finishing the fight with the remaining British forces in Canada, Harrison exploited his newly found fame by taking leave of his position to go on a tour in the East, attending parties, banquets, and celebrations in his honor before resigning from his commission to tend his farm in Ohio (1814).

The next quarter century of Harrison's life was mostly politics, although he lost more elections and political appointments than he won. He served as a US congressman from 1816 to 1819, then he won a seat in the US Senate in 1824, where he began to seek

appointments to other Washington posts. President John Quincy Adams felt compelled to voice his disapproval of Harrison's "rabid thirst for lucrative office." Harrison finally got an appointment in 1828 as ambassador to Colombia, but he failed to stay neutral in national affairs and was about to be expelled when Andrew Jackson recalled him. Forced to go back to Ohio and his poorly performing farm, he became the county recorder just to make ends meet and pay his debts.[16]

With the shortest time in office of any president, thirty-one days, Harrison really had no legacy as president, because he was sick the day after his inauguration till his passing. He and his newly formed political party, the Whigs, did change how men ran for office, and not for the better. Before we even had the name "spin doctors," Harrison's image to the voting electorate was completely changed to the polar opposite of what it really was. Harrison was from the old Virginia aristocracy, born into privilege and wealth, educated at a fine Virginia college in the classics, and about to become a physician, and even though his elder brothers received the bulk of the Harrison estate, he spent money as if he still had the wealth he was born into, to the point of accumulating massive debt. Harrison's campaign managers turned this Virginia blue blood into their "hard cider and log cabin" candidate, taking a newspaper article that denigrated Harrison and putting a positive spin on it. They focused on Harrison's military victory at Tippecanoe, calling him "Old Tip," transforming his image into a down-home, regular guy who was for the masses—and they couldn't have been further from the truth. Martin Van Buren campaigned on the issues and winning people's minds, and Harrison's campaign focused on winning people's hearts with mass-marketed items such as cups, plates,

flags, and sewing boxes with their down-home boy's picture on them. The Whigs also employed cheap stunts to gain votes, such as pushing a ten-foot ball made of paper and tin with Harrison campaign slogans slathered all over it for hundreds of miles (if you have ever heard the saying "keep the ball rolling," it came from this political stunt). Stooping even lower, the Harrison campaign began to hand out whiskey—in bottles shaped like log cabins—to win votes. The alcohol in the rustic cabin-shaped bottles was purchased from the E. C. Booz distillery, so if you have ever heard of any kind of alcohol referred to by the slang term "booze," you now know that it came from the Harrison campaign trying to bribe the voters with whiskey. The Harrison election also had their own songs, portraying Harrison's opponent, Martin Van Buren, as an aristocratic highbrow who ate off a golden plate while Harrison wore homespun coats and shirts without ruffles.[17] The victory for the Harrison/ Tyler presidential ticket taught campaign managers that you can completely misrepresent your candidate and still win an election! Wouldn't it be nice if all the spin doctors *had* to stick to the issues, and not misrepresentation and character assassination of your opponent?

You now have all the background information to speculate on the specters of the former Harrison home, or perhaps you would like to know the conjecture of those who live or work (or both) at the Berkeley residence . . .

THE GHOSTS

If you hadn't figured it out yet, the two or three main ghosts that occupy the Berkeley House are Benjamin Harrison IV and his two daughters (some say that only one of the two daughters remains at the house). Although

Harrison and his two daughters were unable to get the window shut in life—they have apparently been successful in death: a window in the upstairs will apparently slam from the force of invisible hands. One of the daughters has been seen standing at a window late at night with a baby in her arms. A tour guide has been struck several times by a door that opens by itself and bangs into her; she believes the culprit to be Benjamin Harrison IV. Other paranormal sounds in the house include a rattling sound, a baby crying in the basement (of course, when they investigate, no one is there!), footsteps in the attic, glass moving on a chandelier, and hovering or flying fruit in the dining room whenever it is placed in a certain fruit bowl on the table.

On my first visit to Berkeley, I found that people were reluctant to talk with me because a previous paranormal author published highly inaccurate information about the Harrison plantation. So on my second visit, I took this chapter with me so they could both review it for accuracy and realize that I make every effort to present my readers with the most accurate, up-to-date information on each house or building that I investigate and photograph. I also had to go early (on a warm December evening) so that I finished before all the employees left. I had never photographed anywhere that early in the evening—just after 5:00 p.m., when the sun had just set and it was barely dusk—and yet I was still successful in capturing the wraiths at the old plantation home. I was even more shocked to discover— for the first time—that a ghost appeared in my photograph just a few feet away from me in the yard as I photographed the side windows in the old Georgian mansion. The windows, as you will see, were likewise full of faces staring out at me, but I was curious about the identity of the ghost that was brazen enough

to come right up to me in the yard. This ghost, unlike most, needed no highlighting or raising the contrast; it was quite visible without such measures. Could it have been Benjamin Harrison IV, trying to let me know that this was his domicile . . . or perhaps that he was trapped here in some sort of supernatural limbo, unable to move on after being struck down by a bolt of lightning? I cannot say for sure, but what I can say is that you do not have to go out late at night at the bewitching hour to capture ghosts—they will readily appear wherever the sunlight is not too strong to wash them out . . .

SHERWOOD FOREST, HOME OF PRESIDENT JOHN TYLER

The Gray Lady: Can You Reason with Ghosts?

If you think that the dissension in today's government between the executive and legislative branches of government, liberals and conservatives, and Democrats and Republicans is something new, you haven't studied politics close to the mid-nineteenth century. Several firsts in the presidency of the United States occurred after the election of William Henry Harrison and his vice-presidential running mate John Tyler in the 1840s. Harrison's long-winded, rambling, two-hour inaugural address (in the freezing cold, without a coat or hat) was his ultimate downfall, and he would die in office shortly thereafter: the first time a president died while in office. John Tyler, no doubt expecting a very dull four years in office attending funerals and other state events the president could not or would not attend, went back to his Virginia plantation, Sherwood Forest, after Harrison's inauguration. He was rushed back to Washington to be sworn in as the first vice president to take over the office of the president. A short time later he would be the first president to have all but one of his cabinet resign at once after he vetoed two different bills slated to create the Bank of the United States. He was also the first president in office to be kicked out of his own political party—the Whigs.[18] John Tyler would walk a winding, rocky road as president during a contentious time in American politics that would ultimately lead to the Civil War (let's hope today's caustic politics do not

lead to another one!). To find out why, let's go back to John Tyler's roots.

Tyler was born in 1790 into wealth and all the entitlements of the old Virginia aristocracy. Like most of the sons of the old ruling class, he attended and graduated from William and Mary and went on to study law. Passing the bar, he began his law practice at one of Richmond's most prestigious law firms and then used his father's connections to jump-start his political career with a seat in the Virginia House of Delegates—all of this at the ripe old age of twenty-one. (How many twenty-one-year-olds do you know in government today?) It's noteworthy to mention that all the way back in 1811, Tyler began the fight against the proposal that would later be the catalyst for almost his whole presidential cabinet to resign: the Bank of the United States, which he felt was an inroad into broadening the power of the national government—going hand in hand with weakening the powers of individual states. The next year the young lawyer/politician would join the military in what many called *America's second war of independence*—the War of 1812. Emerging unscathed from the war effort, he turned his attentions back to the political arena, this time winning an election to the US House of Representatives; the astute politician learned the value of being politically connected at Dolley Madison's "squeezers": American politics was so acerbic and fractured

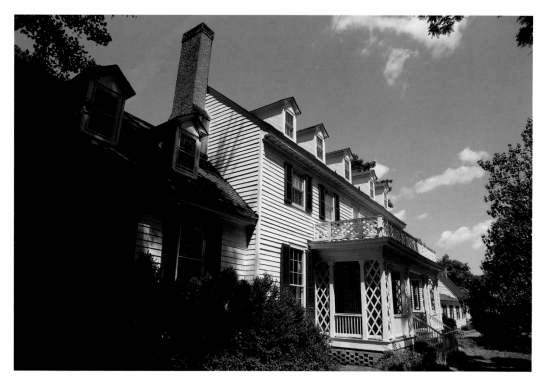

Sherwood Forest, former home of President John Tyler and the longest frame house in America—over 300 feet, more than the length of a football field!

that the socially astute first lady hosted Washington parties every Wednesday in an effort to bridge the divisions; these were so well attended by the Washington elite that people had to squeeze in—hence the name.[19] (More on this later with the "Charm Offensive" of James Madison and his wife, Dolley.) As a member of the old southern aristocracy, Tyler opposed everything that was an affront to the Old South's position of power and wealth: voting rights for men without property, a national bank, a strong standing army, tariffs, and restrictions on slavery in new states west of Missouri—this final provocation would garner Tyler's resignation from Congress in protest of what he saw as an abuse of federal power. Tyler's next venture into politics would be as governor of Virginia, before he would once again return to the national political scene as a Virginia senator in 1827. Just five

years later, he would reluctantly support Andrew Jackson's bid for the presidency as the lesser of two evils, a move that he would later regret and would spurn him to form the Whig Party with two men who would later prove to be political thorns in his side: Henry Clay and Daniel Webster. This time the catalyst was Jackson threatening to use federal forces against the state of South Carolina for not enforcing federal tariffs—the national government overriding the power of the state government.[20]

One of the final acts of the Jackson presidency would set up his successor (and vice president for his second term) Martin Van Buren for failure and the nomination of the Harrison/Tyler ticket in 1840. Jackson's destruction of the Second Bank of the United States led to runaway speculation and inflation

Another example of two different photos of the same ghost?

by state banks; the Jackson solution was called a specie circular, specifying that all federal land could no longer be purchased with credit—only hard money, which back then meant gold or silver. The result was the worst depression the country had ever experienced in its young history thus far, starting in the first year of the Van Buren presidency. Just like in the recession in 2008–2009, banks and businesses failed and thousands lost their property (which was overvalued due to easy credit and to the insolvency both of the lenders and the people they extended credit to), and all of this led to the failure of Martin Van Buren to be reelected in 1840. So the 1840 election presented William Henry Harrison as a simple frontier Indian fighter, and yet he was as much a product of the Virginia plantation aristocracy as Tyler, born and raised right down the road from Tyler's home, Sherwood Plantation. Harrison's victory over Chief Tecumseh's Native American confederacy at Tippecanoe was what inspired the Harrison/ Tyler slogan: Tippecanoe and Tyler Too! After

the election, Harrison lasted only thirty-two days before dying of what may have been pneumonia, giving rise to the Tyler presidency and the fracturing of the Whig Party. When Tyler ascended to the office of president, everyone expected a patsy for the party agenda, and right off the bat Tyler showed an independence from party doctrine regarding the establishment of a national bank. Although

Men do not appear too often with women; could they have been a couple, or even married?

Could these three men have been a part of the Union forces that occupied Sherwood Plantation? The last one looks quite angry. Could he have been the soldier who was killed while trying to set the house on fire?

willing to compromise with Whig Party leader Henry Clay, Clay's refusal to concede on anything resulted in a Tyler veto on two different banking bills passed by Congress. So this resulted in the debacle of the whole presidential cabinet resigning, with the exception of Secretary of State Daniel Webster, although the cabinet was really the choice of William H. Harrison and not Tyler. If this were not enough, Clay actually tried to impeach Tyler but ultimately failed to do anything but pass a resolution of censure. On the bright side of the Tyler presidency, he signed the Log Cabin Bill, created by the Whig-dominated Congress, which enabled a settler to claim 160 acres of government land before it was offered to the public for purchase; the settler would later have to pay the government $1.25 per acre. Tyler actually signed into law a tariff that would protect northern manufacturers, and of course he was all for annexing Texas to the Union—entering the United States in 1845 as a slave state. Tyler fully intended to run for the presidency in 1844, but his nemesis Henry Clay was running against him and Polk. Tyler feared that the three-way split would hand the election over to Clay, and he reluctantly but voluntarily withdrew from the election,

This man seems to have the Tyler family nose . . . a relative from the past?

with his consolation prize being that his archenemy Clay was not elected to the presidency. The final historical first for the Tyler presidency and the final slap in the face from a contentious Congress was that the legislative body overrode a presidential veto (on a military appropriation) before Tyler left

Former residents of Sherwood Plantation?

office. Like the other Virginian presidents before him (except for Washington), Tyler returned to his plantation after his single presidential term deeply in debt, and in his case nearly bankrupt. Postpresidency and after the first southern states seceded from the Union in 1861, Tyler led a compromise movement to keep the Union together. When Lincoln rejected the compromise, Tyler worked to create the Confederate States of America and would be elected to the Confederate House of Representatives. He died in 1862, just a couple of months shy of his seventy-second birthday and a few years shy of witnessing the demise of the southern aristocracy that he was so much a part of.[21]

In Tyler's second year as president he purchased a home and the surrounding 1,600 acres from his cousin. He renamed the property Sherwood Forest in keeping with his status as a political outlaw (outlawed from the Whig Party) like the outlaw Robin Hood, although unlike the original outlaw of Sherwood Forest Tyler would advocate for the Virginia aristocracy, not the Virginia poor. The land was originally part of a 1616 land grant called Smith's Hundred, but the house was not built on the property until circa 1720, having several owners before Tyler purchased the property in 1842 (including William Henry Harrison,

who inherited it sometime after Dr. Rickman). When Tyler added a 68-foot ballroom in 1845, he created another American first that had nothing to do with politics or his years in the office of president: he created the longest frame house in America. The Tyler family still owns the record-setting residence, maintaining the National Historic Landmark through the Sherwood Forest Plantation Foundation.[22]

PREMONITIONS, DISEMBODIED VOICES, AND THE GRAY LADY

Perhaps it's a good thing that John Tyler died in early 1862, because later that year the Battle of Williamsburg would be fought on May 5, 1862, and then the Union army, over 100,000 men strong, would march up the peninsula toward Richmond. During the Peninsula Campaign, the Sherwood Forest Plantation would be occupied by Union troops, with two attempts to burn the historic house down, and the widow Julia Tyler would have to escape to Wilmington, North Carolina, with her five children. She feared the worst for her family with the arrival of the despised Union general Butler, who earned a reputation like that of General Sherman—leaving a wake of destruction and devastation. Who knows if

John Tyler, who would have been seventy-two at the time, would have been able to endure the daring escape and running the Union blockade in order to return to Julia Tyler's family home in New York. What we do know is that Julia Tyler had a vivid premonition of her much-older husband's death in Richmond in January 1862 that compelled her to travel to Richmond by carriage to check on him. He scoffed at her concern, but two days later he suffered an attack and died in the very same setting that Julia Tyler had dreamed of: a large bed with an eagle, its wings outstretched, carved into the headboard.

The first of two attempts to burn Sherwood Forest was by a lone Union soldier who stood at the kitchen door while trying to set the plantation home ablaze; he met a violent death by one of two ways, depending on which version of the story you believe. In one version, his commanding officer shot him either in the neck or the head; perhaps when General McClelland was here, because he and John Tyler were friends. McClelland had posted guards around the house to protect it from vandalism during his stay here because of that friendship; one of the guards could have shot the malevolent soldier. The other way the errant soldier potentially met his end was even more violent: an axe-wielding assailant plunged his weapon into the head or neck of the soldier/arsonist. The second attempt at the burning of Tyler's plantation home was by General Butler when he left. First he burned books from the library, furniture, and the plantation's wheat fields, as well as putting lime in the wells. He then had a bale of hay placed in the front hall underneath a table Tyler had at the White House; he lit the bale, expecting that the historic house would soon be enveloped in flames as he rode away. Just a half mile away on the James River, an observant Union gunboat captain saw the smoke and promptly brought his crew ashore to extinguish the fire. The maid had helped by pulling out some of the hay before it caught on fire. Voices are heard during the summer at Sherwood Forest, when the Union army was stationed there. Could it be that the would-be arsonist, or perhaps other soldiers who died on the property, are talking in the low, almost indistinguishable voices that Tyler's descendants and their visitors hear during the summer's evening hours?

The most famous Sherwood Forest phantom, immortalized in L. B. Taylor Jr.'s book *The Ghosts of Williamsburg . . . and Nearby Environs*, is the Gray Lady, believed to have haunted the 1720s domicile since the late eighteenth century—long before the Tylers took up residence there. Although nothing is known for certain, the Tyler descendants have pieced together a profile of the mystery woman that inhabits their home. The Gray Lady was given that moniker because of her gray outfit, often worn by women hired as a governess by the wealthy for their children. She would have the charge of a small child and divided her time between the first-floor bedroom and the upstairs nursery, connected by a secret stairway. In the nursery the governess would rock the small child to sleep, and it's postulated that the Gray Lady is laden with guilt over the child in her care. Could she feel responsible, or was she responsible for the child's death? The Tylers have heard the distinct sound of footsteps going up and down the hidden stairs, as well as the sound of the rocking chair in both the bedroom and the nursery. Sometimes, when the Gray Lady was heard descending the steps, it sounded as if she was dragging something—could it be the body of a small child? Harrison Tyler, the grandson of John Tyler and a professed skeptic of the paranormal,

This lady fits the description of the legacy of the Gray Lady—a small, thin woman with long curly hair. Curious about the glowing outline to her left?

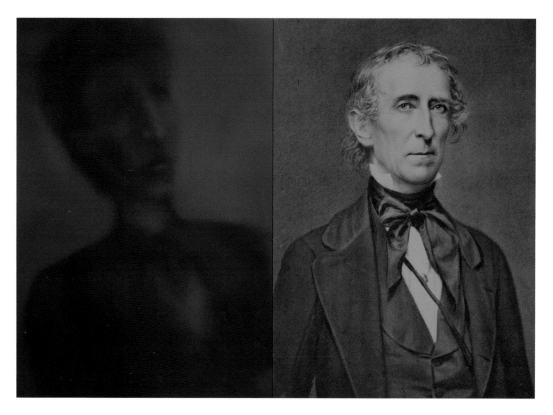

This very dark apparition was near the front door; he reminds me of a young version of John Tyler . . .

became a believer after he experienced her walking through his bedroom, and a sixteen-year-old houseguest had the very same experience. Harrison's wife, Payne Tyler, finally had heard enough to prompt her to acknowledge the phantom and have a one-way conversation with the ghost governess. She told the Gray Lady that the antebellum home had been in the Tyler family since 1842, and as descendants they had every right to be there—but she was willing to coexist with the gray-clad ghost. She announced that they were not going anywhere, so they had to learn how to live together. I have written about the living talking with the dead in a one-way conversation similar to this at two different taverns in Colonial Williamsburg, and in each case the ghosts listened and modified their behavior. This seems to be the case with Mrs. Tyler and the Gray Lady, and she did not hear from the

walking, rocking wraith for quite some time—until a cousin of Harrison Tyler challenged the existence of ghosts in a condescending, chiding manner that even challenged her intelligence. The downstairs bedroom they were in, given the moniker the Gray Room because of the Gray Lady's proclivity for that room, began to vibrate wildly, with loud banging on the walls as if someone or something was violently slamming the shutters against the house. The frightened woman left as fast as she possibly could and did not return for three to four years after her paranormal denial. Needless to say, the cousin did not challenge the existence of the Gray Lady or any other ghost on her return.[23]

Thus far, the Gray Lady's presence could be ascertained only audibly; that would change when a pair of psychics with a special

talent for *seeing dead people* arrived. They visited the home separately, yet each described a similar wraith: a tiny woman in a neutral-colored dress and an overlay—possibly an apron, with black shoes. One psychic even described the Gray Lady sorting clothes at a wardrobe that had a dolphin design at each foot; she had no way of knowing that Julia Tyler had this exact wardrobe when she lived at Sherwood, and it had been removed from the house two years earlier—but never photographed.[24] Even more compelling, a monochrome image of the Gray Lady appeared on the wall of the secret staircase a few years ago, and you can see a photo of the image here: www.sherwoodforest.org/Ghosts.html. It looks like a monochrome graphic in a lighter shade of the existing paint on the wall at the bottom of the stairs, with an older woman's face with her hair in ringlets. Because it looks more like a graphic, there is not a lot of detail in the image. I have a photo of a younger-looking woman, with her hair in ringlets and her shoulders wrapped in a shawl; I have been told that ghosts will often appear as a younger version of themselves—perhaps this is just such a case. I have photos of many others besides the possible photo of the Gray Lady. Some of these faces may be members of the families who owned Sherwood Plantation before the Tylers. Others may be members of the Tyler family. And still others may have been members of the Union army that occupied the plantation during the spring and summer of 1862. For me, the most profound and intriguing photo is the one I believe to be one of the most famous ghosts on Route 5, better known as John Tyler Memorial Highway: the Gray Lady of Sherwood Plantation.

WESTOVER PLANTATION

The Lost Generation of the Byrds: Is Being Fabulously Wealthy All It's Cracked Up to Be?

Upon first glance at this magnificent mansion overlooking the James River, one word comes to mind: wealth. On several websites, William Byrd II is given credit for building the ostentatious plantation manor known as Westover; some say ca. 1720 and others say ca. 1730. But according to the National Park Service, the house was built somewhere around the midcentury mark. Since William Byrd II died in 1744, that would make William Byrd III the man who gets credit for the mansion. Dendrochronology—the study of tree rings— was used on the attic rafters to make this revision on the date and builder of Westover.

The name Westover, however, comes about a century and a half earlier, when a private English company (Virginian Company of London) created small settlements of about one hundred people (in groups of ten families, one hundred being an idealized number) along the James River, called, appropriately enough, *hundreds*. The West Hundred was probably named after the three West brothers, and the fact that their brother was Lord Delaware, the first colonial governor of the Virginia Colony, most likely influenced the decision. John Rolfe, the man who married Pocahontas, wrote about both the West and Shirley Hundreds in 1616. On March 22, 1622, Native American leader (or Powhatan, which is a title, not a name) Opechancanough attacked outlying English settlements such as West Hundred, with the intent of reclaiming lost land and destroying the white population, decimating

settlements all along the James River. One can only wonder—where are the wraiths of West Hundred?

The colonial governor patented 2,000 acres of the plantation called Westover to a Captain Thomas Pawlett, who thus became the plantation's first recorded owner in 1637. Captain Pawlett sold to Richard Bland, who later sold Westover to William Byrd I in 1688. William Byrd II made quite the legacy: founder of the city of Richmond, the owner of the largest library in the colonies (4,000 volumes), lawyer, member of the governor's council, surveyor (helped survey the boundary between Virginia and North Carolina), and a prolific writer. For all his accomplishments outside Westover, he may have had a few shortcomings as a parent. Both his daughter and son were considered spoiled, and his son spent a lifetime gambling and living outside his means.[25]

Let's start with Evelyn, his daughter: She was sent to England at the age of ten to receive a proper education. She was presented at court at the age of sixteen, and even the King made a remark about Evelyn's beauty:

> I am not surprised why our young men are going to Virginia if there are so many pretty Byrds there!

She also caught the eye of aristocrat Charles Morduant, grandson of the Earl of Peterborough. What could father William

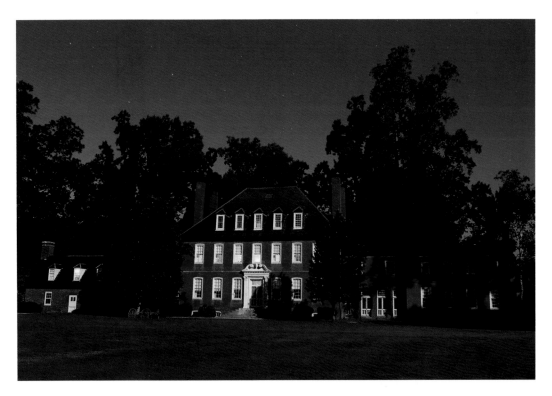

This is the ostentatious Westover Plantation, glowing in the light of a full summer moon.

Byrd II possibly find wrong with a rich, young nobleman? His religion. His daughter's suitor was a Catholic. Even as late as the mid-twentieth century, Protestants and Catholics did not marry! Byrd was adamantly against the union, threatening his daughter in a letter:

> . . . as to any expectation you may fondly entertain of a fortune from me, you are not to look for one brass farthing. . . . Nay besides all that I will avoid the sight of you as of a creature detested.

In other words, he would disinherit her and avoid looking at her as if he hated her— harsh words from her father! Evelyn returned with her father to Westover, the vivacity gone from her young eyes and her joi de vivre crushed. Only nineteen, and beautiful and wealthy, she refused many eligible suitors who came to Westover to seek her approval,

Of the several faces in this windowpane, could one of them be a younger version of the man who committed suicide—William Byrd III?

Perhaps two of the enslaved people at Westover?

The second time I went to Westover I had a psychic with me, and she pointed to this window and said, "I see a very sad young woman." Could this be Evelyn Byrd, the woman who died at a young age of a broken heart?

pining away for her only love. She would die in her sleep of a broken heart before she reached her thirtieth birthday: her father lived to regret such an unyielding decision. But before she passed, she made a pact with one of her few friends (and neighbor from nearby Berkeley Plantation), Anne Harrison.

On the grounds of Westover, under a poplar tree, the two girls promised each other that whoever died first would return to see the other and perhaps tell what the experience was like. The caveat to the pact was that they would not try to frighten each other; the paranormal rendezvous would be proof of life beyond the physical death of the human body. Anne mourned the loss of Evelyn for weeks but finally mustered up the courage to return to the tree where the two friends made their pact. Anne felt a presence, and when she turned around she was inundated with white light emanating from the ephemeral form of her friend. Evelyn gave Anne a smile, blew her a kiss, and then disappeared, fulfilling their promise in the most comforting way. Evelyn has now assumed a new identity; she's the *lady in white*, and she has been letting her presence be known at Westover ever since. From owners and guests to servants and maintenance workers, most have had the pleasure of meeting Evelyn, the friendly ghost. Butlers have told the story of stepping aside to allow a woman dressed in an extravagant gown to pass by; after several steps the elegant figure would fade to nothing. Some guests have been greeted at the foot of their bed by Miss Evelyn; it seems that the affable ghost is unable to speak but always gives them a reassuring smile. Perhaps she has found the love that eluded her in life in her alternate reality . . .

Evelyn's brother seemed equally troubled in life; although he was able to find love, he was unable to live within his means. Like his father, he went to England to study law—and along with his law practice he acquired a vice that would plague him throughout life: gambling. Now that we know that he was

Some of the women from Westover's past.

likely the builder of Westover—that was an additional drain on his inadequate income. It seems strange to use the words "inadequate income" for a man who was fabulously wealthy for his time, but for someone with no spending constraints, those words fit the bill—even for the lord of all this: 179,000 acres, hundreds of slaves, mills, fisheries, vessels, warehouses, and a store. Just eleven years after his father's death, Byrd had to sell land and slaves worth £40,000—nearly three million dollars by today's standards!—and still could not satisfy all his debts. Byrd had to resort to another gamble in 1768: he held a lottery (lotto prizes from one of his estates at the falls on the James River). Don't you find it ironic that a gambler would resort to gambling to solve a gambling problem—and lose?

Like his father, William Byrd II, number three evidently had difficulties on the home front. But just like the date of construction and the builder of Westover, there are discrepancies about Byrd III and the demise of his wife, Elizabeth. According to researchers from Colonial Williamsburg, whom I must say are very thorough, Elizabeth Byrd died on July 25, 1760, a *probable suicide*. Other sources say that Elizabeth died when she climbed up on a high, heavy dresser of husband

William in search of proof of her husband's indiscretions against their marriage. Her mother-in-law Moriah Taylor, who despised Elizabeth, told her she would find evidence of all her husband William's illicit affairs in the top of that dresser. She used the lower drawers as steps as she attempted to reach the upper drawers, searching for love letters, when the heavy piece of furniture fell over and crushed her. She cried out for help for some time before she died; those cries are echoed through the upstairs to this day in an eerie haunting—but then again, some say the cries are from the mother-in-law, who is riddled with guilt for causing the death of her daughter-in-law. So was it suicide or was it an accident?

For the sources that indicate that Elizabeth was crushed by William's dresser, some details about previous events are left out: four years earlier, a report indicated that William Byrd III had repudiated his wife (eighteenth-century speak for the cancellation of the marriage by one party—the man). No divorce, no dividing up of the property, no custody battles or visitation rights—just cancel the marriage! He turned his estate over to trustees, sent his children to England to live with an aunt and an uncle, canceled his marriage, and joined the English army. (It is said that Elizabeth "grieved bitterly"

I'm not sure if this man was a Byrd or not, but he definitely wanted to be seen.

Byrd seemed to be trying to turn over a new leaf: He resigned his post in the army, returned to Westover with his new wife, actively resumed control of his affairs, and returned to the governor's council. He and his second wife had ten children together, and he worked at paying off his debts, producing large amounts of tobacco, wheat, lead from his mine in southwestern Virginia, and products from his iron forge. But the problem was that Byrd was incapable of living within his income. To compound his problems, his spoiled two sons destroyed property at the College of William and Mary and threatened its president. Another debt came in 1771 when his mother died—he owed £5,000 (more than $200,000 today) to his forgotten children by his first wife, Elizabeth. With all of his seemingly insurmountable problems and debts, William Byrd III committed suicide in his upstairs room at Westover on the first or second of January in 1777, at just forty-eight years old.[26] At this point, the third person of the lost generation of the Byrd family began to haunt Westover: sister Evelyn, brother William III, and his wife, Elizabeth. Forty years later, in 1817, the Byrd family would lose Westover.

when her children were sent to England—and she would never see them again.) William began serving in the British forces during the French and Indian War from 1756 to 1781, traveling from Nova Scotia all the way to the Carolinas during his tenure, rising through the ranks till he achieved the rank of commander of the 1st Virginia Regiment (replacing George Washington). During this time he did not see his wife (or former wife), and it was not until 1760, while staying in winter quarters in Philadelphia, that Byrd met the woman he would eventually marry: Mary Willing. If Byrd had dismissed his wife and sent away his children, why would Elizabeth be searching for proof of her husband's infidelity? It would be a moot point! Whether Byrd's first wife was accidently killed by a falling dresser or committed suicide, she is the second member of the Byrd family that is said to haunt Westover. William married Mary Willing close to six months after the death of Elizabeth; his former in-laws derogatively called her Willing Mary.

Westover, Berkeley, and Edgewood are all in close proximity to each other, forming a triangle. Berkeley overlooks the James River to the west, and Edgewood is to the north just across scenic Route 5. Confederates used the third-story window at the Edgewood Plantation house (and the roof) to spy on Union troops stationed at Berkeley. Some of the Union troops were stationed at Westover under McClellan's protégé, Gen. Fitz John Porter. Confederate troops stationed on the south side of the James River fired their cannon at the mansion and hit the East Wing, which at the time was not attached to the main house. The wing caught fire, and Byrd's 40,000-volume library was lost to posterity.

I can't help but wonder if this group of bearded men was a part of the Union forces that camped on the grounds of Westover during the Civil War.

A Byrd descendent, Clarise Ramsey, bought Westover in 1899. She rebuilt the East Wing and connected it and the West Wing to the main house, creating one long, massive residence. Richard Crane acquired the modernized manor house in 1921, and today Crane's great-granddaughter Andrea and her husband, Rob Erda, occupy it.

THE GHOSTS

The most frequent paranormal sighting has been the lady in white, the graceful, beautiful Evelyn Byrd. Her brother, William Byrd III, has been seen in the room where he ended his own life, slumped over a chair. William's first wife, Elizabeth, has been heard but not seen, crying out from the second floor—whether she perished underneath a heavy dresser or took her own life. Then there is the possibility of the victims of the 1622 Indian massacre who lived in West Hundred, wherever that settlement was on the Westover property. Finally, when the Union army returned to Berkeley and Westover, the residents of Edgewood saw a slew of ambulances (wagons) filled with the dead and dying going both to Westover and Berkeley. How many wounded

Union soldiers perished on the grounds of Westover? Of course you also have the residents, slaves, and staff who have lived and worked in a home that is approaching its third century; how many of them still reside at this massive mansion?

Approaching Westover in a vehicle from the back, you will see a rather dark, foreboding outline of ancient trees camouflaging about the closest thing you can find to a European manor house in America. But when you walk around to the front, the light of the full moon bathes the massive green lawn in a silver-white light. The infinity-edge lawn immediately draws the eye to the wide expanse of the James River in front of it, with its glittering trails of moonlight that afford the owners of Westover one of the most breathtaking views anywhere. After absorbing Westover's eye-candy view, I walked to the edge of its slippery bank, with my back to the river, so that my camera could take in the full width of Westover. Taking care not to take one step backward (if I did, I would have slipped right down the dew-soaked bank and into the James), I took a few glamour shots of the antebellum plantation home. Then it was time to get down to the business of finding the ghosts.

As we moved about the front, taking various angles of Westover mansion and lawn, we kept hearing people talking. Although we could hear what sounded like a whole group of people conversing as if they were at a party (it was a Friday night), we could not make out what they were saying. I finally decided to try to find the party, because ghosts gravitate to people—I might be able to capture the people and their paranormal eavesdroppers all in one group. As we were looking back at the house from the riverfront, the sound was coming from the left in a maze of hedges, trees, and gardens. We went back into the maze to start our search, and the talking stopped as soon as we got about twenty feet down the path. Everyone in my crew heard the conversation—but I still wonder if there was an actual re-creation of the sound of a party, because we could not make out any words!

In our search for the source of the sound, we came across the tomb of William Byrd II, the hard-nosed disciplinarian/father who threatened to disown and disinherit Evelyn should she choose to remain in England and marry the Catholic nobleman. I took several photos of the monument and did not see any anomalies, so we decided to explore more of the grounds. As the last of my crew walked past the tomb of William II, he swears that some unseen force tripped him, something I can neither dispute nor substantiate. Nevertheless, I would advise caution should you decide to walk past William's tomb—perhaps he's still a bit cranky.

Although we failed to find the paranormal party, we did find a plethora of possible participants. We found many, but only a few made the grade for this book: the clearest, the most colorful, or the most unusual was chosen.

I'm at a complete loss to explain this odd group of ghosts; perhaps a page out of the mansion's Epicurean past when the wealthy had both the time and money to pursue whatever they deemed pleasurable.

SHIRLEY PLANTATION

The Paranormal Painting:
Palpitating, Peering Portrait of Pratt

In 1610 Sir Thomas West arrived at Jamestown after the disastrous *starving times*. He persuaded the remnants of the settlement to stay and soldier on. Three years later, King James I presented West with a royal land grant of 4,000 acres for keeping the colony going. West named the grant West and Shirley Hundred, using both his name and his father-in-law's, Sir Thomas Sherley, in the title of the property. (Yes, the spelling of words, particularly people's names, in the seventeenth and even the eighteenth centuries varied greatly.) With a date of 1613, this makes it Virginia's oldest plantation as well as America's oldest operating plantation. In 1638 Colonel Edward Hill purchased and established a 450-acre farm on the banks of the James River on the original land grant, creating the oldest and longest-running family-owned business in the United States (as of 2020, it has lasted 382 years!), now more than 700 acres. Hill not only shrewdly managed his plantation but was also very active in Virginia politics, including holding the office of treasurer of Virginia as well as Speaker of the House of Burgesses. There were three Edward Hills who inherited the property; however, Edward Hill (IV) would die of consumption (tuberculosis) at the age of sixteen, leaving the Hill family without a male heir to take over the plantation. So the Hill family legacy would stop at three generations, and the farm would go to Edward's sister Elizabeth and whomever she would marry. When Elizabeth Hill married John Carter (eldest son of Robert

"King" Carter, given the moniker because he was the colony's wealthiest and most influential resident) in 1723, Edward Hill III began construction on the Great House as a wedding gift. Taking fifteen years to make it habitable, the couple finally moved into the 10,000-square-foot mansion in 1738; construction would continue for another thirty-five years, with the family's lavish taste for luxury regardless of the cost. A large carved pineapple is the centerpiece of the roof and aptly symbolizes the hospitality offered to guests of the Carter/Hill families for more than a hundred years before and during the American Revolution, including the likes of George Washington and Thomas Jefferson. The backstory of another marriage that took place at the Shirley Estate would lead to the birth of a famous American:

Anne Hill Carter, the beautiful young daughter of the next generation of Carters, was carrying a punch bowl to the dining room when it began to slip from her grasp. Who should come to her aid when he observed the falling punch bowl and caught it but her future husband, a young military officer by the name of Henry "Light-Horse Harry" Lee. Evidently he had his eye on Anne even before the punch bowl slipped from her grasp! The two would later marry and have a son who became a tactical genius for nineteenth-century warfare—General Robert E. Lee. But the most fascinating tale of the Shirley Plantation is not about a famous American, but about an infamous phantom, not known for her legacy during life but her postmortem mischief.[27]

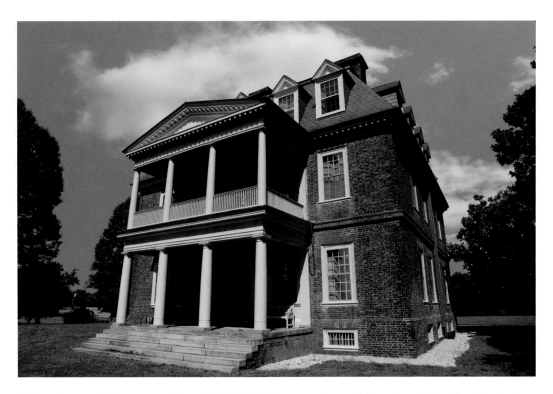

Shirley Plantation's Great House, Edward Hill III's 10,000-square-foot wedding gift to his daughter Elizabeth, completed in 1738.

THE PALPITATING, PEERING PORTRAIT OF PRATT

Martha Hill Pratt, born in the late seventeenth century, and the daughter of Edward Hill III, was born and raised at the Shirley Plantation. Not much is known about her because she married and moved to England with her husband. Her portrait is one of a gallery of paintings of the family that hung on the walls of the eighteenth-century dwelling until the mid-nineteenth century. Her sister Elizabeth, whose husband, John, took over the reigns of the plantation, told her family that the painting was of their Aunt Pratt, which is how she has been known to the family ever since. Lost to history is an accurate portrayal of the woman's personality, but one can only conclude from her poltergeist tactics that she was a dominant force to be reckoned with—

perhaps even spoiled. The assertive, prevailing personality of her poltergeist was demonstrated long after her death in 1858, when her portrait was moved from a downstairs bedroom and taken to the attic when that generation of the family began remodeling the first floor. Angry at her banishment from public display on the first floor to the obscurity of the third-floor attic, she kept the family and guests awake at night with a loud, incessant sound of *rocking* (another version of the story calls the noise a *tapping*, and yet another version calls the noise a *severe knocking*). When someone mustered the courage to look into the attic, the sound would cease, but they felt ill at ease from the cold stare of the eyes in the portrait, and they felt the frigid chill of a nearby ghost run down their spines. Aunt Pratt would prevail as the home's occupants, some fatigued from the sleepless nights at

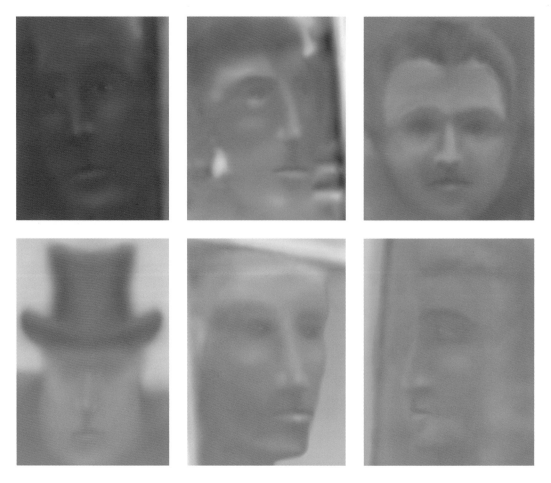

This group of male ghosts still resides at the Shirley Plantation; I can only wonder which ones are Hills and which ones are Carters.

the manor house, decided to move the painting back to its original place in the first-floor bedroom. The family did not hear another peep from Pratt for more than a century, until they tried moving the haunted painting again. It's interesting to note that during the Civil War, the plantation was occupied by Union troops, and the Grand House was used as a hospital for war casualties. During this period, all of the home's valuables were taken and stored in the attic, and the Pratt portrait was noticeably silent—evidently Aunt Pratt knew what would happen to her painting during this period of the plantation's history. At the war's end, all of Shirley's paintings, furniture,

and decorations were taken out of the attic and restored to their original space. Several generations would come and go before Aunt Pratt would have to assert herself to a new generation of the Carter/Hill family, as well as the general public.

In 1974 the Virginia Travel Council searched the commonwealth for haunted relics that could be put on display at the Rockefeller Center in New York City to encourage tourism to the state, and Aunt Pratt's painting was proudly put on display as evidence of a Virginia haunting—and she did not disappoint. Of the many spectators who witnessed the painting

Are these two bearded men part of the Union forces that camped at the Shirley Plantation? They may have been some of the wounded who were cared for and died at the Great House.

rocking and shaking in its display case, an NBC news reporter was able to capture video of the painting's paranormal palpitations. The next morning, workers found that the painting had fallen to the floor several feet away from the display and had begun moving toward an exit! After that, they locked the painting in a closet at closing time to prevent further damage and movement. That night the maintenance crew reported hearing knocking and crying sounds coming from the closet, and of course when they opened the door, no one was inside and all was silent. The next morning the painting had inexplicably left the locked closet and was lying on the floor outside; Aunt Pratt was heading for the exit again. A psychic was consulted, and she determined that there were two women involved in the portrait. Two plausible theories were offered: the first was that Aunt Pratt's portrait was painted over another woman's, leaving the other woman struggling to show her identity. The second is that another woman sat in to model for Aunt Pratt, leaving either her or Aunt Pratt desirous of having either her real identity or perhaps her real likeness shown to the eleven generations of descendants of the Carter/Hill family and/

or to the 40,000-some people who visit the plantation each year.[28]

The beating taken by the frame of the haunted portrait during its display at the Rockefeller Center was such that it was sent to Linden Galleries in Richmond for repairs before it was put on display again back at Shirley Plantation. While it was there, instead of the usual rocking, vibrating behavior displayed by the female phantom or phantoms when put on exhibition in New York City, the shop owner said he heard bells ringing—and there were no bells on the premises![29]

Now back at her preferred spot in the Grand House, Pratt is content to silently gaze at her surroundings from her spot on the bedroom wall, although some tour guides remind their groups not to block her view out the window. For those who doubt the power of the presence behind the Pratt painting, a fairly recent story may convince you. A tour group exploring Shirley's Grand House was taken to the room where the portrait hung, and the tour guide told of the painting's paranormal legacy. One skeptic in the group,

These two may be the remnants of the enslaved that are bound to the plantation in death as they were in life.

a man standing next to an armoire in the room, promptly exclaimed that the whole affair was just a bunch of bull. Evidently denying the power of Pratt is not the thing to do in front of her—an armoire door violently swung open and hit the doubting Thomas in the derriere, causing his quick departure. I can only wonder if he left a believer . . . Some have actually seen the female phantom at the window, and that's where I come in with a photo that adds a whole new dimension of bizarre to the paranormal legacy of Aunt Pratt:

I happened to show up on a late-spring day to photograph Shirley's Grand House, and off to the right side of the grounds a wedding was taking place. Of the many photos that I took, the one that was most intriguing was of a woman with long, curly, dark hair in a white dress. Behind her, looking over the top of her head, was a man who had either white or silver hair or was wearing an eighteenth-century-style wig. The man had what appears to be a very

ephemeral arm around the woman, and the front of the woman's dress is open, showing her breasts. When I saw the portrait of Aunt Pratt, she too was wearing a white dress, and she had long, dark, curly hair—although her hair was pulled back in the painting. You can compare the photos yourself—but if that is Aunt Pratt, is she trying to convey the message that she had an illicit affair with an older man here at the plantation? Could it be that she was sent away to England, perhaps even forced to marry someone she did not love, rather than remain here in America, where the affair could continue? I feel that she is trying to relay some sort of message to her family, which is why she is so adamant about remaining here at Shirley; I just don't know if I am interpreting the photo correctly. What do you think? Of all the faces I've captured, this of course is the most compelling because of the background story and the fact that the image seems to convey something totally different about what little is known about Aunt Pratt. Perhaps she

is content hanging on the bedroom wall with her portrait—or just maybe she is waiting to tell the world about her life, her love, and the real reason why she went off to England for the remainder of her life. Could you think of any other reason why the spirit of this woman clings so tenaciously to this spot on the wall of the bedroom?

This recent resident of the Shirley Plantation is wearing clothing from the twentieth century. I only wish his face would have come in a little clearer.

This is the most intriguing of all the photos from the Shirley Plantation because it has a woman in a white dress with long, dark, curly hair—just like the painting of Aunt Pratt. But who is the mystery man behind her? Did she have an affair with an older man before she was sent off to England to marry? Is this affair why she so tenaciously clings to her spot on the wall of the Great House?

ROSEWELL PLANTATION

The Legacy of Letitia Dalton: The Men Stared . . . and the Women Glared!

Wouldn't it be great to see where Thomas Jefferson actually wrote the rough draft of the Declaration of Independence? He did so at the home of his lifelong friend, John Page, in what is known as the "Blue Room."[30] John Page was the third generation of the Page family to live at the Rosewell Plantation in Gloucester, Virginia, in an ostentatious three-story home that was comparable to some of the finest homes in the city of London. The fact that Jefferson wrote the first draft of this document in a friend's home is indicative of how close their friendship was; they met as classmates at the College of William and Mary and remained lifelong friends. Page, like Jefferson, served as governor of Virginia; he also served in the Virginia General Assembly, as well as several terms representing Virginia in the US Congress. Unlike Jefferson, Page actually fought in the Revolutionary War, eventually reaching the rank of colonel before the war ended. But the mansion where Page and Jefferson discussed politics and spawned their ideas of revolution had been in existence for about a half century before the schism between the colonies and England created a new nation.

Rosewell began in 1725 by John Page's grandfather, Mann Page (continuing that southern tradition among the wealthy of using the wife's family surname for the child's first name). Construction was not finished in 1730, when Mann died; his wife, Judith Carter Page (Do you remember how wealthy the Carters were?), was able to acquire funds from her father's estate to continue the construction in 1737—twelve years later and they are still building Rosewell! That year, Mann Page II took over Rosewell from his mother and supervised the rest of the construction of the mammoth manor house. The second generation of the Page family left in 1765 for Mannfield, leaving the mansion in the capable hands of the eldest son, John Page, who began renovating and redecorating his massive living quarters just five years after taking over. That same year (1771), he began his career in politics in the Virginia House of Burgesses.[31]

John Page began serving in the First Congress of the United States at the temporary capital in New York City when a woman seventeen years his junior caught his eye. The forty-seven-year-old widower escorted thirty-year-old Margaret Lowther to a party; sometime after their rendezvous, Page discovered that his younger date had left her glove in his carriage. According to their romantic legend, the two began exchanging notes—the first by Page, who returned the glove with the following note:

"Taking 'G' from 'Glove' leaves 'Love'

Tis that I offer thee.

Margaret replied with another note:

"Taking 'P' from 'Page' leaves 'Age,'

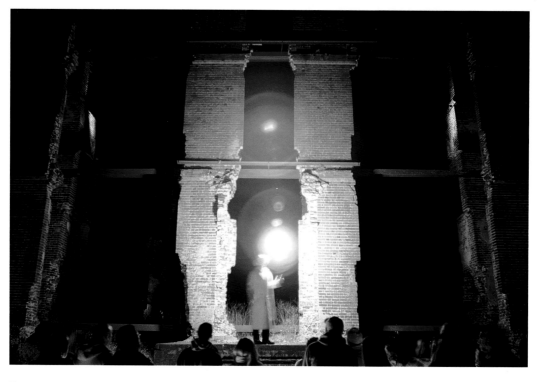

This is all that remains of the Rosewell Plantation House, the home of Thomas Jefferson's lifelong friend John Page and the place where Jefferson composed the rough draft of the Declaration of Independence.

And you are too old for me."

Was she only teasing, or was she serious? If she was serious, something changed her mind; she eventually became his second wife. What was it about John Page that altered Margaret's initial snub? Was it his personality, his political position, or his money that swayed Margaret's decision to marry a man seventeen years her senior? They continued to write and exchange poems during their marriage; perhaps it was really love . . .

Rosewell would remain in the Page family for a little more than one hundred years; the year 1837 ended the Page legacy at Rosewell. Four other families (Booth, Catlett, Deans, and Taylor) would live in the massive manor

before it was gutted by fire in 1916, leaving a partial shell of a brick facade and four chimneys.

THE WRAITHS RUSH IN . . .

Most of the homes in Colonial Williamsburg were actually townhouses for the colony's wealthy, because it was often the wealthy who were either elected to Virginia's representational government or appointed to the governor's council (you had to be a landowner to even qualify). But these townhomes did not leave the legacy that the plantation homes did. Rosewell, named after a brook of fresh water on the property that *rose well*, has a plethora of paranormal stories to its name, and these stories just add to the intrigue of the shell of one of Virginia's greatest antebellum mansions.

One of legacies of Rosewell is that at the end of every workday the slaves can be heard coming back from the fields, and I photographed this group of skull-like apparitions right along the treeline at the end of the day.

Native Americans lived on and farmed on the land for thousands of years before Rosewell was even thought of, and I was part of a ghost tour on the night before Halloween that reminded us of that. The fields on both sides of the road leading up to the burned-out shell of Rosewell are still being farmed; the cornstalks are a present-day reminder of one of the crops that the Native Americans cultivated on the land. As our tour guide gave us some of the pre-European history of the grounds we stood on, I took the opportunity to take a few photographs. What I could see was a field of cornstalks, dried and frostbitten, under a late October starry night. What I could not see was a rash of unseen visitors floating across the field and ready to accompany the tour and hear their own personal story once again. I was shocked by how many there were; in the photographs that I took, I counted at least fifty. Several of the apparitions took a position over our tour guide's lighted torch that he carried, and maintained that spot throughout the remainder of the tour. It made sense to me—if ghosts like to hang around artificial light, they would also gravitate toward fire. It also made sense that ancient peoples would sit around a fire at night and call up the spirits of their ancestors—because I now had proof that they actually come!

An apparition took shape right in front of me in infrared light that was stunning in its clarity and detail: the shape of a young woman had coalesced directly in front of my camera, as if to let me know that this was her haunting grounds, and perhaps she knew that I was there to capture her likeness. Although the camera picked up only her head and shoulders, it was enough to show in detail what she had on. Most of the time I only capture the face, but here was a full-bodied apparition. It was an incredible experience—and I have the photograph to prove it. We had only just begun the tour, and I had an incredible photo! I listened intently to every story that the guide told, keenly anticipating any story that had a young woman in it—because she had come to see me personally. There were probably others whose story I would hear who did not have the power, the know-how, or the desire to make an appearance—I guess they shall remain anonymous.

THE BOY WHO WOULD BUILD ROSEWELL

The tour moved down the road to an area to the left of the mansion, and our guide told us the story of a boy who was fascinated with the construction of this palatial home and was eager to help and to learn. He came when he

was six years old with his father (a mason from Fredericksburg) and wanted to assist with the construction any way he could. In the beginning the boy was given small, inconsequential jobs to keep him occupied, but as the years went by, the youngster began to pick up more skills. By the time he was thirteen years old, he was working on the scaffolding on the roof. One early morning, when the hoarfrost coated the timbers of the scaffolding, the young teenager was eager to start and climbed to the top of the scaffold to continue working on the roof. Perhaps the boy was a bit too eager, and from the height of about four stories he slipped and fell to his death, landing on a pile of unforgiving bricks. The young teenage boy who died so suddenly and so unexpectedly is now one of the Rosewell wraiths. As our guide related his story, I took photos of him that showed the presence of several apparitions hanging off his torch, and perhaps every word of his tale. Was one of them young Philip, the boy so zealous to help build this palatial plantation home?

THE SMELL OF THANKSGIVING . . . FROM 1741

The next stop was just to the left of the manor house, with its left side dimly lit by a spotlight. We were asked if we could smell anything, and the person with me suggested that she caught the scent of a fire and cooking food. Evidently one (or more) of the ghosts there is communicating to us through the aroma of cooking food. Why? We were standing on the site of the Rosewell kitchen (a separate building in the eighteenth century), where a terrible accident occurred. It was Thanksgiving 1741, and the slaves were in the kitchen preparing for a large feast. Two simultaneous things happened: a fire from the kitchen hearth spread to the building, and the kitchen door jammed.

The Page family headstones in the family's graveyard were moved to Abingdon Church cemetery, but the bodies were left here. Could this be John Page, or the face of another member of the Page family left behind?

The fire consumed the building and the lives of eleven slaves working inside; evidently the scent of food and fire is the only way they have to let us know they are still there . . .

THE MEN STARED . . . THE WOMEN GLARED

When a truly beautiful woman makes an entrance into a room, that's what happens, particularly if the men doing the staring are already taken. Letitia Dalton made such an entrance into Rosewell, descending the grand stairway in an elegant and extravagant red gown, and yes the men stared and the women glared. She is thought to have been responsible for the deaths of four people: her sister, her husband, and two slaves. But one wonders if this is the result of gossip and conjecture of those envious of her beauty, or if they really had a basis for their accusations. When the

This large assembly of apparitions made their appearance at what remains of the Rosewell ice house; I can't say that any of these resemble the likeness of a thirteen-year-old girl—the young girl who fell into the ice pit and tried to claw her way out.

woman responsible for so much salacious scandal, was discovered by her husband coming out of the woods, leaving one to wonder if the husband caught wind of his wife's betrayal. There's no telling where to draw the line between vicious gossip and the truth, but evidently Letitia Dalton met her mysterious end a short time after that evening at Rosewell. She continues to descend a stairway that no longer exists in her flamboyant red gown, making a grand entrance for those who are brave enough to traipse the grounds of Rosewell under the bewitching cover of darkness.

My reluctant psychic accompanied me to Rosewell that evening, and she was convinced that the woman who came across the Indian fields when we began the tour and made an appearance right in front of me was Rosewell's infamous lady in red. Evidently Letitia was trying to make another grand entrance, and for my part, I believe she succeeded. Although psychically the psychic did not detect any murderous intent, she did describe the flamboyant phantom as a *man-eater*, intent on being seen and admired. She also believes that Letitia's husband is responsible for her disappearance . . . after capturing her in a compromising situation with another man.

men stared, they were blinded to her murderous legacy, but the jealous eyes of the women were reminded of nothing but her lethal intent.

Lucy Burwell Page Saunders, the last child of Governor John Page, held a lavish gala at Rosewell, and Letitia, who lived at a nearby plantation, was invited. It's not known whether Lucy truly wanted Letitia to attend or just felt a societal obligation to extend an invitation. But come she did, and she made her final, ostentatious entrance down the Rosewell stairway that night—as a living, breathing woman. According to the intrigue that has been handed down, Letitia, who attended the ball with her current husband, made a clandestine rendezvous with another man on the grounds of the palatial estate. As the tale was told that evening, Letitia, the

THE MISSING FINGER—CHEWED OFF OR HACKED OFF?

One of the slaves from the Rosewell Plantation, in a desperate move to escape forced labor, made a mad dash for freedom. Slave owners were quite adept at tracking down runaway slaves, using hunting dogs and a posse of trackers. They captured the missing slave and brought the middle-aged African American back to Rosewell. He was beaten and whipped and then brought down into the basement of the mansion. Shrieks of pain emanated from

Here are the Indian fields—the fields of corn where the spirits awakened as we made our way to the plantation house. Among the many spirits, the whole body apparition of a young woman appeared in the bottom right of the photograph—and right in front of me!

the cellar of the manor house, and the story handed down by many generations says that the man actually gnawed off his index finger. I'm sorry, but I have a hard time believing that a man who was probably badly bitten by dogs, then beat, and then brought back home to be whipped would have it in him to gnaw off his finger. I believe the plantation overseer chopped off his finger as an excruciating reminder not to run away. Some have heard the shrieks of pain coming from Rosewell's empty and abandoned basement years later, a poignant reminder of the brutality of slavery.

Late in the twentieth century, two men came to experience the mystique of Rosewell while they explored its ruins one evening at dusk; they may have gotten more than they bargained for. They brought their dogs with them but left them in their vehicle as they went out back of the burned-out shell of a house. They heard their dogs barking like crazy, and went back to their vehicles to investigate. They could not calm the animals down, so they got in their vehicle to leave. As they were just about to pull out, an angry African American man came out of the woods, walked to their vehicle, placed both hands on the hood, and gave the men a look that sent chills down their spine. The driver threw the car into reverse and gunned the car out of the driveway. They drove dangerously fast out of the area and did not stop until they were miles away. They pulled over and got out to look at the front of the vehicle. The handprints were still on the hood. Both men took note of a curious feature about the handprints: one hand was missing an index finger . . .

PRESUMED DEAD . . . BUT STILL ALIVE!

One of the biggest fears of the eighteenth and nineteenth centuries was to be buried alive. Some people would go into such deep comas that respiration or pulse could not be detected by conventional means, and as a result, some people were literally buried alive. So great was the fear that some people rigged up a bell attached to a string that went down through the earth and the top of the coffin to the person's hand inside. Should they awaken from their comatose state, they could ring the bell to summon someone to dig up the coffin. (What they did not realize was that a person could awaken and then suffocate from a lack of oxygen in the confines of their coffin. This is the reason that a dead person's body was laid out in their home and a *wake* was held: the relatives would sit around to see if the person awakened from their deep sleep). Being buried alive was one of George Washington's biggest fears, as well as the experience of one young teenager at Rosewell.

Thirteen-year-old Katherine had contracted tuberculosis, and the disease progressed to the point that her loved ones thought she had exhaled her last breath. Katherine was presumed dead, and her body was taken out to Rosewell's icehouse, a pit dug out in the ground for storing blocks of ice. The pit is surrounded by brick walls that make it look more like an oversized wishing well than a place to store ice, usually cut from freshwater lakes up north and brought down to be sold to those who had the wealth and means to purchase the blocks. Katherine's body was placed just inside the door of the icehouse to await the three-day period of burial arrangements. Sometime during that three days, she must have awoken in a panic. In an unfamiliar place and disoriented, she must have fallen into the pit among the blocks of ice. Marks in the brick are still there where the poor, half-frozen teenager tried to crawl or claw her way out of her icy prison. It was not long before the recovered teen succumbed to the elements, her death hastened by her icy surroundings. When the family came to retrieve the body for the funeral, they discovered that the girl's body had been moved, and, to their horror, marks in the brick were indicative that the girl had indeed awakened from her coma and shortly after died from exposure. Some say they have heard Katherine's cries of "Help me! Please help me!" come from the icehouse.

A new high school was built in Gloucester in 1976, and a girl who attended that school was given the assignment to do a report on a local historical place. This particular girl chose to do her report on Rosewell, and she had her mother bring her out to the Rosewell ruins to see and then write a firsthand description of the magnificent manor. Upon going to the back of the house and ascending the steps into the masonry shell of the mansion, she was confronted by the young Katherine and immediately felt the same icy chill that Katherine experienced before she breathed her last. She noted a look on the teenager's face that was a combination of anger and confusion; was she trying to convey what her last moments felt like, or was she reliving them and looking for help? The high school teen was frightened and frozen to her core, and her instinct was to get out of there as quickly as her frigid legs could take her. When she returned to her car, she discovered that her mother, waiting patiently inside, had experienced the same glacial chill that had enveloped her. Katherine's ghost gave both the Gloucester teen and her mother a taste of what it really means to be chilled to the bone. I can only wonder if the teen included her icy experience with the specter of Katherine in her report . . .

Here is the cropped, enlarged photo of the young woman from the previous photograph; one of the former female residents from the plantation's past? Perhaps Letitia Dalton?

FERRY PLANTATION

The Witch, the Trickster, and the Painter with the Dirty Shirt

Virginia Beach: surf, sun, sand . . . and supernatural. Wave runners and wraiths, beachgoers and ghosts, paragliders and paranormal, fun times and phantoms—a new way to look at one of Virginia's premier travel destinations. But wait—you didn't know that **Virginia Beach has ghosts?** They are everywhere, and there are some very cool legacies and legends that make them appealing this time of year.

One of Virginia Beach's most intriguing haunts is the Ferry Plantation, a very early-nineteenth-century building. English history at this site began as far back as 1642, when this spot was one of possibly eleven stops for a ferry that ran along the Lynnhaven waterway; hence the name Ferry Plantation. On July 10, 1706, in the second Princess Anne courthouse, Grace Sherwood stood trial for witchcraft. Grace went on trial at the age of forty-six, just about five years after the death of her husband, accused of witchcraft by her neighbors and put on trial and found guilty. How did they determine her guilt? According to the Ferry Plantation website, it was a trial by water: "Grace was tied crossbound and dropped into the water above a man's depth. If she were to sink and drown, she was innocent and could be buried on holy ground." But if she floated, as the majority of people do, she would be found guilty and imprisoned (they burned witches in Salem, not in Virginia Beach). Today, the Old Donation Episcopal Church stands where the courthouse once was; would

you like to guess the name of the road? Witchduck Road!

In 1735, a third courthouse was built to replace the timber courthouse where Grace Sherwood was tried (or nearby); this time much closer to the ferry landing than the previous one. This courthouse was used for only sixteen years, and then in 1751, the fourth courthouse, built in Newtown, began its tenure. The old courthouse then became a kitchen for a new plantation home built by the Walke family, owners of the property at that time. The manor house burned to the ground in 1828, and from the ashes the bricks were taken to give rise to the house that stands today—completed in 1830. They rebuilt the house for their son Charles MacIntosh (his mother was a Walke), who was seventeen years old at the time. Charles (and his family) were against Virginia seceding from the Union, but he reluctantly resigned from the Navy to be commissioned captain of the Confederate ship CSS *Louisiana*.[32] Charles was fatally wounded and his ship was destroyed in 1862.

THE GHOSTS

On my first visit to Ferry Plantation, I followed the directions and ended up in a neighborhood with high-dollar homes sitting on or near the Lynnhaven waterway, and all the while I'm thinking to myself that something was wrong. Surely this haunted, nineteenth-century structure was not squeezed into this

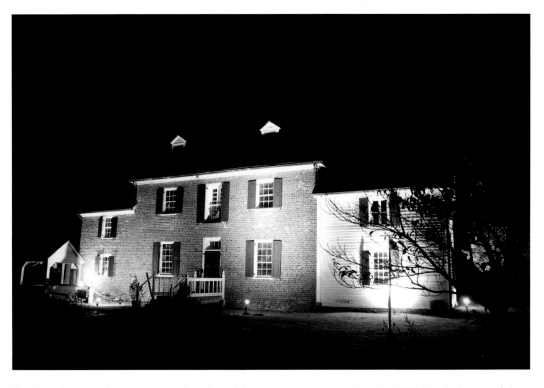

The Ferry Plantation home rose from the ashes of the previous home, completed in 1830. But the legacy of the land goes all the way back to 1642!

neighborhood of upscale homes. Then I saw the sign and a parking lot and realized that this piece of Virginia Beach history had fallen prey to developers, who packed it in as tightly as they could to a modern development. The Ferry Plantation is very well lit at night, with spotlights all around it. That may be good for protecting it from vandals and thieves, but it makes my job more difficult. "Why?" you ask. Because so much light makes it difficult for the ghosts to be seen—it washes them out, which is also why you don't see or hear too **much about ghosts making daytime** appearances. Condensation on some of the windows was working against me that evening, but despite the odds I was able to capture a few images that defy description.

One possibility for the female apparition could be the only woman who was convicted of witchcraft in Virginia: Grace Sherwood. Another possibility could be the apparition of Sally Walke, a tall, betrothed beauty promised to a Civil War soldier who never returned. The black-haired maiden was given the news of the demise of her fiancé in April 1863 but evidently still awaits the return of his spirit next to the fireplace, leaning on the mantel and claiming that she is chilled. Could Sally be the woman in the window, unaware of just how cold she really is? Or the phantom female face could be the wife of Charles F. MacIntosh, who was eight months pregnant when Charles, the captain of the naval ironclad *Louisiana*, was mortally wounded. Perhaps she is still ruminating over the unfortunate events that befell her family and the fact that her unborn child would never know his or her father.

The next apparition appears sideways and looks more like one of the masks used to symbolize the theater than a person. I photographed one other apparition that had a

One of the phantom female faces from the Ferry Plantation; could this be Grace Sherwood, the accused witch, or perhaps Sally Walke, the tall betrothed beauty who still waits for her lover to return from the Civil War.

the eyes have a very dark appearance with no detail—a rather intimidating look, wouldn't you agree?

The third photo is of a bald African American man—perhaps appearing a little younger than when he passed. The last owner of the plantation house had caretakers keep up the old residence once she went to a nursing home, and they all witnessed the ghost of an African American repeatedly performing a series of tasks over and over again—a *residual haunting*. Investigators discovered that a slave named Henry lived at the slaves' quarters on the plantation, living out his entire life on the third floor of the kitchen—even after 1863's Emancipation Proclamation. Perhaps quiet, subdued, and content to live his afterlife as he lived his life—in the shadows of the plantation's more social ghosts—Henry continues his march from the basement of the manor house up to the second floor, kneeling in front of a wall, as if he is still feeding the flames of a forgotten fireplace, hidden behind the wall for many years.

similar look at the Geddy House in Colonial Williamsburg—although the one at the Geddy House had a grin, but it's not your normal grin. It looks mischievous, as if the apparition is up to no good. One woman who saw the face labeled the ghost as a *trickster*, which I thought was a good word to describe both apparitions. I know that one of the ghosts at the Geddy House falls into that category, sometimes touching, pulling, or pushing tourists who have come to look at the interior of this eighteenth-century house, but I'm not sure if the Ferry Plantation wraith has a similar modus operandi. I just wonder if the trickster is one of the many ghosts of children who have been seen at the old manor house. This is the first photo where the face has appeared completely sideways, though, but in both cases

The final photo has two apparitions in it; I think the same face has appeared twice in the same photo (like a double exposure). I would suggest that he is from the mid-nineteenth century because beards were fashionable for men around the time of the Civil War. Although Civil War captain James MacIntosh of the CSS *Louisiana* had a long, gray beard (check out his photo on the Ferry Plantation website), I agree with what others have said: the face resembles General Thomas H. Williamson (1813–1888), the son of former owners Thomas and Anne Walke Williamson. He actually painted a watercolor of the old manor house, and a child who visited the house a few times with her grandmother actually saw a man with a long beard wearing a "dirty shirt" and painting

Yes, this trickster really appeared sideways in the window, with dark eyes and a mischievous grin.

Could this be the ghost of the African American caretaker (Henry), who still goes through the motions of feeding the flames of a forgotten fireplace, hidden behind the wall for many years?

a picture on the second-floor landing of the staircase. Perhaps I've captured the ghost of the former general?

When I left the Ferry Plantation house that evening, I put my photography equipment into the car and got into the driver's seat, I looked into the driver's side mirror just in time to see what appeared to be a ghost making an appearance behind the car. I turned around quickly and opened the door, hoping that the ghost would remain long enough for me to get my camera back out, but the ghost disappeared as soon as it realized that it had been recognized. I didn't even get a chance to get near my camera—it's almost as if they are as afraid of us as we are of them. So the next time you think of Virginia Beach, whether it's sunning yourself on the beach or relaxing in your hotel room, remember that there is a supernatural side to the ocean-side resort. Virginia is not only for lovers—Virginia is for ghosts!

I think this face resembles General Thomas H. Williamson (1813–1888), the son of former owners Thomas and Anne Walke Williamson.

ABINGDON CHURCH

The Scent of a Woman

As is the case so often in colonial America, colonists named places in their new settlements after cities, towns, and counties back in England. Abingdon Church falls into that category: Abingdon Parish was named after the former English home of some of the colonists in the County of Gloucester, ca. 1650. The first church was a wooden structure lost to the ravages of time, but the current brick building was the third church built over almost the same footprint of the second structure, built in 1655. This church has a direct connection to the father of our country: George Washington's maternal grandfather, Augustine Warner, donated the land for the new church. The third building, constructed about 1754–55, is the one still standing today on 143 acres of land right on Route 17. Like the Bruton Parish Church in Williamsburg, the Abingdon was constructed in the cruciform (cross) shape, a building that was simple in form and an elegant example of one of colonial Virginia's largest state-sponsored churches of this kind.[33]

Because Abingdon was directly tied to the English government, it fell out of favor with Americans immediately after the Revolution and was abandoned until repairs were made in 1826 and services resumed. During the Civil War, the occupying Union forces used this church, like Westover Church in Charles City County, as a stable. The pews were thrown out, and other parts of the inside of the church were damaged, if not completely destroyed. After the War of Northern Aggression (the Civil War), as it was called in the South, changes were made to the church when it was renovated, and late in the nineteenth century the church took on an architectural style labeled Gothic Revival. The building has recently undergone an expensive renovation (over half a million dollars) to restore the building to its original eighteenth-century architecture, perhaps making some of the ghosts who occupy the church and its surrounding cemetery a lot happier—the dark and mysterious feel of the Victorian-era Gothic Revival was changed back to the bright, airy feel of the original architecture.

A curious thing I read about the church cemetery: the grave markers from the Rosewell Plantation (remember the Page family?) were moved to Abingdon Church, but the bodies were left in the ground at Rosewell. I fail to see the logic in that decision, but I have to wonder what, if anything, happened to the ghosts? Was it to keep historical gravestones in a more protected area, while the bodies remained close to their former home?

THE SCENT OF LAVENDER

I have heard that this church is haunted by a Civil War soldier, but I cannot find the details of the phantom's antics, nor are people exactly forthcoming about ghosts in their place of worship. On the night we explored Abingdon, I captured a face in the right side window,

George Washington's maternal grandfather, Augustine Warner, donated the land for the Abingdon Church. The third building, constructed about 1754–55, is the one still standing today on 143 acres of land.

looking out at us as if it was curious about what we were doing there at night. One person spotted an apparition of a woman in a long, black, lacy gown with a white, V-shaped portion in the neck/chest area. Although she moved too fast for me to capture on my camera, we both shared an experience that we thought might have come from this apparition: we both smelled the scent of lavender. Here's the catch—there were no nearby flowers or trees that could have been the source of that scent. We experienced that scent one more time: As I put my camera away in its case in the back of my SUV, we both caught a quick whiff of the scent a second time, as if she wanted us to know that she was still there before we left. There was no breeze that night, so it's not as if the scent blew in from a nearby garden. Before we left, we checked all around the parking lot to see if we could find a possible source of the scent. (Although I did not, one of the guys recognized the scent as lavender because a former girlfriend wore lavender-scented perfume.) Without a localized source for the scent, we could conclude only that it was a paranormal re-creation of lavender perfume by a former wearer of the scent. But that is just one of a few ghosts that we came across that evening . . .

After photographing the right side of the church, we went to the left side of the churchyard, trying our best not to step on a grave. As we stood in a small pathway, the hair on our arms stood straight up and we felt a bone-chilling cold as a nearby ghost sucked the heat energy right out of us. I hurried up to take a photo and found that a whole group of apparitions surrounded us, including a very large circular apparition that was right over us. Several seconds later, a full-spectrum photo to the left captured two faces, one much larger and clearer than the other. This

is one of the more paranormally active places that I've photographed, and the scent of a woman wraith was a new and memorable experience. I've experienced the paranormal visually and audibly before, I've been tapped and touched before, but this was my first experience catching the perfumed scent of a presence that I could not see.

This softball-sized medallion of a cross within two circles appeared in a nearby tree—unseen by our eyes but visible only to the camera.

I'm not sure if this apparition is wearing a cap or if he is actually a Civil War soldier wearing the cap that was part of his uniform.

Left: Could this be the ghost of the woman who gave off the scent of lavender?

Middle: The next three photos were just heads sticking up out of the ground in the cemetery on the left side of the church, including this clear face of this young boy.

Right: Not quite as clear is the photo of this bearded man, perhaps from the Civil War era.

The largest, clearest photo was this young man—or perhaps an older man who appears as he did when he was younger—it was quite a shock to see this head just sticking out of the ground of the cemetery, right where I just walked . . .

ST. PETER'S CHURCH

Shadow People, Black Mists, Dark Energy: Indicative of Evil?

The presence of evil near a church would alarm most, but the photograph shows the black mist, if you would even label it evil, hovering near the outside of the house of worship—not inside. As for what it is or, even more importantly, what it means I cannot say, and that characteristic, more than most, is what frightens people: we fear what we do not understand. So rather than dwelling in the dark on what we cannot comprehend, take in the historical background of this castle-like church in the country.

In the woods of New Kent County stands a church that has been dubbed the First Church of the First First Lady: St. Peter's Episcopal Church. Yes, Martha Dandridge Custis Washington attended this church as a young woman, was married to her first husband (Col. Daniel Parke Custis) here, and was *possibly* married to Col. George Washington here—quite a landmark to be hidden away in the woods! (Her vows to the first president may have been spoken just a few miles away at her home, White House Plantation. Some think that it's no coincidence that their residence in Washington, DC, was dubbed the White House.) It is very likely that Washington at least attended this church while courting the wealthy young widow, whose first husband served the church as a vestryman and as a churchwarden, as did her father, Major John Dandridge. However, there is another historical Virginian who believed that Washington was actually married in this church—but that has a backstory.

The Virginia General Court established St. Peter's Parish on April 29, 1679—keep in mind that in colonial America, the Church of England was intertwined with the government. The current structure was not completed until 1703, replacing an earlier building known as the Broken Back'd Church. The front tower, giving the church a castle-like facade, was not built until 1740. The third-oldest church in Virginia was the site of eighteen-year-old Martha Dandridge's first marriage to one of the wealthiest heirs in Virginia—Daniel Parke Custis—in June 1749. Daniel's curmudgeon father initially refused to allow his heir apparent to marry Martha, but an afternoon tea with the young woman charmed him enough to give his consent. Just eight years and four children later, she was one of the most eligible widows in all of the colonies. Young Martha had lost her husband and two of her four children, but—still young and extremely wealthy—she had a bevy of suitors. One man towered over the competition, literally, and he was considered one of the best dancers in Virginia: Col. George Washington. Whether at St. Peter's or at the White House Plantation, the rector from St. Peter's married Washington and the wealthy widow. Another first lady, Letitia Christian, wife of President John Tyler, attended St. Peter's Church, and the assumption is that she was baptized here in 1790.[34]

Sometime after the American Revolution, worshipers, due to the general distaste of Americans for the Church of England,

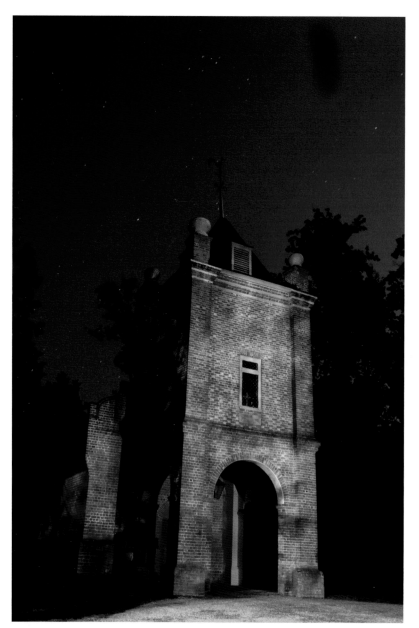

St. Peter's Church in New Kent County was completed in 1703, and has been dubbed the First Church of the First First Lady Martha Washington. Notice the black mist hovering at the top right.

abandoned the church—the religious arm of the English government. Another religious group, the Presbyterians, made use of the building around 1820; Episcopalian services began in 1843, when the two denominations shared the same church building and later the same rector. During the Civil War the Union occupied the area, and St. Peter's suffered the same fate as many other church buildings in the area (such as Abingdon Church in Gloucester): the federals stabled their horses in the pews; some of the Yankees even carved their names in the brick on the exterior walls. After the war the church was badly in need of repair, and in October 1869, General Robert E. Lee tried to raise funds for the repair of the building, writing, "St. Peters is the church where General Washington was married and

These two faces were looking out of the diamond-shaped window lattice from the tower's front window.

attended in early life. It would be a shame to America if allowed to go to destruction." Lee's son William Henry Fitzhugh Lee was in charge of a partial restoration in 1872, with a full interior restoration coming many years later—in 1964—following the new designation given by the Virginia General Assembly in 1960 (First Church of the First First Lady). Evidently, General Robert E. Lee (who was married to Martha Washington's great-granddaughter) and his son thought that Washington was married here, as many other Virginians do today. Lee provided a substantial amount of the funds for the partial restoration.[35] The church that looks like a castle is famous for its Washington connection, and a little infamous for its paranormal activity, which was patently evident from the very first photograph.

THE HOVERING BLACK MIST

There is a theory in physics that the vast expanse of space has something hidden from our eyes: dark energy. Other than that, it's a complete mystery. How do they know it's there? It's a theoretical explanation for the accelerating expansion of the universe;[36] something's out there that's causing the universe to expand—they just don't know what it is. Having photographic proof of an ever-changing

electromagnetic conscious, is it just as plausible to have a dark-energy consciousness? Just as many people have witnessed a supernatural white, mist-like light, people (including myself) have seen a black, mist-like absence of light. Is it inherently evil? Are black mists, shadow people, and other dark forces the malevolent side of the spirit world? I cannot say for sure, but what I can say is that for the first time I've captured a black mist on camera, and it's hovering near but not over St. Peter's Church. It stayed for just one photograph and disappeared as quickly as it came. I had to wonder: if unbeknown to me, a confrontation had taken place between the forces of light and of darkness, explaining the absence of the black mist in the next photograph, taken just seconds later.

I have encountered a dark, shadowlike apparition at the Old House Woods Road—something that was very faint in the night sky. It appeared to have a flying motion, but it was too quick to capture on camera. I must have pressed the shutter button at just the right instant to capture one near St. Peter's, because it too was gone in an instant, but I could not see this apparition with the naked eye. When I magnified the image, I hoped to find a face or some other distinguishing feature(s)—but it just resembled a black mist. Check out the black mist to the top right of the church's castle-like front tower.

While I was preoccupied with the black mist that showed up in the front of the church, someone saw something out of the corner of his eye that he thought was me. When he discovered that it was not me, he looked back to see the ghost move down through the graveyard and behind a large tombstone. He immediately alerted me, and I took several shots of the graveyard. In the final shot, I captured an entity looking out from behind the gravestone as if he was hiding from us.

Ghosts that are afraid of people? I saw the 2001 film *The Others* with Nicole Kidman; it was about just such a thing, but it looks like I'm witnessing it in real life. I captured a couple of faces in the tower, and one inside the church with a pair of creepy eyes that project an unforgettable stare. Several other classic white faces showed up by the tall monument to the dead; they were not as clearly defined and thus were not included in this book. Another church with another first—*the black mist*; I highly doubt that the First Church of the First First Lady would be willing to list my first on their website, and I don't blame them . . .

Here's the face of the ghost that ran in front of our SUV down into the graveyard and hid behind a tombstone.

This wraith was in the sanctuary's window, with drooping eyes that just upped the creepy factor while the back of his head looks like it's wisping away.

THE COTTAGE

An Old-Fashioned Shotgun Wedding

There is a big story of scandal, murder, and intrigue to go with such a tiny place—part log cabin and part framed structure with siding, and the facts from this story were taken from the plaques on display inside the "cottage." Siding was later put over two of the three exposed sides of the log cabin part, so that you can see the logs only on the front side of the cabin. The core of the house was built about 1810, and surprisingly the "log cabin" part, which served as a kitchen, was added on later, about 1837, and the house resembles conjoined twins of a different mother (I would have thought that the more primitive part of the structure would have been built first). It is an anomaly that a log cabin addition was even built—the English, who primarily settled Virginia, built frame houses with siding, and not log structures, which were usually built on the American frontier. This building has gone through a variety of uses, including its original use as a kitchen/smokehouse (probably for a business), a school, and then later a home. A unique factor about this building is that it is one of only two buildings that have a surviving "smoke hood" in this country, which was used before the fireplace and chimney were added. I know you want to hear about the scandal associated with one of the former owners of this building and the reason for the lingering ghosts, don't you? Why talk about "smoke hoods" when there is scandal in the air?

Then scandal it is—Thomas Barham bought this property about 1860, and his son would be directly implicated in the disgrace and dishonor of someone who was capable of doing anything to get what she wanted—according to one family. The disparagement of the reputation of a young woman whose family was prominent, powerful, and wealthy came just a few years later: Lula Ball wrote to her father with the implication that she had "behaved improperly" with a young man who had promised to marry her. Just so we are clear on this, the words "behaved improperly" are nineteenth-century Victorian-era speak for "having sex." So Ms. Lula, before the age of condoms and contraception, had engaged in some very risky behavior with Thomas Barham's son, Bennett Barham. Maybe she was trying to cover herself in case she discovered that she was pregnant, but for whatever reason, she had raised the ire of her father, the rich and powerful Walter Ball. Walter, together with his son, did what any self-respecting southern family did when their honor was at stake: they kidnapped Bennett Barham from his business in nearby West Point and took him by train to Washington, DC. Their objective was to have a good old-fashioned shotgun wedding. It turns out that Bennett was a pretty brave man. Even looking down the barrel of a shotgun, he refused to say, "I do," when his part came up in the wedding vows. After the family returned to their Virginia homes, Walter Ball went on

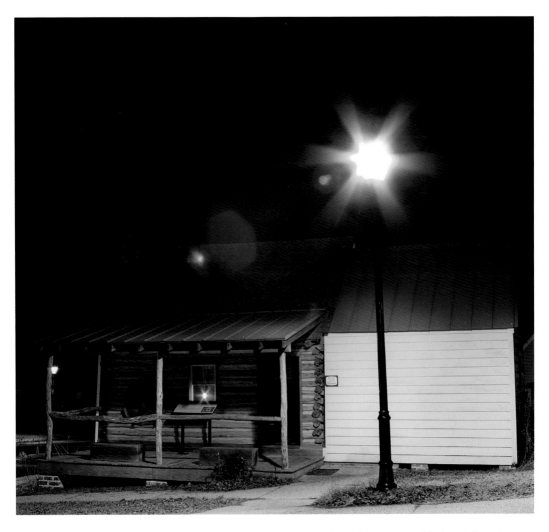

The Cottage in New Kent was built circa 1810, surprisingly with the log cabin portion added much later in 1837. This house, which looks like the conjoined twins of different mothers, is also conjoined to a scandal that still haunts this odd-looking house.

trial for kidnapping Bennett. At the trial, the young Barham admitted that he was engaged to Lula, but he denied the implication that they had sex. He also refused to live with Lula and renounced the marriage.

Walter Ball had had enough, and he decided that he would end the life of the man who had dishonored his family. Bennett was riding down the road in a "jumper" (a horse-drawn buggy) with his brother Thomas riding alongside him on horseback when the confrontation occurred. Walter rode his horse up in front of the buggy and turned around to fire several shots at Bennett, seriously wounding him. Bennett had to remove his gloves before he could return fire, but when he did, the young man's aim was dead on, killing the enraged father instantly. Bennett would recover from his wounds at his father's property, and since the marriage was determined to be legal, he had to file for divorce. At the trial, a doctor testified that no man had ever wronged Lula Ball—nineteenth-century speak for she was

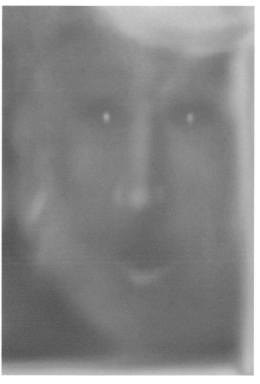

Perhaps this is Thomas Barham, who bought this property about 1860, and whose son was accused of behaving inappropriately with a young woman.

I was first greeted at the Cottage by these two phantom faces staring out the back door window.

still a virgin. Could the doctor have lied at the court proceedings, or was Lula Ball an obsessed young woman who could not take rejection? A subsequent lawsuit brought by the Ball family forced Thomas Barham to sell this property to settle it, ending the scandal for the living. But who are the ghosts that still live at the Cottage? Is it the angry father-in-law, Walter Ball, still looking for the young man who dishonored his family and murdered him? Or is it the jilted daughter, still obsessed with the man who rejected her? Or is it a similar story about love and rejection that we don't even know about?

I stood in front of this cottage many times trying to capture an apparition of some kind, but to no avail. Then one autumn night, with the full moon out in all its silvery couture, I went around to the back of the Cottage. Through some of the windows on the back, you can see straight through the windows in the front of the house and out onto the street—where I found the ghosts that I had been looking for. Perhaps they thought that they could safely come out once I had gone around to the back of the tiny house; I was finally able to capture some of the people who had something to do with this home's storied past, but their names and their roles are unknown to me. I would like to believe that they are some of the main characters in the drama between the Balls and the Barhams . . .

Perhaps this is a photo of a couple who owned the Cottage before the Barhams.

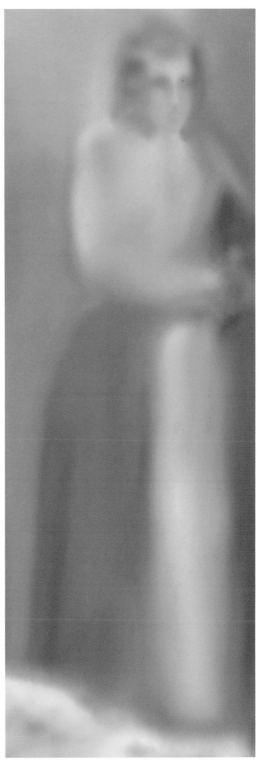

This full bodied apparition stood out in front of the Cottage, and I just can't make out what she is still holding on to—can you?

THE NEW KENT COUNTY JAIL: A COLD STARE FROM THE INMATES!

The old jail sits nearby, but I have very little history or compelling stories to go with it: This tiny two-room (or should I say two-cell) building is the former jail for New Kent County, built in 1910. It was refurbished in 1998 and now serves as the headquarters for the New Kent Historical Society. Although I could find no one to share any paranormal legacies about this diminutive prison, I do have some photographs that are intriguing: this tiny little building seems to hold a long-faced character and quite the array of eyes, and I have chosen the clearest of them to show you that crime doesn't pay . . . in this life or the next!

Multiple sets of eyes look out at me from the old New Kent County Jail.

This face looks out from inside the jail's window, but his hairstyle says that he is probably from the eighteenth century. He could have either been part of the British, French, or American forces that used this road during the Revolutionary War.

CHAPTER 16

(BASSETT) ORDINARY

The Washington Connection & the Slave Woman Guarding the White Child

I found this building one of the easiest to capture the paranormal, and one of the most difficult to find a historical background. I finally discovered some state government papers giving the date of the tavern as ca. 1690. William Bassett donated the land for a county courthouse (one acre) and in a shrewd business move built an ordinary (bed and breakfast) right across the road from the proposed site. The problem is that there were three William Bassetts, but judging by the date, it could only have been William Bassett III. The Bassetts were wealthy landowners and had a very large plantation home (all wealthy plantation owners gave their homes a proper name—the Bassett family named theirs Eltham) just a few miles away from the ordinary. William Bassett III, elected to the General Assembly and a member of the House of Burgesses when he died in 1744, was an important figure in Virginia politics. I'm surprised that given the importance of the Bassett family, the "ordinary" is not known as the "Bassett Ordinary"; perhaps it was in the late seventeenth and early eighteenth centuries.

Assuming that William's son inherited the ordinary when his father died, Burwell Bassett is the most historically connected owner. Burwell's first wife died in 1754, and he would later marry Anna Maria, the sister of Martha Dandridge. The Dandridges lived just a few miles from the ordinary, but you probably know Martha by her second married name: Martha Washington. Not only were Burwell Bassett and George Washington brothers-in-law, but they were also intimate friends. Washington spent more time at the Bassett plantation home (Eltham) than at any private home other than his own (Mt. Vernon). When Washington went to Williamsburg to attend meetings of the General Assembly or to the nearby Pamunky River Estates to tend to the land holdings of the Custis heirs (his wife and two stepchildren), he would frequently visit the Bassetts, attending social gatherings as well as hunting and fishing in the nearby Pamunky River with Burwell. Washington's stepson John Park Custis, an aide to his stepfather, contracted typhus during the siege of Yorktown and was cared for by the Bassett family at Eltham. Immediately after the surrender of British troops on November 5, 1781, Washington left his troops to go to the bedside of "Jacky," but he would die just a short time later at Eltham. (Jacky's ghost has been seen haunting the Yorktown Battlefield, recognized by his clothing and blond hair.)

Now that you know the background of the first two owners of the ordinary, let's examine some of the historical activities around it. The road that passes right in front of this former tavern, sometimes called New Kent Road and sometimes called Old Stagecoach Road (or just Old Stage Road), was a route that was historically significant in two wars: the Revolutionary War and the Civil War. During the last year of the Revolutionary War (June 1781), General Cornwallis moved the British troops between Williamsburg and Richmond

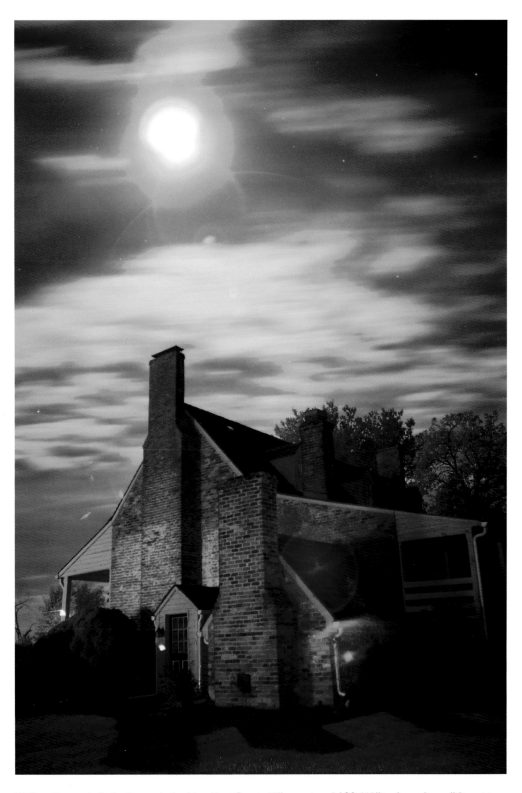

William Bassett built the Tavern in the New Kent County Village, circa 1690. William's son Burwell Bassett became intimately connected to George Washington after he married Martha Washington's sister Anna Maria. Who knows, Bassett and Washington may have eaten here after their frequent hunting or fishing trips!

This group of partial faces and eyes showed up in the back of the tavern/house—curious to see what I was doing there late at night under the light of the full moon.

by using this road. As the British army passed through, they would confiscate and/or destroy whatever could be useful to their enemy: tobacco, food, uniforms, flour, and muskets. General Lafayette shadowed Cornwallis's troops to see if he would turn around and engage them in a surprise attack—which he did not. Washington wanted to know if the element of surprise was a part of Cornwallis's battlefield repertoire. One can only wonder if anything was taken or destroyed from the ordinary.

During the Civil War, Confederate general Joseph E. Johnston's forces withdrew from Williamsburg during the night after the Battle of Fort Magruder to the more tenable defenses set up in Richmond. Union general George B. McClellan's Army of the Potomac followed the Confederate forces at a slow, overly cautious pace that he would later be criticized for, setting up the ordinary as a communications headquarters while using Eltham (just a few miles away) as his personal headquarters. Again, I wonder if any of the men from either side who fought and were wounded in the Battle of Fort Magruder (Williamsburg) made it to the New Kent Courthouse village and then died, perhaps at the ordinary.

AN INTRIGUING WHOLE-BODY APPARITION!

I have captured a variety of paranormal activity at the ordinary; one window out back held several different partial faces and an eye— perhaps curious about my activity outside. But the most intriguing photo was the capture of what appears to be an African American slave woman with her arms wrapped around a small white child (girl?) as if she is protecting her. The two were standing on the side of the ordinary as if they might be hiding—perhaps hiding from one of the armies that had passed through? Although I have captured a lot of recognizable faces, it's rare that I can capture the whole body—let alone two! Whole-body apparitions are a rarity, and I was lucky to stumble across this woman and child, probably there with an intriguing story to tell—if only I could hear it . . .

These full-bodied apparitions showed up on the side of the house; what appears to be a slave woman protecting a small white child. One could only wonder from what—perhaps one of the armies that marched up and down this road? Highwaymen? More importantly, did she and the child die here?

CHAPTER 17

BOXWOOD INN

The Curtis Family: Philanthropy in Life . . . & Death

Besides waiting on tables, another way I earned extra money while I attended the College of William and Mary was by playing guitar in various bands. One of the places we played frequently was a bed and breakfast called the Boxwood Inn, on the outskirts of Newport News. A couple of members of the band always felt uneasy when we played there—particularly when there was nobody else in the dining room (such as when we set up and tore down the equipment). When owner Barbara Lucas took us on a personal tour of the whole house, we found the office and a couple of the upstairs rooms to be unusually cold. Barbara took me up into the attic to ask me a structural question (I am a carpenter too), but the rest of the band bowed out because they were uncomfortable with the perceived paranormal presence. As I've said before, I have no psychic abilities and went up into the attic to answer her questions without a second thought. There were lots of really old things in the attic, including some antique trunks, window screens, window blinds, and scrap wood—but nothing paranormal manifested while I was there. Since my visit to the attic I have witnessed a bottle flying across the dining room and taken a number of photos that bear witness to the fact that a number of wraiths make the Boxwood Inn their home.

This house was built more than a century ago, in 1896, as a private residence, and then later it served as a post office, a general store, the Warwick County Hall of Records, and

officers' quarters (during both world wars). During these various roles, the building seems to have acquired a few residents that just can't leave—even in death. The original owner was Simon Curtis, the son of the owner of the nearby Endview Plantation—Dr. Humphrey Curtis (we'll come back to him later). Simon wore many hats during his lifetime, including magistrate, postmaster, store manager, treasurer, and loan officer / philanthropist. During the Depression, he would purchase people's mortgages from the bank and rework the loan so that they would not lose their homes. It's Simon's office that is one of the cold spots in the Boxwood; perhaps he had some unfinished business that has kept him there all these years after his death. After Simon's last living relative passed, the home was abandoned and would eventually await its destruction by the City of Newport News. Barbara Lucas and her husband saved the condemned house from demolition, remodeling it in order to transform it to its present-day role as a bed and breakfast. Not only does Simon Curtis find it difficult to leave, but his wife, Edith, and her personal nurse are also thought to be part of the Boxwood's entourage of supernatural occupants. Edith (Nannie) Curtis is a helpful ghost who doesn't believe in sleeping late and evidently knocks on guest's doors in the morning to wake them up.

Another anecdote of Nannie Curtis clearly demonstrates her willingness to help: when the new owner broke a fingernail and said out

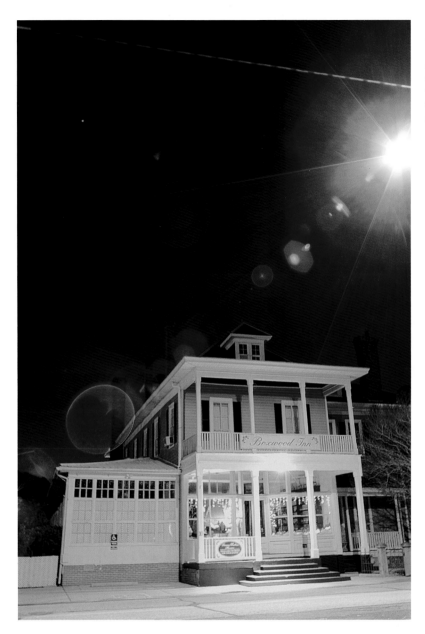

Jack-of-all-trades Simon Curtis built the Boxwood Inn in 1896, and his unusually cold office, among other things, may indicate that Simon and his wife still reside there.

loud that she needed an emery board, the ghost provided one right away — sitting in plain sight, a new, clean nail file in a house thick with dust. The owner jokingly told the ghost, "Thank you. Now I'd like $100!" Shortly after that, she felt something stuck to her shoe and retrieved a gold tooth, which she sold to a pawnshop for $100. Nannie is said to be a happy ghost that bathes the inn in a perpetual good spirit.

When I went to the Boxwood Inn, I took more than a hundred photos both inside and out, and I came across a ghost phenomenon that I have seen only two other times: once in front of the 1770 courthouse, and once in the doorway of the Bruton Parish Church, both in Colonial Williamsburg. The only part of the ghost that appeared clearly (in these two photos) is the left leg from about the knee down to the foot/shoe. The rest of the ghost

Could this be a former employee involved in one of Simon Curtis' many business ventures at the Boxwood?

Simon Reid Curtis' photo can be seen online at www. leehalldepot.org/History/The-Simon-Reid-Curtis-House. Imagine Simon's photo without the mustache—I think this is a match! Note the little tuft of hair near the front of his bald head, just like in the photo online.

is an ephemeral white mist in the shape of a human (something that I call a classic white, because it resembles a typical Halloween ghost drawing). The phenomenon appeared again in the last two photos taken in the foyer of the Boxwood— I captured two classic whites that night just a few feet apart from each other. The first ghost has what appears to be flip-flop on the left foot, with its other leg up in the air almost as if it's dancing. It has to be a more recent death—how long have flip-flops been a part of the footwear business? Let me tell you the story of the second classic white to appear in the Boxwood foyer, again with only the lower left leg and shoe visible.

During this photo session, a manager was in the foyer speaking to some guests while I photographed the upstairs. I took a few shots

from the upstairs pointing down. I captured this second classic white standing right next to the manager, with the left leg clearly visible, even more so than in the photo with the flip-flop. I saw what appeared to be a tennis shoe, and I immediately knew that this wasn't one of the old ghosts from the Boxwood's past. The next week I went to speak to a paranormal group at the Boxwood, and I took the photos to show the manager. When I showed her the classic white apparition that appeared next to her, I commented, "This is a recent ghost, and he is standing right next to you—look at the tennis shoe on the visible foot!"

She put her hand to her mouth, as her eyes welled up with tears, and she choked out these words: "That's not a tennis shoe . . ."

A forlorn African-American face looks into the front door's sidelights from the outside.

I'm not sure if this apparition is young or old, male or female, benevolent or malevolent, but I do know that it is likely responsible for throwing a bottle of Tabasco sauce across the room just a few minutes later—I witnessed it.

I was a bit confused, because it looked like a tennis shoe to me, but she regained her composure to further explain: "That's my son's work shoe! I still have those shoes under my bed! The darker part is leather, and the lighter part is mesh—he loved those shoes because they were so comfortable, and he wore them everywhere. Yesterday was the tenth anniversary of his death." I was floored by the significance of this photo!

I don't know whether or not the manager's son was/is capable of showing his former face—but he did seem to know that his mother would recognize that shoe, and that she would find comfort and solace in knowing that he was right by her side nearly ten years after his death. Out of all the ghost photos that I captured at the Boxwood, this last one is the most compelling, because it tells the story of a son's

love for his mother and shows that he was right next to her on this significant anniversary. He evidently knew that she was still mourning his sudden and unexpected death, and stood by to comfort her loss the only way he could. Any caring parent knows that it's unthinkable to outlive your children, but in this case the child reached out from the other side to let his mother know that he was there for her. How many people do you know who would love to get this same kind of reassurance from their loved ones who have passed on?

Several partial faces look into the dining room from the outside as if they are curious about all the human activity within.

A distorted misty-white, ephemeral apparition makes an appearance in the Boxwood's hallway; notice on the right foot—a modern shoe: a flip flop or shower shoe (or whatever your name is for this type of footwear).

Another image similar to the last; this one is also wearing a modern shoe: a tennis shoe or a type of modern work shoe. But the real story is that this is a son who is trying to get close to his mother—and she identified him because of that shoe—his favorite pair of work shoes, and she still has them. He appeared next to her on the tenth anniversary of his sudden and unexpected demise . .

AQUIA CHURCH

Murder in the Vestry Tower Lingers On . . .

Aquia Church in Stafford County is often on the list of the "most haunted" in Virginia, and it has quite the compelling story to back that assertion. However, to put any one place at the top is highly subjective, and unless the person doing the evaluation has visited every haunted site in Virginia, they cannot make that judgment call. That said, Aquia Church, completed in 1757, has a murder mystery attached to it that may explain the paranormal experiences during its post–Revolutionary War period. I found it intriguing that the church, begun in 1751, was within three days of being completely finished when the carpenters left a fire too near a pile of wood shavings at night when they left work—and it burned down. So the current church was rebuilt on the ashes of the former, and it has managed to survive to the present, albeit with a few paranormal occupants that make anyone who stays after dark quite uncomfortable.[37] But this murder mystery will need a little more history to adequately explain it:

The Declaration of Independence, signed in 1776, immediately caused a problem with the Anglican Church, because the church was an arm of the British government, and church attendance at least one time per month was mandatory. In 1777 a group of vestrymen from various churches in Virginia got together to edit Thomas Jefferson's "Virginia Statute for Religious Freedom" in order to separate from the Anglican Church and allow Virginians the freedom to worship where they wanted.

Although Jefferson's statute would not become law until 1786, state support for the church ended in 1775, when the royal governor of Virginia left in the night—fearing for his life and that of his family. On January 22, 1799, Virginia's Assembly repealed all laws favoring the Anglican Church, including seizing any property (glebes) of inactive churches that was used as a source of income for their rectors (preachers). This was the death knell for many Anglican churches in Virginia, and Aquia's glebe lands would be taken after the death of Reverend Robert Buchan in 1803. Aquia Church would not have another rector for thirteen years, and the church was essentially abandoned. (The Potomac Church, a much-larger church nearby, was also abandoned after Buchan's death and was burned by the British during the War of 1812.[38])

A revival of the Aquia Church began slowly in 1817, when local families tried to clean up the abandoned church. It was at this point that a gruesome discovery was made in the vestry tower (not a belfry—it never contained a bell): the skeletal remains of a young woman with blond hair were found, with the wooden floor stained with her dried blood. No one has a clue as to the identity of the woman or how long she lay there before she was discovered (although it had to be enough time for the flesh to rot away, leaving just the skeleton and the hair), and the efforts to clean up the blood stain were unsuccessful until they replaced the floor. Her blood stained the vestry floor for more than a

Aquia Church, completed in 1757, has an unsolved murder mystery inside the church that keeps most of the parishioners away from the building at night. This homicide/haunting has earned the church a place high up in the pantheon of "most haunted" in Virginia!

hundred years, and though the blood stain is gone and her skeleton was given a proper burial, her troubled spirit has been seen by enough people that many of the church's members will not go near the church after dark. The theory is that the woman was killed by a group of highwaymen while journeying north or south on the nearby road (now called Route 1), and from the sounds of the haunting, she must have run into the church and up to the top of the vestry tower, where her throat was slit. You may call that theory into question when you hear one of the modern sightings of the ghost with the blond hair. Many have heard the sound of phantom footsteps running up the stairs, many others standing outside the church have seen the distraught blonde woman up in the tower window, and one custodian witnessed the phantom female face floating over the Aquia Cemetery multiple times.

A bearded male face may be indicative of the Confederate or Union presence on the grounds of this church.

This clean-shaven face and the coiffed hair are more suggestive of eighteenth-century styles for men—perhaps a former rector?

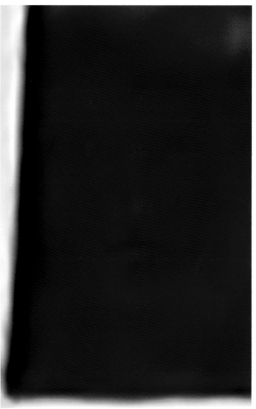

Here is a female face, and so I have to ask—Is this the woman who was murdered inside the church?

Before we leave the historical aspect of Aquia Church, there is another era—the mid-nineteenth century—that may contribute to the paranormal activity here. The Confederate and the Union armies both used the grounds of the old house of worship as an encampment, leaving graffiti and scars of their presence on the inside and outside of the building, as well as in the graveyard. There are records of some Union soldiers dying here from camp fever, as well as being killed while on picket duty. Besides the graffiti from both sides, the church lost windows, walls were damaged, marble floors were torn up and broken, gravestones were used to make fireplaces, tombs were dug up, and horses chewed on the pews when the building was used as a stable for the cavalry. So in addition to the tragic murder of the young blonde woman, some of Aquia's ghosts may be the result of soldiers dying unexpectedly, as well as their disturbing the dead by digging up existing tombs.

The following legends may or may not have something to do with the paranormal activity at Aquia Church. About ½ mile away from the church, off Route 1, back in the woods is a small body of water that locals call Witches' Pond. Sometime in the eighteenth century, a witch by the name of Edith was put to death at Witches' Creek, or what some call Aquia Creek in the backwoods. This is an undocumented event that results in the following paranormal events: the pond water turns red in the spring, the figure of a woman hovers just above the water or along a path in the backwoods, splashing noises are heard from the water, shrieks that seem to get closer and closer are heard in the night, and a shadow figure rushes at anyone who dares to enter the woods at night. There is what some call an

The top face again looks female—a little different from the previous photo—but is she the victim of a violent unsolved homicide? Why is the man in the lower right in the same window?

backwoods? Was she a victim of her own cult? Whether any of these legends or events have to do with the haunted Aquia Church, I cannot say, but it certainly adds to the intrigue.

Out of all the sightings of the blonde female phantom at Aquia Church, there are two that I think stand out. Several decades ago, Aquia was celebrating its history, and part of the celebration included Civil War reenactors. The group arrived on a Saturday night and camped all night so that on Sunday morning, when parishioners arrived, it would be like taking them back to the area's nineteenth-century history. During the night the reenactors sat around the campfire. They kept seeing a red light flickering through the vestry window throughout the night, and they just thought that it was a defective lightbulb, or that it was loose in the light socket. One congregant and the rector went over to speak to the reenactors before the church service the next morning, and a reenactor mentioned the flickering light, fully expecting a rational explanation. The rector, Father Kerr, without a moment's hesitation, said it was the vestry's blonde phantom, given the moniker Blond Beth by the congregation. But the rector's next statement really floored the Civil War reenactors, convincing them that what they had witnessed the night before was paranormal: "By the way, there are no lights or electricity in the vestry!"

altar and what others call a *sacrificial table* back in the woods as well, thought to have been there since the 1600s—and yet another story has it built in the 1930s by the Catholic Church as a tribute to the Brent family, buried in a cemetery in the woods. In recent years, locals have spotted devil worshipers conducting ceremonies back in the woods, along with vandals and those who are curious about both the paranormal and rumors of satanic rituals. What is documented is that the skeletal remains of another young woman were found in the woods in 1998, and just like with the case of the blonde woman found at the Aquia Church, law enforcement has no idea who she is. I thought the most compelling piece of evidence found on the woman's bony finger in 1998 was a black onyx ring with a pentagram engraved in it—was this woman part of a devil-worshiping cult that gathered in these

The second story is even more recent, and it involves a police report filed by a woman who lives in a neighborhood near the church. While at her kitchen sink, she looked out the window into her backyard in the pouring rain and saw a woman with long blonde hair in a white gown, holding her throat, perhaps choking as if she could not get her breath. The woman called 911, and the emergency dispatcher told her to stay inside because it was dark and there

The guy on the left looks like a typical eighteenth-century man, but the face on the right is a real anomaly. It looks female, but the teeth and the way the mouth is open almost looks like an animal; what do you think?

was a drenching rain in progress. So the police and an ambulance were sent to the address; the ambulance was placed on standby till the police could locate the choking woman. The police searched through the wooded backyard for the blonde woman in white, but they could not find a trace of her. Here's the rub: despite the deluge of rain, which made the backyard a soggy, mucky mess—there were no footprints that the police could find to follow the missing, choking phantom. Was the woman's throat cut in this backyard, and then she made her way to the vestry tower of the Aquia Church, where she climbed to the top and then perished? Perhaps this woman is trying to tell her story and hopes that someone can put together the jigsaw pieces of her last moments of life on Earth.

On my visit to Aquia Church, I was able to capture a plethora of phantom faces, both male and female. Perhaps one of the female phantoms was the victim of that brutal murder; maybe the male faces are Civil War soldiers who perished on the church grounds, or even a former rector or two. But there are a couple of faces that I would call unsettling, at the least, and at the most the angry skeletal face looks downright evil. Could this be one of the highwaymen who murdered the young blonde woman, or does this apparition have something to do with the shadow figure seen in the woods behind the church? Since I cannot say with any degree of certainty who any of these ghosts are, I will leave you to ponder who or what resides on the grounds of this very haunted church . . .

On of the more intimidating photos in this book—this angry skull-like apparition must be connected to the macabre murder in the vestry tower.

FORT MONROE

*The Quest for the "Power Couple" of
the South . . . and Their Nemesis*

When the first English settlers came here in 1607, Captain John Smith observed the strategic, arrowhead-shaped piece of land that points directly to the entrance of Virginia's southeastern harbor. Being a military man, he saw the "little isle fit for a castle" as the ideal place to build a fort to protect the fledgling young colony's new settlements. Two years after they arrived, Fort Algernon was constructed—just a plank fort with seven artillery pieces. This little wooden fort on the Chesapeake Bay became the starting point (and some say the end point) of an ugly chapter in American history:

It was here in 1619 that a Dutch ship would trade slaves for supplies, making it the first recorded arrival of Africans in English North America. Initially, slave labor was used to construct Fort Monroe but was later replaced by the forced labor of military convicts. The irony is that this is where slavery began, and almost two and a half centuries later, this is where General Benjamin Butler, a self-taught Massachusetts lawyer, took the first step toward the abolition of slavery: he took in several slaves who were going to be used by the Confederate army to build fortifications, and when their owners demanded their return, he replied that since Virginia had left the Union and was now deemed a foreign country, the Fugitive Slave Act was no longer applicable and the slaves would be kept at Fort Monroe as contraband of war. Fort Monroe was given the moniker "Freedom's Fortress," and

thousands of slaves left their life in bondage for the freedom given to them within the confinement of the massive stone fortress—another irony. Butler created a camp, found them work (with real wages), and gave them food and clothing. This was a blow to the Confederate army, which was using slave labor to build fortifications, dig redoubts, and do other dangerous jobs that would put white soldiers in harm's way. Butler's interpretation of the law would reach Washington and, after some debate, resulted in a law passed by Congress on August 6, 1861, allowing the confiscation of slaves used for military purposes against the Union. According to the *New York Tribune*, Butler, who could not hold all the escaped slaves within the walls of Fort Monroe, was planning to use the city of Hampton as a refuge camp for former slaves. Confederate colonel John Magruder (the actor who fooled the Union commander into believing that he had many more troops than he actually did at Yorktown) got wind of the plan and had his troops burn Hampton to the ground. From the ashes of the city of Hampton rose a fugitive slave camp, housing thousands of former slaves and appropriately being called "Camp Contraband."

Fort Monroe's final connection to slavery happened in May 1865, when Jefferson Davis was captured on the run and brought back to the Union fortress to face charges of treason, masterminding the conspiracy to assassinate

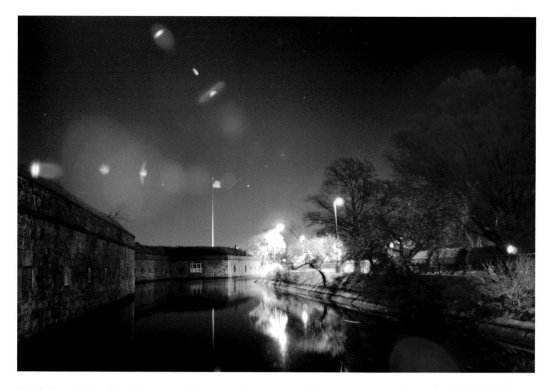

Here's the outside of Fort Monroe and its surrounding moat, a fifteen-year construction project for the US Army that was completed in 1834 under Robert E. Lee. Among the many ghosts seen at the nineteenth-century fort are the ghosts of the leaders of the opposing sides of the Civil War: Abraham Lincoln and Jefferson Davis.

President Lincoln, and the mistreatment of Union prisoners of war. The leader of the revolutionary government advocating slavery was imprisoned for about a year and a half.

But let's digress a little bit for more of the property's and the fort's history. In the 1730s, the planked Fort Algernon was replaced with something a little more substantial—a brick fort—and was renamed Fort George (almost everything was named after the reigning monarch). This area of Virginia, being at the entrance to the Chesapeake Bay, is very susceptible to hurricane damage—especially if the hurricane follows the water into the bay (as opposed to crossing land, making it considerably weaker). In 1749 a hurricane decimated the fort, and for many years the strategic vantage point of Virginia's southeastern harbors lay defenseless. What is interesting

to note is that although the fort was destroyed, an oak tree was left standing. This oak tree had been alive and growing on this small island for about one hundred years when John Smith came to Virginia in 1607, and it survived several more hurricanes and still stands on the parade grounds of Fort Monroe today.

Fort Monroe was built as the direct result of what happened during the War of 1812: southeastern Virginia was left vulnerable to attack, and the British used the land that once housed Fort Algernon and later Fort George as a temporary base to burn the city of Hampton, and later moved up the bay to burn Washington. After that, Congress realized the need for defenses on this land to protect the entrance to the Chesapeake Bay and the capital and allocated money for what would become the largest moated fort in North America. Designed

As I walked along the ramparts of Fort Monroe frequented by the ghost of Jefferson Davis, I captured these apparitions trying to coalesce and I could only wonder if this was the leader of the Confederacy out for an evening walk along the wall of the fort that imprisoned him.

for a garrison of about five to six hundred men, the fort would hold ten times that many during the Civil War years. French general Simon Bernard, once an aide to the then-deposed Napoleon Bonaparte of France, was commissioned to design the new fort to protect the entrance of the Chesapeake Bay—and the new citadel was given the nickname Gibraltar of the Chesapeake. Bernard designed the ten-foot-thick masonry walls in the shape of a star (not the five-point one that you might be thinking of right now), surrounding 63 acres of land. In addition to the seemingly impregnable walls (for that time period), the fort would eventually have the artillery firepower of four hundred cannon. This fort was a substantial project; the construction began in 1819 and was not completed until 1834—a fifteen-year undertaking.

This half-round window over one of the doors to the Casement Museum had quite the array of faces. What if one of them answered to the name Jefferson . . . ?

Another irony of the building project is that Robert E. Lee, a young West Point grad, was the man selected to supervise the last three years of construction on the fort. A twenty-four-year-old Lee would marry and have his first child at the fort that would eventually become a thorn in his side: it was

Doesn't this face remind you of a hard-nosed officer in the army?

Another unknown face from one of the Casement Museum windows; that mustache looks more mid-nineteenth century than any other time period.

the staging ground for military actions taken against Norfolk, the Outer Banks (North Carolina), and, most importantly, the capital of the Confederacy—Richmond.[39] Historians believe that the Civil War would have lasted much longer had the fort fallen to the Confederacy.

The Civil War years saw the apex of the fort's use as an active military base, playing a role in testing experimental weapons. The "Lincoln Cannon" is a good example: The 49,000-pound behemoth was one of the largest smooth-bore cannons ever made, with the ability to shoot a 300-pound projectile over four miles! It was quickly made obsolete when it was discovered that a rifled barrel was more accurate. It was placed on the beach to protect the area from another new military technological advance—ironclad ships. This behemoth now rests on Fort Monroe's parade ground. Observation balloons and other new technology to hasten the end of the war were tested at the fort, but the biggest advance in weaponry was the ironclad ships, and the first battle of the ironclads took place right out in front of the fort, with President Lincoln there to observe the indecisive battle between the USS *Monitor* and the CSS *Virginia*.

Quarters No. 1, built in 1819, was the first building constructed in the enclosed area of the fort and was built for the fort's commanding officers and VIP visitors. Abraham Lincoln stayed there when visiting the fort, not only observing the first battle of the ironclads on March 9, 1862, but also coming to participate in the planning of the Battle of Norfolk later that May. (Did you know that in early 1865, Lincoln came to Fort Monroe to try to negotiate

Here is the window at the Chapel Center, with a large blond face in the top left and the face and torso of another male apparition in the top right pane.

This is probably another Civil War era face from the same window, different windowpane. Rather dark eyes, wouldn't you say?

an early end to the war with representatives from the Confederacy? Under the watchful eye of Union soldiers from the ramparts of Fort Monroe, the unsuccessful peace talks were held on a ship in the Chesapeake Bay.) These visits were enough to get the ubiquitous spirit of Lincoln to haunt Fort Monroe; the ghost of the wartime president has been seen at Quarters No. 1—but that's only the tip of the paranormal iceberg . . .

Besides Abraham Lincoln, Jefferson Davis, First Lady of the Confederacy Varina Davis, the Marquis de Lafayette, freed slave Harriet Tubman, and Robert E. Lee, another famous American—perhaps one you wouldn't expect— spent time at Fort Monroe serving his country: Edgar Allan Poe. Literature's father of the detective story and the macabre had lost his funding for school (his stepfather refused to

pay for his second semester at the University of Virginia), and he ended up in Boston jobless and penniless—the Army seemed to be his only option. He enlisted in May 1827, and contrary to what most stories say about Poe, he excelled in the military, achieving the rank of sergeant major of the artillery; however, after two years, Poe's brilliant mind tired of the military, and he decided that he wanted out, despite his success and promotions. At his third and final station of duty, Fort Monroe, he spoke with his commanding officer, Lieutenant Howard, revealing his real name (he enlisted under the name Edgar A. Perry), real age, and the lowdown on a difficult childhood, and sought his advice on how to get an early discharge after serving only two years out of a five-year commitment. The empathetic officer helped arrange an early discharge—Poe would have to find someone to take his place and pay him (which he never did). But the more salacious story is that Poe tried to be discharged by demonstrating that he was insane—showing up for duty wearing nothing but his hat (yes, that story is a bit more titillating, but the facts to support it are not there . . .). No, I did not find Poe's ghost at Fort Monroe—naked or clothed—but I

This troubling, bizarre face in one of the half-round windows over the doors to the Casement Museum looks as if he is in extreme pain. Since this is a military facility—could this man have been a prisoner of war that was tortured here—perhaps to his death?

Could this be the woman who was murdered by her husband after he caught her in bed with a younger man?

discovered that it has been seen at a nearby hotel; however, as of yet I have not found an apparition that resembles him there.

Since the fort's heyday during the Civil War, the citadel continued to be of strategic importance until after World War II; however, as the weapons and bombs get bigger and are capable of traveling farther, Fort Monroe becomes more of an anachronism every year. That's why after WWII the fort became an installation for writers of Army manuals, and why it was closed under the Base Realignment and Closure Act in September 2011—but fear not, lovers of history and the paranormal, most of the old buildings are protected as a national historic landmark. This not only ensures access to the historic fortress, but also entrée to commune with the ghosts from its storied past—including some iconic figures from history. I may have met some of them in the afterlife—I can never be sure—but I will

introduce you to the ones that I've encountered and let you decide . . .

THE GHOSTS OF FORT MONROE

When I traversed the bridge over Fort Monroe's moat, the opening through its granite walls looked so small that it felt like I would scrape both sides of the SUV that I was driving. I crawled through the opening, anxious that the slightest veer off my straight-line course would result in an expensive repair bill. The possibilities at Fort Monroe were enticing, and a photo of Lincoln, Jefferson or Varina Davis, or Edgar Allan Poe would be priceless—a real coup de gras! The first place we came upon was the Casemate Museum, which is actually part of the walls of the fort. Within its walls is the place where Jefferson Davis was held in chains, and a cot, a table, a chair, an ivory pipe, and some books are the sparse reminders of the president of the Confederate

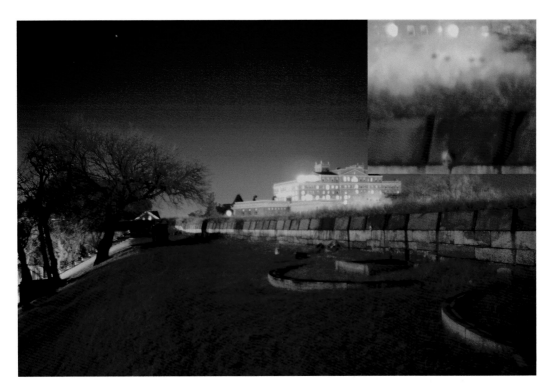

Here is the view of the top of the wall, with a view of the haunted Chamberlain Hotel in the distance and a couple of wispy white ghosts along the top. Pets of the former fort residents are buried all along the top of the wall—a real life *Pet Cemetery!* (*Top right:* a cropped close-up showing the group of ghosts moving together in a mist—people . . . or pets?)

States of America. But just in case one forgets entirely about his presence here, he will rattle his chains in a very Jacob Marley fashion to remind everyone that he was wrongly accused of plotting the assassination of Abraham Lincoln. His specter can also be seen taking evening walks along the ramparts (the tops of the fort's walls), as he did during his imprisonment here—without the guards that accompanied him when he was alive. Ironically, he has also been seen standing under the flag representing the government that he fought so hard against—I wonder what he thinks about the struggle and all the bloodshed now?

Another apparition that has been seen, heard, and felt is that of the former first lady of the Confederacy, Varina Howell Davis. When she heard of her husband's imprisonment at the fort, she came and stayed at one of the quarters opposite the area where her husband was held. The curtains will part, and the window will vibrate with Varina's presence as she waits to catch a glimpse of her husband taking his evening walk on the ramparts. Some have even heard the grieving woman sobbing—not only from the window, but also along the ramparts. Others claim to have seen the distraught woman walking the ramparts herself, hoping to catch a glimpse at her husband's wraith, because it seems that though they were together for most of their married life, they are separated in death. But then again, what do I know? I have no idea what's going on in the dimension that houses the presence and thoughts of either of these ghosts . . .

Quarters No. 1 was built in 1819 for the fort's commanding officers and VIP visitors. Abraham Lincoln stayed here when visiting the fort, and he has been seen here after his assassination—one of the four places in the country that the tall, lanky president has been spotted post-mortem!

I photographed the ramparts directly over the Casemate Museum (a casemate is a vaulted room within the walls of a fort), and near the spotlight closest to the room where Davis was held, I did capture a misty light that was trying to coalesce into two or more figures—perhaps one of these is Davis himself? In the windows of the Casemate Museum, I found quite a few apparitions. Some were just featureless classic whites, and some were recognizable faces. I cannot say if any of them look like Jefferson Davis at any age, but it is intriguing to think that perhaps one of them is. I am once again made to wonder: Is fame, or the strength of one's personality in life, any indicator of how one appears in death? You would think that death is the great equalizer, but is it really?

The next ghost story associated with Fort Monroe is another "white lady": this one is dressed in a white nightgown and is seen walking "Ghost Alley." No, she was not famous, but infamous for the compromising position her husband found her in. The exact details vary from one storyteller to another, but the gist of the story is this: A young (in some cases, beautiful) woman married an older man. A flippant and, some say, empty-headed woman, she quickly found the man (a captain?) to be a stodgy curmudgeon, a bore, and, in some stories, impotent. The husband spent a great deal of time away from home, and his spouse sought out the company of a man closer to her age. Captain curmudgeon came home early from one of his trips to find his bride in bed with the younger man. After chasing off his competition, the husband returned to the bedroom and shot his wife. Now she is seen roaming the streets inside Fort Monroe, particularly the road now dubbed

Here are some of the residents that I captured on camera at Quarters No. 1 inside Fort Monroe.

"Ghost Alley," looking for her lover.[40] Someone in my party spotted her on the night of a full moon, walking down the road, but when I turned to take a photo, all I captured was a spherical torch over the street. Perhaps she was a bit photo shy; after all, she was wearing only a nightgown . . .

Having seen and heard of so many ghosts given the moniker "white lady," I have come to believe that they, like the classic whites, are only able to re-create their former selves with white light. Considering that so many ghosts are made up of multiple colors, it seems odd that they are only able to appear in white—especially when white is the combination of all colors of light. Perhaps the white light is their natural appearance, over which they have little to no control. As I hypothesized before, I believe that the faces and humanlike figures are a hologram projected by an electromagnetic consciousness of these former humans, and I also believe that it is a learned skill—otherwise they would all be doing it. Let me put it to you this way: If you died and were incapable of contacting or communicating with your loved ones or friends, would you make every effort to appear to them—or to anyone possible?

Quarters No. 1 has a plethora of ghosts, the most famous of which I mentioned before: Abraham Lincoln. Another possibility, although not nearly as exciting, is the apparition of a

I'm not sure why he showed up in Quarters No. 1 in this color of light, but I have to wonder if he was an important officer that stayed in this building—maybe a general?

I'm not sure who this is, but he was evidently curious to see who I was . . .

little girl, who calls for her cat, Greta. Workers (during its tenure as office space for the Army) have seen the ghost of a gray cat disappearing around corners in this building—which brings me to another interesting aspect about the old garrison: all along the grassy areas of the ramparts (which are about ten feet thick and have grass on them, with the exception of the parts that held cannon—they are concrete), officers and soldiers have created a pet cemetery, with small headstones memorializing some of the many pets that have passed on while their owners were stationed there. It should come as no surprise that the gray cat at Quarters No. 1 and other wraiths of former pets have been seen at this fortress.

It's interesting that merely acknowledging the presence of ghosts seems to quell their desire to make mischief. (Do you recall how the Williamsburg Masons always make a point to greet Peyton Randolph?) At the Fort Monroe gift shop, employees often hear children running and playing (making a distinct noise on the stone floor). The shop's location is in an area that formerly housed military staff and their families, the shop being the actual dorms for the children. The little phantoms resorted to playing with the merchandise and leaving it scattered over the floor of the gift shop—that is, until the last employee to leave acknowledged their presence. A simple "Good night, children" was discovered to be sufficient to keep them from making a mess overnight in the shop. That was easy! I wonder what would happen if I asked them if I could take their photograph? I guess that's a moot point though, because they won't let me inside at night . . .

There are so many ghosts and ghost stories at Fort Monroe—I have the photos to prove it. Most of the sightings are from the Civil War era, but unfortunately they shall remain anonymous and their legacy unknown, which is a shame since so much history was made here—I wonder what they could tell us? I can't help but wonder if one of the faces looking out of the half-round window or the coalescing mist on the ramparts just might be Jefferson Davis . . .

This looks like a young boy, perhaps the son of an officer who lived here; did the boy pass over to the other side while living here?

I know, a little blurry, but how is this for a mid nineteenth-century army officer who was important enough to stay at Quarters No 1?

CONFEDERATE WHITE HOUSE

A Tale of Two Presidents . . . and Two Lost Sons

One evening I went to visit a family member who had been taken to Virginia Commonwealth University Medical Center. I parked my car in the center's parking garage and entered the building from the side. As I made my way to the information desk to get directions to the room I was seeking, I looked out the windows. I saw an elegant home—dwarfed by the towering medical complex—that looked lost to its surroundings. I was curious about the history of the building and asked about the out-of-place relic from a bygone era. An African American woman, pleasant when she gave me directions to the room I planned to visit, changed her whole demeanor when I asked about the background of the house in question. "It's the former 'White House of the Confederacy,' and it now serves as a Museum for the Confederacy," she said rather acerbically. Perhaps the wrong person to ask—I ended my inquiry right then. I could understand what the building stood for to this woman, but I for my part had no idea—I had not been in that area of Richmond before. While I did not agree with what the building stood for either, I did see its potential as another haunted chapter in my book—and I was not disappointed! But first, here is a little more about this antebellum building and its former residents:

In doing my research for the background of this haunted manor, I was enamored with author and historian William Seale's comparison of the two White Houses—just 90 miles apart from each other, with a history that is so similar it's as eerie as the building's present-day residents (the following comparisons to the two White Houses, the two executives, and the two first ladies are drawn from Seale's work "The Other White House"[41]). Even the leader of the second "American" revolution on the North American continent, Jefferson Davis, has eerie parallels to his nemesis in the other White House, Abraham Lincoln! But let's take a look at the actual buildings first.

THE TWO WHITE HOUSES

Both seats of the executive branch of government on opposites sides of the Civil War stood on Virginia soil, overlooking two of the major Virginia river systems that feed into the Chesapeake Bay. The Washington White House overlooked the Potomac River (yes, in the District of Columbia, but land given by Virginia to house the capital), and the Confederate White House overlooked the James River. Both buildings were approximately the same age: the Washington White House was rebuilt after the British burned the capital during the War of 1812—the completion date was late in 1817; the Richmond White House was a home built for John Brockenbrough that was completed in 1818. James Hoban designed the second Washington White House, and Robert Mills, who once worked as a draftsman for Hoban, designed the architecturally similar Richmond White House.

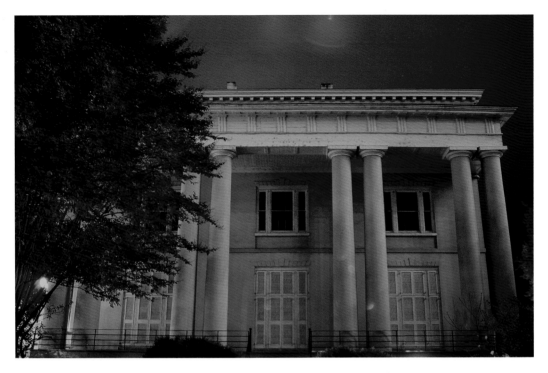

The White House for the Confederacy: eerily similar to the White House in Washington on so many counts, and just as haunted! All of the faces were quite dark due to the lack of light anywhere inside the manse, and they appeared on this side of the house, mainly in the center window.

Both buildings had undergone renovations, with the Richmond White House getting the addition of a third floor and the Washington White House sporting the addition of its north and south porches, giving the residence its present-day look.

THE TWO CHIEF EXECUTIVES

Having noted the comparison of the two buildings, let's take a look at the two men who lived in them and the similarities in their lives: Lincoln and Davis were approximately the same age, born less than a year apart. (I know, you're thinking why am I telling you about Lincoln when the story line is about the haunting of the Confederate White House? Stay with me—it's integral to the legacy of the haunting!) Lincoln arrived in Washington with his family by train to be sworn in as president on March 4, 1861, at the age of

fifty-two. Davis arrived in Richmond with his family by train to be sworn in as president on August 1, 1861, at the age of fifty-three (for the second time—before Virginia seceded from the Union, Davis was inaugurated as president in February in the first capital of the Confederacy, Montgomery, Alabama). Not only were the two men just about the same age, but they were born only about 100 miles apart. Both acknowledged the enormity of the tasks that they undertook, and they both recognized the risks involved. Lincoln addressed his friends in Springfield from the back of the train before he departed for Washington, stating:

No one, not in my situation, can appreciate my feeling of sadness at this parting. . . . I now leave, not knowing when, or whether ever, I will return.

Perhaps this is a previous owner of the house before its role as a presidential residence, or maybe someone on the staff of Jefferson Davis, or a ranking officer in the Confederate army?

Is this the same woman from different photos? Notice in the second photo she is smoking and you can even see her teeth as she exhales!

likewise shared an indifference to food, often going without eating, and both looked gaunt and emaciated toward the end of their tenure in office.

Although both men chose different career paths, they were both successful at their choices. Lincoln was a self-educated lawyer, and although part of the spin of his political campaigns was how he grew up very poor in a log cabin, he actually was a very successful corporate lawyer who was making his way to the top. Davis was educated at West Point and would later earn plaudits for innovation on the battlefields of the Mexican War, including an innovative "V" formation that won the Battle of Buena Vista. While Lincoln was a rising star in the field of corporate litigation, Davis became a rising star in politics, thanks to his connection to General Zachary Taylor, the general he served under during the Mexican War and his former father-in-law (Davis's first wife, Knox Taylor, died early on of fever). Taylor, like many successful generals in US history, parlayed his battlefield success into the world of politics, winning the presidential election of 1849, and Davis rode on his coattails. Rather than four years, Taylor's presidency lasted only sixteen months—he died of cholera in office; Davis returned to his home state of

Davis had a similar sentiment, writing to his wife about his inauguration ceremony,

> The audience was large and brilliant, upon my heavy breast was showered smiles plaudits and flowers, but beyond them I saw troubles and storms insurmountable. We are without machinery, without means, and threatened by powerful opposition, but I do not despond and will not shrink from the task imposed upon me.

Both the Lincoln and the Davis families shared the tragedy of losing a son before their presidency and one during their term; the Davis boy will be of particular interest because he may still inhabit the home he died in—the Richmond White House. Lincoln and Davis

This phantom face was very small in the upstairs window, but what was unusual is that his lower chin appeared below the window and over the wood— transparent but still definable! (The vast majority of the ghost apparitions end with the glass, regardless of whether the face is complete or not.)

Another official in the Confederate government . . . or the Confederate army?

Mississippi to make an unsuccessful bid for governor. President Franklin Pierce would appoint him to the position of secretary of war in 1853—the irony being that Davis would make many needed improvements to the Union army during his tenure—improvements he would regret as president of the Confederacy.

THE TWO FIRST LADIES

The wives of these two men could not be more different—except for their demanding expectations of the staff in their respective executive mansions, leading to employee turnover. The Washington elite looked down on Mary Todd Lincoln; although highly educated and well read for a woman of her time, she was too "western." The allegiance of much of her family was to the Confederacy; some of her relatives were either wounded or killed on the battlefield. Because of this fact, many northerners accused her of being a southern sympathizer, and the southerners considered her a traitor. (Varina Davis had a similar problem in not being accepted by Richmond society, but she handled it in a completely different way.) Add to this the fact that Mary Todd came from a wealthy family and was angry that Lincoln's secretary made all the decisions about White House social affairs, leaving her the small role of deciding such things as the menu. How much of Mary Todd's problems at the White House were the result of depression and anxiety or from real-life exclusion and accusation from Washington society can only be guessed, but the sudden death of her son Willie in 1862 only exacerbated her troubles. After the boy's death she began to hold séances at the White House to try to communicate with her deceased son.[42]

Is this the same face as the one in the last photo, or a close relative?

What appears to be a very angry young boy stares out the window; it makes you wonder what kind of anger could hold you back from moving on?

Varina Davis, Jefferson Davis's second wife, was eighteen years younger than he and only thirty-five when she entered the Richmond White House. As a result of their connections to the presidential administrations of Zachary Taylor and Franklin Pierce, Jefferson and Varina were a Washington *power couple*, and the assertive Varina had won a place at the head of Washington society. She was so adept at social affairs from her experience in Washington that she handled all the ceremonies, galas, receptions, dinners, and balls at the Richmond White House with skill and grace. Richmond's Executive Mansion, under the guidance of Varina Davis, mirrored all the pomp and circumstance of the one in Washington. The receptions at the Lincoln White House were rigid and awkward, but this former Washington power couple wore formality like a comfortable old shoe—this was their world, and they charmed anyone

who would join them. In stark contrast to the Lincolns' unruly children, the Davis children were disciplined and well behaved: Varina was a strong mother who attended and schooled her children on a daily basis. Her two little boys would make an appearance at White House receptions dressed in Confederate uniforms—and were often commended by guests for their good behavior in polite society.

While Mary Todd Lincoln was extravagant in her spending in Washington, Varina Davis had to make due with furniture that she was able to acquire from estate sales and auction houses. She did supplement her furnishings with something a little more personal: she collected whittled curios given to her by wounded soldiers whom she visited in the hospitals (they are still on display today). Another thing that was indicative of the Confederate government's limited funds: the Davis family was expected to pay the salaries of the White House staff—even though the events held there were often governmental in nature (the state department paid for the staff at the Lincoln White House).

Mary Todd Lincoln lost her son Willie in 1862; Varina Howell Davis lost her son Joseph Davis II in 1864. Both families experienced loss during a period when the losses on the battlefield helped extend and deepen their grief. Young Joseph had evidently slipped out of sight of those looking after him and went to the back porch to walk on the porch railing in imitation of circus performers whom he had seen. The five-year-old slipped and fell about fifteen feet down onto a brick patio, receiving a fatal, crushing blow to his head on impact. The boy held on to life for hours until he finally succumbed to the mortal wound, attended by his anguished parents. Perhaps it was the birth of Winnie just two months later,

Another young person who looks forlornly out the White House window.

Some of the furniture was sold, but much of it was left behind. Davis gave his wife a pistol and taught her how to shoot in the garden out back of the Confederate White House. He gave her all of the gold in his possession (keeping only five dollars for himself) and put her on a train with their four children, two maids, and his personal secretary. He advised her to escape to Florida and to go abroad; she was not to stop running until she was out of the country.

Jefferson Davis remained in the Richmond White House as long as he could hold out, but when Richmond's last line of defense crumbled, he had no choice but to leave. On the morning of April 2, 1865, Davis was sitting in St. Paul's Episcopal Church when he was given a note from Robert E. Lee warning him of the imminent fall of Richmond. Davis got up and walked out, not ready to cede defeat, but with plans to meet up with Robert E. Lee in Danville, Virginia, and to make their way to Texas. There they would make a final stand; Davis felt that the loyalty and strength of Texas could sustain a Confederate victory.

or perhaps it was their resiliency, but the Davis family was able to move on from the tragedy. But apparently five-year-old Joseph was not; the child is said to haunt the former executive mansion to this day.

Davis's hopes to continue the fight ended with the Confederate defeat at Appomattox, and he fled to the South and was reunited with Varina but sent her on ahead. Once she reached Savannah, her entourage boarded a boat for England. Her husband was captured in Georgia, and federal troops stopped Varina's boat and captured the former Confederate first lady, keeping her under guard at a Savannah hotel. Thus ended the legacy of North America's second revolutionary government, but the Confederate White House would have one more historical moment before drifting off into obscurity.

TIME FOR FLIGHT

By March 1865 the inevitable was obvious to Jefferson Davis—his family's days at the Richmond White House were numbered. The family decided that Varina would flee the Confederate capital with the children.

A HISTORIC MOMENT . . . WILL IT KEEP REPEATING THROUGHOUT TIME?

Jefferson Davis fled Richmond on April 2, 1865 (some say he fled on the 3rd), and on April 3 the Confederates set fire to Richmond, sparing the Confederate White House, the Governor's Mansion, and the Virginia Capitol (most of the warehouses and businesses along the waterfront were burned). That same day, Union commander Godfrey Weitzel made the former executive mansion his headquarters, and it would remain such for the occupying federal troops until 1870. The historic moment came the next day (although there is some disagreement—some say the 5th):

Abraham Lincoln and his son Tad came by train to view the charred ruins of the Confederate Capitol, to walk the streets of Richmond as some Richmonders burned the Stars and Stripes in protest and disgust, and to visit the Richmond White House. Recall that Davis left Richmond so quickly that he did not have time to collect most of his things, including his rocking chair on the first floor. Lincoln tried out Davis's favorite chair, pronouncing it "mighty comfortable" to his son and the rest of his entourage. Lincoln ascended the curved stairway to the second floor, which was Davis's office, and sat at his desk. An aide signaled through the window to the thousands gathered outside, who chimed in with a victorious "Huzzah!" to the president inside. This must have been a profound moment for Lincoln; with well over half a million lives lost, the war was days away from its conclusion. Lincoln held meetings with military and local officials here, and just ten days later he would be fatally shot at Ford's Theater.

According to Charles A. Stansfield, Abraham Lincoln's ghost has been seen at his Springfield house, peacefully sitting at his rocking chair.[43] But surprisingly, the phantom of the assassinated Civil War president has been seen in another rocking chair: the one at the Confederate White House. The moments Lincoln spent in the Davis White House must have had such an impact that he includes it in the four locations that he haunts: his Springfield house, Fort Monroe, the Washington White House, and the "other" White House. Perhaps this is one of those moments that the departed president will keep living over and over throughout time . . . but then again, if you remember physicist Slawinski's theory on the electromagnetic consciousness—the human soul—you will recall that they exist outside time.

When the Union occupation of Richmond ended in 1870, the building was turned over to the city, and it became a school for the next twenty years. In 1890, the building was in need of repairs and was set for demolition, but a group of Richmond women came to its rescue. They created the Confederate Memorial Literary Society, bent on making a fitting memorial to Jefferson Davis and the Confederacy. In 1894 the city of Richmond deeded the building over to the group, who created the Confederate Museum.

THE GHOSTS—THAT I FOUND

On the first night that I visited the Confederate White House, an ambulance was parked out front; the EMTs were inside and they appeared to be cleaning up and preparing for their next run (the VCU Emergency Room entrance is right next to the converted museum, and with one or more shootings in the city every night, it can get quite busy). With the ambulance blocking the view of the front, I went to the side and then to the back of the building and

immediately wondered why it was now the back. The back portico (once the front, overlooking the James River) has huge columns like a Greek temple, and its ostentatious Greek Revival appearance gives this residence much more of a presidential look than the part of the house facing the street. I noticed some full and partial faces in the upstairs windows that seemed to be just as curious about my presence as I was about theirs. This White House had more than its share of paranormal occupants, but none that looked like the chief executive who lived here or his nemesis, the commander in chief who visited here. I did find the face of a young boy and immediately thought of young Joseph Davis. I can't say with any certainty about the identity of any of the ghosts, but I would like to think that the boy's face is evidence of the departed soul of the Davis child.

After seeing a painting of a young Joseph Davis before his tragic death, I think this photo is a strong possibility to be the boy's ghost! (Check the photo online for yourself.) Could this be the young son of President Jefferson Davis who fractured his skull from a fifteen-foot fall from a balcony at the Confederate White House?

EDGAR ALLAN POE MUSEUM

Is the Master of Murder and Macabre Just a Shadow of His Former Self?

As the newly hired editor rounded the corner of a Baltimore street, his mind was deep in thought, focused on his upcoming job in Philadelphia, when he was caught completely unawares and struck across the forehead by a rod-wielding thug. As he fell to the ground, dazed by the initial blow, others continued to strike him with rods and clubs, and he faded into unconsciousness. Hours later, he awakened in a dimly lit room with a group of other men who had been beaten unconscious, his body searing in pain from the beating that he had taken. Every time he awakened enough to be aware of his surroundings, someone would come over and give him the choice to either take the pills he had in his hand or face worse beating than he had before. Days later, he was awakened by a bucket of cold water in his face and told to get up. As he struggled to gain his footing, he could see other men awakened in a similar fashion. What appeared to be the leader of the gang got up in front of the dazed group of men and clarified why they were beaten and brought to this abandoned building. He told them that this was Election Day, and that they were there to vote for a certain candidate. Once they had cast their ballots, they would be brought back to the same building, where they would exchange clothes with a similar sized person, and then go back out and vote again. They would repeat this action several more times and then go to a different polling station and start again.[44] At the day's end, he was left for dead at Ryan's Fourth Ward poll. Although what you just read is *not* fact, it is what many *believe* to be the likely cause of the death of Edgar Allan Poe. Some of his friends blamed his death on a weeklong drunken binge, but nobody could explain why he was wearing another man's clothes. This was nineteenth-century voter fraud, and this drugging (or sometimes drinking—whether willingly or forced) and kidnapping strategy, called *cooping*, was common practice in America—especially around big cities such as Baltimore.

What is known about Poe's death is that he left for Philadelphia on September 27, 1849, and according to the 1867 account by Joseph Snodgrass, he was found on October 3, 1849, by Joseph W. Walker, who worked for the *Baltimore Sun*. Walker arrived at the Fourth Ward polls—Gunner's Hall—on a rainy October day and found a delirious man in shabby clothing surrounded by drinkers "in the bar-room, sitting in an arm-chair, with his head dropped forward." (According to Poe Museum curator Chris Semtner, the "story about Poe lying in the gutter" when he was found "is apocryphal.") The man was semiconscious and unable to move, so upon closer examination, Walker recognized Poe and asked how he could help. The distressed writer, barely able to talk coherently, gave him the name of Joseph Snodgrass, a magazine editor like himself, but who had medical training. Snodgrass contacted Poe's relatives in Baltimore, who refused to care for him, so Snodgrass sent him to the Washington College

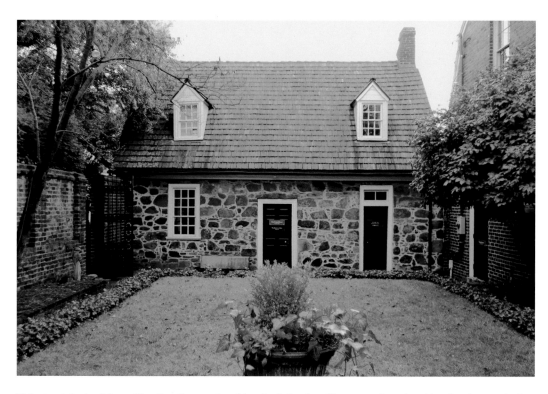

Unfortunately the Edgar Allan Poe Museum is neither Poe's boyhood home or where he either lived or worked as an adult. It does however have the largest collection of memorabilia in the world from the prolific author.

Hospital, where he died just four days later. His final days in the hospital were spent in a delirious state, and he never recovered his cognitive abilities enough to explain how he ended up in the Baltimore gutter. The only word he said during his hospital stay—he kept calling out the name "Reynolds"—was the name of a person who to this day is an unknown part of Poe's final, most perplexing mystery.[45] Cooping would not explain the delirium and the hallucinations Poe experienced at the hospital; Poe may have contracted something even before he left Richmond, because he was not feeling well and was advised by his personal physician to postpone his trip to Philadelphia. One physician (Dr. R. Michael Benitez) was told (in 1996) the symptoms that Poe exhibited during the last few days of his life in the hospital—without revealing who the man was or that the incident had taken place all the way back in 1849—and without hesitating,

the doctor thought that the person in question had contracted *rabies*. There are other theories about the missing week, as well as who or what may have killed Poe, a mystery that only the master of suspense could have left to this world as his last legacy. So take a talented, innovative writer who is considered the father both of the modern detective/mystery genre as well as the science fiction and horror genres, and then end his life at the young age of forty with all the intrigue and mystery that he put into his prose and poetry, and you have a recipe for a haunting—a sudden, unexpected death when he was about to be married and start a new job. If that were not enough, Poe's rival (Poe wrote a disparaging review of this man's book when he worked as the editor of the *Southern Literary Messenger*), Rufus Griswold, wrote Poe's obituary: a lengthy, libelous portrayal of Poe as an alcoholic, womanizing madman who was addicted to

I believe the noises we heard in the empty room upstairs were made by this wraith that I captured in the window shortly after, and my second visit I captured a face eerily similar. Is it the same ghost?

opium. He also wrote that the morbid, macabre, and murderous tales that Poe wrote about were firsthand experiences. Griswold would later parlay that into the first biography of Edgar Allan Poe, thinking that it would put an end to the man's writing legacy and satisfy his desire to get even. Instead it aroused people's curiosity about the now-famous (dare I use the word *infamous*?) author, creating a demand for his short stories and poetry that cemented his place in the halls of great nineteenth-century writers.[46] Which writer have you ever heard of—Rufus Griswold . . . or Edgar Allan Poe?

The Edgar Allan Poe Museum in Richmond (Baltimore has one too, as well as a professional football team named after Poe's most famous poem, *The Raven*) is unfortunately not the home of John Allan and the place where Poe grew up, nor is it one of the places he stayed or worked as an adult. It is a group of several buildings that house the largest collection of memorabilia in the world from the prolific poet, writer, and editor, including personal things that he may be drawn to postmortem. The old stone house, ca. 1754, was here during Poe's years in Richmond, both as a child growing up (just a few blocks away) and during his years as a successful writer/editor. They did use artifacts from the building that housed the *Southern Literary Messenger* (Poe wrote many stories, reviewed books by other authors, and worked as the editor of this magazine—making it the most popular magazine in the South during his tenure) to restore this building, including lumber, locks, doorknobs, and hinges; bricks from the same building were used to build the Poe Shrine in the backyard. The museum's curators were

These two faces were in the bottom right window of the "North Building," very close to each other. They look just slightly different—could they possibly be twins?

able to acquire a staircase from Poe's boyhood home and install it in one of the buildings dedicated to Poe.[47] I can only wonder if Poe divides his time between locations in Richmond, where he grew up and found love and success, and the places in Baltimore, where he first published his stories while living in poverty, and where he met an unexpected, perhaps violent end, depending on whose theory you believe. (If you would like to read other theories on how Poe met his end, check out the *Smithsonian* article that I referenced several times in this chapter.[48])

IS POE ONE OF THE SHADOW PEOPLE HAUNTING THE MUSEUM?

Since a collection of Poe artifacts and memorabilia arrived in the early twentieth century, a dark shadowy figure has been seen hanging around the premises. Two artifacts it seems to prefer are Poe's walking stick and the hand mirror of his wife, Virginia, although the figure has been seen in the garden or nearby a tour group, as if eavesdropping on what the guide is saying. Is it Poe? Many seem to think so! The ghosts of two blond children, perhaps the offspring of the home's original owners, have been seen in the garden, particularly showing a fondness for the fountain near the Poe Shrine. The never-aging children have shown up in photos taken by museum guests for the last twenty years; less frequently, the shadowy figure of what may or may not be Poe makes an appearance in photographs taken near tour groups and in the garden.

When I first entered the Poe Museum, I was greeted by one of the two museum mascots—a black cat with a tiny tuft of white

This face (perhaps a youngster?) was in the same window—different windowpane. Could this be one of the children who play in the fountain?

water in it). Although my psychic and Pluto could both see him, neither I, nor my camera could pick up any anomalies. Several minutes later, she pointed out that someone was looking out of the upstairs window of the old stone house (where we heard the noises), and I was able to capture a few faces in the window on the right. I was intrigued that one of the faces was a blond male, and I wondered if this might be the father of the boy playing in the fountain, intently watching his son . . . and us.

My second visit to the Poe Museum was on an idyllic summer Sunday afternoon, and evidently the ghosts were observing all the people listening to the music program and touring the premises. Although there was paranormal activity in all the buildings on the property, I was able to capture the clearest apparitions at the North Building, which centers on explaining what is known about the mysterious death of the prolific poet. Some even think that one of the ghost photos resembles the brooding author; perhaps he does not appear just as a dark shadow. I captured three very clear faces in the first-floor window to the right of the door, which showed up in infrared and ultraviolet light, but by far the most intriguing figure was a full-body apparition of a woman with large dark eyes but missing other facial features, wearing a long gown and cradling the skull-like apparition of perhaps a child in her left arm. Adding to the intrigue is a second phantom face just below the woman's hand. It was sometime after I captured this photo that I came across a photo of the prolific Poe posed in a similar manner, as if the apparition of this woman was trying to assimilate the essence of the writer's macabre side by striking a harmonious stance. In the courtyard I took numerous photos of the fountain from every different angle, trying to find the apparitions of the two blond children

hair on his chest (Pluto), curious to check me out and then ready to go into the back garden area with me once I paid the admission and got a map and the lowdown on where everything is. With my reluctant psychic by my side, we entered the old stone house, devoid at the time of any tourists or museum personnel. As I started to look around and set up my camera, we heard a cacophony of different noises emanating from the empty upstairs, as if the invisible occupants wanted us to know someone was home. I captured nothing on camera in the downstairs area, and the stairway to the upstairs was cordoned off for museum personnel only. The other buildings proved to be uneventful for us, but as we went outside into the garden area, Pluto was near the fountain, and his eyes were darting back and forth as if following something that I could not see. My psychic could see what I could not—a small boy with long blond hair, about five years old, was playing in the fountain (it was during the winter months, and there was no

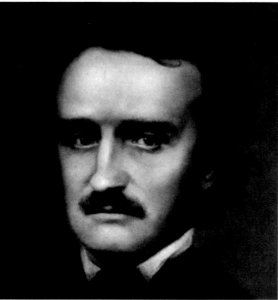

Out of all the faces that I found, this one is the closest to the likeness of Edgar Allan Poe, but that may be up for debate. What do you think?

that have been seen playing there. Finally a visage appeared in the very last photo that I took: a face kind of devoid of any detail and unlike that of a child, but I will take what I can get. The Poe Museum has all the paranormal activity befitting the man who wrote of death that "The boundaries which divide Life from Death are at best shadowy and vague. Who shall say where the one ends and where the other begins?" Perhaps that vague shadow now embodies the man who wrote those words

. . .

This rather strange looking face appeared in the transom window over the back right door to the old stone house, circa 1730 to 1750.

A young looking face from the North Building in the far left window, first floor.

This bearded man may have lived in the North Building during the nineteenth century.

I can only wonder if this is either the father or the older brother of the two young blond children ghosts that play in the fountain.

These two are the last male faces that I found at the museum; they both look rather troubled, wouldn't you say?

A female face, and I can only wonder if she was involved with Poe, or just a former resident of the North Building . . .

Nearby, this woman was the only phantom face in the whole museum that was looking off to the side— perhaps at another wraith?

This is one of the most intriguing photos from the museum, with a female phantom clad in a long gown appearing without a nose or mouth, but holding a skull-like apparition that has the darkened eye openings as well as a mouth and nose. (Notice another face at the floor level below the skull?)

I took more than fortyphotos of the fountain in the courtyard of the Poe Museum, hoping to capture the two young blond children playing. This was the very last photo that I took, and you can see a small face appearing on the left side of the ball on the top of the fountain.

Here is the previous photo, zooming in on the face at the top. No, it doesn't appear to be a child's face, but it is a face! Perhaps not what everyone sees at the fountain, but still a small victory!

THE MANSE, BIRTHPLACE OF PRESIDENT WOODROW WILSON

The Haunted Manse but . . .
Christine the Haunted Limousine?

As a young boy I was told by my grandmother that her father not only was related to Woodrow Wilson but also was the twenty-eighth president's doppelgänger. As a Virginian most of my life, I knew that Wilson was associated with New Jersey: first as a professor at Princeton, later as the president of Princeton, and then as the governor of New Jersey. So I was surprised to learn that Wilson actually was born in Staunton, Virginia, but lived only the first year of his life at his birthplace. Still, that fact got him into the exclusive club of Virginia-born presidents (eight); Wilson would later spend more time in Virginia earning his law degree at the University of Virginia. Although my grandmother was not able to pass her maiden name of Wilson down to me, she did pass on a curiosity about what the twenty-eighth president stood for and accomplished. After a requisite java-laced, caffeinated beverage at a nearby Starbucks (yes, even rural Virginia has them), I was directed by Siri to 20 North Coalter Street in Staunton, Virginia, to visit the birthplace of the Wilson side of my family. At first glance, it appeared to be an unassuming two-story brick structure facing me. I would soon discover that by entering the gate and going down the side of the home to the gardens out back, what I was really looking at was a very assuming Greek Revival manse of 4,000 square feet, with four massive pillars rising up three stories that gave the home all the ambience of an out-of-place plantation home of the antebellum South on the streets of Staunton. The manse was built in 1846 to house the pastors of Staunton's First Presbyterian Church, including three slaves leased by the church to care for the pastor's home and family. Woodrow Wilson's parents, Dr. and Mrs. Joseph Ruggles Wilson, moved into the home in 1855, and Thomas Woodrow Wilson—"Tommy"—was born a year later. Three original pieces of furniture reside there from Joseph Wilson's tenure as pastor of the Staunton First Presbyterian Church, including "Tommy" Wilson's crib, a rocking chair, and a drop-leaf table.[49]

The family moved to Augusta, Georgia, when Wilson was only one; young Tommy would split his early childhood and teen years between Augusta and Columbia, South Carolina. I find it both compelling and admirable that the only president of the United States to have a PhD (and a law degree) did not learn to read until he was ten years old—possibly due to dyslexia! Wilson graduated in 1879 when Princeton University was still called the College of New Jersey, then returned to Virginia to get his law degree from the University of Virginia. Wilson, ever the idealist and reformer, practiced law in Atlanta, Georgia, briefly before deciding that was not the career for him. He returned to academia to earn a PhD in political science from Johns Hopkins

The birthplace home of President Woodrow Wilson appears rather ostentatious from the back hillside with its massive columns and porticos.

University in 1886. He would teach at two smaller colleges before being hired by Princeton as a professor of jurisprudence and politics. In 1902 Wilson rose to the presidency of Princeton, where for the next eight years he garnered a national reputation for educational reform. During his tenure as professor and later as president at Princeton, Wilson authored nine books, including a five-volume history of the United States and a biography of George Washington. In 1910 the Democratic Party noticed the reformer president and suggested that he run for governor of New Jersey. Wilson expressed his willingness to run, warning the party bosses that the caveat was he would not owe political favors or participate in the rampant corruption of New Jersey politics. To the dismay of the entrenched, corrupt politicians, their naive college professor was his own man and started election reformation, including laws that mandated campaign finance disclosure, as well as limitations on campaign spending, making corporate campaign contributions illegal. Outside of election

The Wilson family only lived in this manse for about a year, so these photos are more likely of residents who built more of an attachment to this Staunton house.

reform, Wilson advocated worker's rights, including a worker's compensation law for those injured or killed while on the job, as well as creating a public utility commission to monitor and set reasonable rates. In the 1912 presidential election, William Jennings Bryan, a former three-time candidate himself, threw his considerable support behind the progressive New Jersey governor. With the Republican Party split between incumbent president William Taft and Teddy Roosevelt, the latter seeking a third term under his own Bull Moose Party, Wilson easily won the presidency. I cannot extol the virtues of the first piece of legislation passed under Wilson's watch—imposing a federal income tax while reducing tariffs. Establishing the Federal Reserve and the Federal Trade Commission (prohibiting unfair business practices) was next, followed by child labor laws, government loans to farmers, and an eight-hour workday for railroad workers. In 1916 Wilson won a narrow victory for a second term; although he campaigned on the platform of keeping the United States out of the war (World War I), his next four years in office would be dominated by the war. In early 1917 Germany lifted all restrictions on their submarines, and it was open season on US merchant ships— which by the way were carrying supplies and arms to Germany's enemies. What really raised the government's ire was the Zimmerman telegram, which tried to persuade Mexico into an alliance with Germany, promising to return all territory in the Southwest that had been lost to the United States back to Mexico. Wilson asked Congress to declare war on Germany on April 2, 1917, and it was America's participation that turned the stagnant trench warfare in Europe into victory for the Allies. It was on the heels of war that Wilson began a push for peace that included a "League of Nations" (forerunner to the United Nations)

to band together to, in essence, make World War I the "war to end all wars." In September 1918, as the war was winding down, Wilson began a publicity campaign that included a cross-country speaking tour to promote the League of Nations to the American voters. On September 25 he collapsed from the stress, ending the tour and paving the way to a paralyzing stroke on October 2—and so began the mystery of the final years of the Wilson presidency.[50]

Although a woman has never been elected president of the United States, it is widely believed that one served as president in secret. Woodrow Wilson's condition was kept secret from the public, and Edith Bolling Galt, Wilson's second wife and likewise a Virginian, served both as the guard and the go-between for her husband during the remainder of Wilson's time in office. She was already prepared for this role, attending many meetings in the Oval Office and given access to the secret code for confidential war documents. So when Wilson's stroke partially paralyzed and blinded him, leaving him bedridden for the remainder of his presidency, Edith Wilson would read and decide what papers from the presidential cabinet or from the Congress would get to the president. There was a lot of speculation and accusations that she was making executive decisions on behalf of her husband, which she would later refute, but many are convinced that from October 2, 1919, until March 1921, Edith Wilson served as the de facto president of the United States. She even had the secretary of state fired when he met with the cabinet without asking Wilson's permission.[51] The papers of Wilson's doctor, Cary Travers Grayson, now housed in the Wilson Museum in Staunton, confirm the extent of the president's stroke and the attempt to conceal that information from the government

This is the best paranormal photo from this historical manse, with the subject quite clear and even in color!

Someone's beloved pet from the past still makes its home at the Greek revival mansion.

as well as the public both by himself and Edith Wilson.[52] How ironic is it that women's suffrage (the Nineteenth Amendment) was passed by Congress on June 4, 1919, and ratified on August 18, 1920, granting women the right to vote under the watchful, albeit covert eye, of our first female president?

Neither Woodrow, before his stroke, nor Edith was able to convince the Republican-controlled Congress to vote in favor of his proposal for a League of Nations, but the Nobel Committee recognized Wilson's foresight in pursuit of a lasting peace. He won the Nobel Peace Prize in 1920 for his efforts to create the League of Nations with the hope that World War I would be the "war that would end all wars." He was too ill to attend the ceremony and accept the award, but the rest of the world duly recognized him for his efforts to reform international politics. Wilson was the first American president to take the United States from its isolationist policies to becoming a

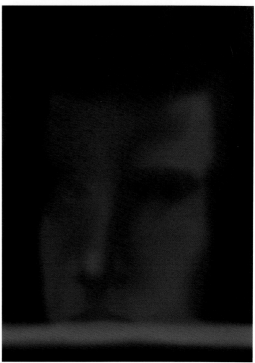

These two male faces showed up in the windows of the very first presidential limousine, and I wonder if they were the chauffeurs during the Wilson presidency.

major player on the world stage. For his foresight and reform, some historians have ranked Wilson seventh in importance among the US presidents!

This woman's apparition showed up in the front windshield of the Pierce-Arrow presidential limousine; the windshield is split lengthwise into two pieces of glass, which is why you see the chrome trim of each piece right at the hips of the female apparition. I think because the windshield was opened slightly (at an angle) the apparition's height is exaggerated. A second woman wraith appeared in one of the side windows of the limo, fashionably dressed for some event . . .

THE GHOSTS OF THE MANSE, THE LIMOUSINE, AND FASHION PLATES SOMEWHERE IN TIME

On a beautiful weekend afternoon I visited the birthplace manse of Woodrow Wilson and photographed the front and back of the building, as well as the Woodrow Wilson Presidential Library, but after discovering that Wilson lived only the first year of his life here, I did not expect to find any apparitions resembling the twenty-eighth president. I would soon discover several surprises, the first being a full-color apparition of an elderly, forlorn man in the second-floor window of the manse, with blond and white hair and a mustache, and wearing either a blue robe or a blanket. I would also find several monochrome faces in the transom door windows, but the most fascinating was a full-color apparition of a dog. If that were not enough to make my day, I also would discover a plethora of paranormal activity two doors down at the presidential library.

The right side of the building is all plate glass and houses the original 1919 Pierce-Arrow presidential limousine that Wilson rode in. (It's ironic that he was the last president to travel to his [first] inauguration in a horse-drawn carriage, and the first president to have a presidential limousine.) Perhaps you are familiar with or have even read Stephen King's tale of a haunted car—*Christine*. All of my photographic indications are that the first official limousine of an American president is haunted too, although I cannot say what moniker it prefers. Perhaps the ghosts are former drivers for the Secret Service and may propose a more masculine name. Or they may select the name of one of the female phantom fashion plates that I captured in the front windshield glass.

This female phantom showed up in the large plate glass window of the Woodrow Wilson Presidential Library with her back to me, looking rather forlornly at something I cannot see.

In that window I captured further proof that ghosts travel together in "mists," as well as three full-body apparitions of females in period clothing! (I apologize for not being enough of a fashion historian to pinpoint the dates of their vintage clothing.) But for as many apparitions as I captured in that mist and in the rest of the window, it seemed as if the whole paranormal enclave in Staunton, Virginia, came out to that presidential library that afternoon . . . and I was happy to capture them on camera.

Through the plate glass window of the Presidential Library, with a tree mural in the background, you can see a large number of ghosts amassed together and moving as a "mist." How many faces do you see?

HIGHLAND, HOME OF PRESIDENT JAMES MONROE

Highland . . . or Hollywood?

After successfully finding ghosts at nearby Monticello (coming in a later chapter), I was completely underwhelmed by what I perceived to be the Monroe homestead. It was as if someone took two completely different homes, painted different colors, and conjoined them in a way that would have made Monroe's mentor, friend, and amateur architectural savant Thomas Jefferson cringe. What was not apparently clear when I paid my entrance fee was that it was not the home that Monroe lived in! Monroe lived in a home on the property he affectionately called "Highland" from 1799 to 1823, and the home in question, according to tree dendrochronology, was not built until sometime between 1815 and 1818. This was originally a two-room dwelling built by Monroe for lodgers, and later owners of the property built an addition onto Monroe's guest lodging quarters (in the 1870s), creating the hybrid, conjoined dwelling that for years was mistaken as the home of our fifth president. In 2015, archeologists discovered the footprint of a much-larger, freestanding home that had burned down, which included the base of a large chimney, several lengths of stone wall, and segments of a thicker wall that would have housed a cellar.[53] Suddenly they realized that the man Thomas Jefferson trained as a lawyer, who was the three-term governor of Virginia, the only man who ever served both as secretary of state and secretary of war (in James Madison's cabinet during the War of 1812), the two-term president of the United States, and the president of the University of Virginia, would have lived in a much more ostentatious home than the conjoined, modest monstrosity that has been mistakenly labeled his home for years. James Monroe was the last of the Virginia dynasty—four of the first five US presidents hailed from Virginia and are considered the last of the founding fathers to ascend to the presidency. James Monroe was a member of another exclusive club—he was one of three of the first five presidents to die on the new nation's birthday—July 4; Thomas Jefferson and John Adams were the other two. But before we get too far into death and ghosts, let's take a look at the legacy of James Monroe.

With both his parents deceased by 1774, Monroe began his formal education at the College of William and Mary at the age of sixteen. After Governor Dunmore (Royal Governor of Virginia) abandoned his home in the capital, Monroe and some of his classmates helped loot the arsenal at the Governor's Palace, taking 200 muskets and 300 swords and donating them to the Virginia militia. You can go to the rebuilt Governor's Palace today and see the collection of guns and swords that Colonial Williamsburg has reamassed and put on display in the grand foyer. I urge you to go there and just imagine a young Monroe and his classmates enthusiastically removing all the weapons from their mounts on the walls and proudly taking them to the Virginia militia. (Check out *Breakthrough Ghost Photography of*

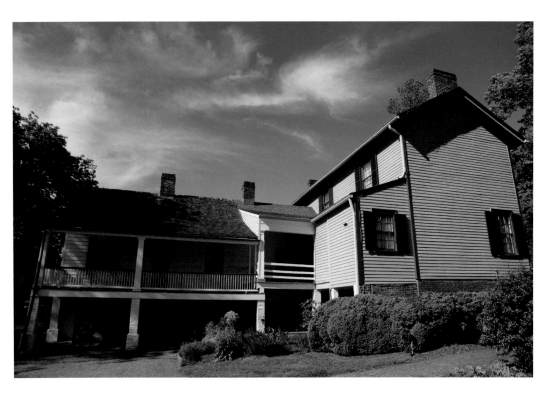

As it turns out, Highland, the home of President James Monroe, is not the building you see on the property; the original Monroe house burned down! This was originally a two-room dwelling built by Monroe for lodgers, and later owners of the property built an addition onto Monroe's guest lodging quarters (in the 1870s), creating the hybrid, conjoined dwelling that for years was mistaken as the home of our fifth president.

Haunted Historic Colonial Williamsburg, Virginia, Part II for the history and ghosts of the Governor's Palace.) He would leave his classes just two years later (in the winter of 1776) to fight in the Revolutionary War. He took part in Washington's famous crossing of the Delaware River as a young lieutenant and was subsequently gravely wounded in the Battle of Trenton. He would suffer for the rest of his life with his war injury, often rubbing his sore shoulder to alleviate the pain emanating from the musket ball still lodged inside (by the way, keep this in mind when we talk of Monroe's ghost!). Although Monroe was carried off the field, he would recover to fight again in the Battles of Brandywine and Germantown—with the promotion to captain. He ascended another rung in the ladder of military ranks, being promoted to major as

well as serving as the aide-de-camp (an officer on the personal staff of a general, who acts as his confidential secretary) to General Williams Alexander during the devastating winter of 1777–78 at Valley Forge. He would later serve as a scout for Washington at the Battle of Monmouth, but because the Continental army had an excess of officers, he recognized how slim his chances were of getting his own command, so he resigned his commission. He was appointed colonel in the Virginia service and was sent by Virginia governor Thomas Jefferson down to North Carolina to scout the advance of British forces there.

Sometime in 1780 or after the Revolutionary War (October 19, 1781, was the date of surrender of the British at Yorktown, essentially ending all major conflict), depending on whose

In the original part of Monroe's guest lodging quarters, a whole group of ghosts gathered in the window and stared as I photographed their dwelling

This mixed race woman (dark skin and blond hair) appears to be sleeping in the side window of the lodging quarters.

Another female phantom makes an unhappy appearance in one of the side windows.

timeline you consult, James Monroe began his law studies under the tutelage of Thomas Jefferson. It was during this period that the young Revolutionary War veteran and his mentor created an enduring friendship that lasted a lifetime. In 1782 Monroe began his political career when he was elected to the Virginia Assembly. In 1783 Monroe stepped onto the national stage, elected to Congress, where he became one of the leading politicians in Virginia. Two years later the twenty-six-year-old congressman met his future wife, just sixteen at the time, and the following year they were married. Without getting into the endless intrigue that is the game of power and politics, let's just say that over the next few years, Thomas Jefferson, James Madison, and James Monroe, part of the Virginia dynasty, were pitted against the opposite political agenda, whose proponents included the likes of John Adams and Alexander Hamilton (yes, the central figure in the play *Hamilton*). I will have to say that I was quite surprised to learn

that when James Monroe was elected to the US Senate, he *vigorously opposed* the administration of his former general—the man whom he scouted for and spent the bitterly cold winter with at Valley Forge. Somehow I think there is a piece to this puzzle that is missing—a backstory, some intrigue, some confrontation that led Monroe not just to disapprove of Washington's policies, but to vigorously assail and resist the country's first administration. Despite the political conflict, Washington appointed Monroe as US minister to France in 1794. Although Monroe was a Francophile and fluent in French, this was no easy task in a country that was five years into a revolution, with the increased power of the Revolutionary Tribunal leading to mass executions in mid-1794. The Jay Treaty with Great Britain (pushed by the Anglophile political enemies of Monroe) created problems with the French Revolutionary Government—ending Monroe's tenure in France. The irony is that the people who pushed the new treaty (which raised French suspicions) were the same ones who blamed Monroe for undermining the relationship with the ally that helped them win independence.

Monroe returned home to practice law and to manage his plantations, and he was elected governor of Virginia in 1799. In 1803 the newly elected Jefferson sent Monroe to France to negotiate the purchase of the territory at the mouth of the Mississippi, including the island of New Orleans; imagine their surprise when they found that Napoleon was willing to sell them the whole territory! Monroe next served an unsuccessful stint as a British envoy (he was unable to negotiate a treaty stopping Britain from impressing American sailors into their navy), and he returned to the United States. He was elected to the House of Delegates, then as governor of Virginia again,

This group of male faces may have been guests at the Monroe lodging house or past owners of Highland.

and then President Madison called on him to serve as secretary of state. Both Madison and Monroe felt that the continuing seizure of American ships to impress American sailors had to be stopped, but they both miscalculated how unprepared the military was for war. Monroe would serve twice in the dual capacity as both secretary of state and secretary of war (due to his experience in the Revolutionary War). In August 1814, while serving two cabinet positions, Monroe took on a third responsibility of scouting out British troop positions right before they burned Washington. He warned Madison of the coming attack and stayed in the city to aid in evacuations. The British burned most of Washington, including the White House, and when Monroe returned to the city, Madison placed him in charge of its defenses. Monroe's unceasing devotion to the war effort and service in the Madison cabinet earned him the respect of all the men who participated in the War of 1812, and placed him in a position for the 1816 presidential nomination, which he easily won.

In 1820 Monroe won by a landslide, winning every electoral vote but one. That began a period of time called the Era of Good Feelings (although some call this a misnomer, citing the Panic of 1819 and the clash over slavery that ended in the Missouri Compromise), which included the acquisition of Florida from Spain, the Missouri Compromise, the recognition of the newly independent countries in Central and South America, and the Monroe Doctrine. The Monroe Doctrine stated that European countries should stay out of the affairs of the Americas, that no further attempts should be made to colonize in this hemisphere, and that the United States would defend any country that came under attack from a European nation, and yes, that the United States would not involve itself in any European conflict. I think another Virginia-born president (whom you have read about) changed that last point . . .

Monroe retired to his *other* home in northern Virginia, called Oak Hill, not Highland,

in 1825 (I would have liked to photograph this home in northern Virginia too, but it is a private residence). He became the regent of the University of Virginia in 1826 and in 1829 became a part of the convention to rewrite the Virginia Constitution. Like Jefferson, Madison, and Tyler, Monroe was deeply in debt when he returned home from political life for the final years of his life. The three members of the Virginia dynasty all neglected their plantation business as well as incurred massive amounts of debt during their years in government service, particularly as president. Even after their tenure as president, these men had to keep up appearances for all those who came to visit, aggravating an already bad financial situation. Monroe had to sell all of his property in Virginia, including Highland and Oak Hill, and he ended up living with his daughter in New York City the final year of his life, dying on July 4, 1831. In 1858 his remains were taken from New York to Hollywood Cemetery in Richmond, Virginia, and reinterred with much fanfare on the centennial of his birth.[54]

CAN A GHOST—WITHOUT A PHYSICAL BODY—STILL FEEL PAIN?

On a warm spring afternoon, I drove up the Highland driveway, a bucolic setting of windblown grassy fields on top of a worn-down mountain in Appalachia. In a pasture off to the left of the Monroe lodging house, a herd of Angus cattle grazed and clamored among themselves, while to the right of the house a catering company gingerly set up for a late-afternoon wedding. I could not help but think that the unknown bride and groom could not have picked a better-looking day for their nuptials; I could only hope that the ghosts felt the same about coming out for a photo op. As

Could this be Monroe in his later years?

I noted before, the house looks as if someone randomly intersected two completely different homes into a T shape, and I believe the white part of the house is the older part, with a plethora of paranormal apparitions showing up. The window to the right of the door on the second-floor porch had a multitude of blurry faces inside, but when I got to the other side, I had apparitions that were much clearer, including one that actually resembles our fifth president. I had two really clear African American faces show up on the side of the house, but on the backside of the house an almost full-body apparition of a young man showed up in four window panes—and I could see him in the viewfinder! It was a great day for brides, grooms, ghosts, and ghostographers.

I mentioned above that Monroe's remains were moved from his initial burial spot to Hollywood Cemetery in Richmond, to discuss something that I never really thought about until I learned that Lincoln's ghost appears both at Fort Monroe and the Confederate White House in Richmond (as well as the Washington

White House and at his home): itinerant ghosts. Are ghosts free to travel wherever they want? In the case of Monroe, I have an ephemeral apparition on his Highland property that resembles him, and yet people have seen him at the Hollywood Cemetery—actually rubbing his shoulder as if he still feels the pain from an old bullet wound (by the way, why would a ghost—without a physical body—feel pain?). I have captured many ghosts moving about on the streets of Williamsburg, but I guess the thought of ghosts being free to travel hundreds of miles away seemed a little incomprehensible—until now. Perhaps there are no limits on ghost movement, and they are free to travel wherever they want . . .

This is the largest and clearest ghost photo from Highland of a young man in the back window of the house. It appears as if there are several other apparitions trying to look over top of his head, and notice a very small apparition in the very top center.

MONTPELIER, HOME OF PRESIDENT JAMES MADISON

The Brooding, Broke Stepfather or the Bad Boy of the White House?

As I drove along the winding, sometimes narrow roads of rural Orange County, Virginia, homes ran the gamut from shanties littered for years with rusting hulks of cars, farm equipment, rotting sheds, and junk to manor homes in bucolic settings with equestrian facilities that could almost take one back to a premechanized era. Once arriving on the grounds of James Madison's Montpelier, I emerged from the trees to a large, gently sloping pasture surrounded by white fence, but strangely devoid of any grazing animals. In front of me, farther up the hill, a palatial chateau overlooked the whole scene, with four massive columns holding up a portico that in and of itself gave a sense of grandeur to the antebellum structure. Behind me, one had a magnificent view of the Blue Ridge Mountains, free of buildings, billboards, banners, and that most obscene obstruction of all—power lines. But wait—to the left of this magnificent mansion is something equally offensive and out of place: someone has placed giant letters on the lawn spelling out the word "love." Granted, love is a precious commodity that enriches and enhances our lives, and face it, we humans need love. But that doesn't mean you demonstrate that need in giant letters on a place devoted to the history of the writer of the document that is our government; it's about as out of place as a neon light over the top of the Lincoln Memorial proclaiming "freedom." I digress from my little tirade to

pay homage to the man who wrote arguably the greatest document on the construction of government in history—and then about his ghost.

Reticent, reserved, and sometimes reclusive, James Madison, the shortest man to ever become president (some say 5 foot, 4 inches; others say 5 foot, 6 inches), was a giant in the political science of government formation—creating checks and balances that limited power—the genius behind the Constitution. Madison was born in 1751, the eldest son of a wealthy Virginia planter who early on showed an independent streak by choosing to enter the College of New Jersey (later to be called Princeton) rather than enrolling in Virginia's College of William and Mary, a route chosen by the majority of Virginia's elite. He completed a four-year program in only thirty months, then remained to take on Hebrew, philosophy, and other subjects; although he did not receive a higher degree, Princeton now claims that Madison was its first graduate student.[55] Madison's dedication to study was such that he would sleep just four to five hours a night—and his health suffered for it. Back at home in 1772 he began to study law, and yet he had no ambition to set up a law practice. Madison's passion was public service, and he began in 1774 by joining a prorevolution Committee of Safety, a group that supervised the local

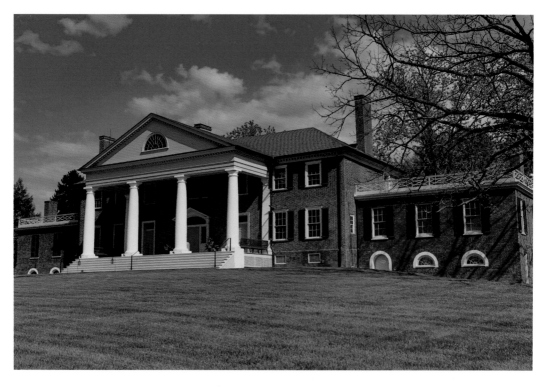

A very palatial Montpelier, Home of President James Madison (and birthplace of Madison's brainchild, the Constitution), sits high on a hill with an enviable view of nearby Appalachia.

militia. Two years later he would join the Virginia Convention, where he would most notably begin to work with Thomas Jefferson on statutes on religious freedom—beginning a lifelong friendship and creating political ties that would help profoundly form a new political experiment. In 1777 Madison ran for the Virginia House of Delegates, but the principled candidate lost because he refused to bribe the voters with free alcohol. Despite the initial setback, he was chosen the next year to the Virginia Council of State, which directed state affairs along with then governor Thomas Jefferson, soon becoming both his closest advisor and personal friend. Next up for Madison was a stint in the Continental Congress, at twenty-nine the youngest and perhaps brightest mind, with a vision for the future that others in that body could not see. While others wanted a loose confederation of independent colonies, Madison advocated a strong central government to win a decisive military victory against the British.[56] One can look only at the inadequate way the Revolution was funded (or, more accurately, underfunded) and the subsequent difficulties Washington encountered to realize that Madison was right. Madison would have to wait for another convention to win this fight. Madison's next political battle was back in his home state of Virginia, where in 1784 he fought with his political rival Patrick Henry against taxing Virginians in support of a state-sponsored Christian religion. Other measures that Madison fought against included religious tests to hold public office and attempts to criminalize heresy.[57]

Madison had long held that the Articles of Confederation were a weak attempt to unify thirteen independent states, leaving the consortium vulnerable to both foreign attack

The Confederate army came to Montpelier for the winter after its defeat at Gettysburg; could these men have been a part of that encampment?

and domestic infighting. He was able to reprise his struggle for a stronger central government in 1787, both setting in motion a convention as well as leading the Virginia delegation to Philadelphia. He supported the effort to persuade Washington to chair the assembly, knowing full well that his support was essential in order to give the convention legitimacy in the eyes of the young nation. Madison's Virginia Plan became the basis for the constitution of a new government, and Madison worked hard to make sure it was ratified. The fear expressed by the states was that a strong central government would give one person or a few people too much power, but the beauty of the document Madison created was the checks and balances that would prevent that; that proactive measure would essentially persuade all the states to ratify this unifying document and create the *United States of America*. His second-most-significant accomplishment was to keep a promise to Thomas Jefferson, who likewise expressed trepidation about a strong central government without spelling out individual civil liberties.

This anomalous apparition appears to have characteristics of a baby and an adult . . .

So Madison, elected to the House of Representatives in 1789, introduced the Bill of Rights to guarantee different aspects of freedom within the new republic.[58] Madison, the bookish, small, frail man, was bestowed with the moniker Father of the Constitution—a document that would serve as a blueprint for burgeoning democracies around the world in the hopes of preventing one man or a few men from securing and abusing too much power!

This forlorn face appeared in the sidelight window of the mansion's front door.

While this face, with its mouth not quite formed or distorted, appeared at the back door. Note the large, intimidating eye at the bottom left . . .

Madison was a strong supporter of Washington's presidency in the beginning; he, along with Jefferson, would break away from the Federalists, as they were called, because they began to support commercial and financial interests (at the behest of Treasury Secretary Alexander Hamilton, both Madison's and Jefferson's emerging nemesis) over the agrarian interests of the South. The two Virginians essentially began the nation's predominantly two-party system, forming the Democratic-Republican Party. (Yes, one party bestowed with the two names of our present-day political parties that have galvanized Americans either into the position of far-left liberals or far-right conservatives.) When Thomas Jefferson was elected president, he chose Madison as secretary of state, a platform that would enable him to succeed Jefferson to the presidency with the help of a wisely chosen secret weapon.

Madison, the reserved, restrained, reticent introvert, would marry a vibrant, vivacious extrovert, his polar opposite, Dolley Payne Todd. During Jefferson's presidency, the widower would sometimes use the wife of his secretary of state to host White House events and banquets. Dolley reached out to everyone in Washington City (Washington, DC), creating a base of support for her husband in preparation for the next presidential election, and her endeavors were called the Charm Offensive. As brilliant as Madison was at political science and government, Dolley was likewise as radiant, scintillating, and creative with people and relationships. This beautiful, trendsetting woman was both loved and criticized; when critics chided her for her involvement in politics, wearing makeup, gambling, or using tobacco, although hurt, she bore the criticism with finesse and charm. She invented the modern model for a political campaign—in this case, Dolley worked harder and had more input into her husband's successful bid for president than he did. As a trendsetter and a fashion plate, Dolley also created the model for the first lady, including

These next two look very similar, but not exactly alike. Could one or both of them be the "bad boy of the White House"?

using her position as a platform for a charitable cause. It seems that the two major political parties were as contentious and acerbic with each other as they are today; perhaps even more back then, because they were actually fighting duels and killing each other over political issues. Dolley's solution was to bring them all together for an informal party every Wednesday that would quickly be given the moniker "squeezer"—because so many politicians and their wives would come that they would have to squeeze into the banquet room. Her idea worked—politicians from across the aisle came to eat the newest fad food in the country—ice cream—and they actually created a dialogue to lower the divide between the two formerly caustic opponents.[59] Madison's successes during his presidency were a team effort that had as much to do with

Dolley's vivacious personality as it did with James's brilliant intellect. Opposites attract, and one can make up for the other's deficiencies in a team effort to accomplish something, and the Madisons are a shining example.

Madison's first term in office was overshadowed by events in Europe that came to affect American trade with Europe— particularly England and France. The British were embroiled in a caustic conflict with Napoleon Bonaparte of France and saw nothing wrong with stopping American ships and impressing sailors (forcing them into the service of the Royal Navy) as well as restricting trade with France. Jefferson's Embargo Act was repealed in the first year of the Madison presidency; many felt it had done more damage to the American economy than to

either France or Great Britain. Two other measures would fail when Napoleon suggested the possibility of stopping all trade restrictions, and Madison reacted by blocking all trade with Britain. Politicians from the South and the West embraced these measures, many hawkish on war with Great Britain, whereas politicians in New England were not only against war, but some were also calling for secession from the Union. In June 1812, Madison asked Congress to declare war on Britain—the first time in the history of the new nation that a sitting president asked that war be declared. The problem was that the United States was wholly unprepared for such a war, with only about twenty ships, compared to Great Britain with about 1,000. At the time, British troops were much more experienced, with years of hardened battle experience against Napoleon in Europe, and the United States barely had a militia. The war did not go well for the United States in the beginning, with a failed invasion of Canada. One bright spot, however, was Oliver Perry's naval victory in Lake Erie. When the Napoleonic Wars ended with his defeat at Waterloo in April 1814, Britain was then able to concentrate on the war in North America, which spelled disaster for the US capital. In August 1814, troops sailed up the Chesapeake Bay to Washington and in the ensuing battle routed American forces and burned the Capitol, the White House, and many government buildings there.[60] Madison is the only sitting president, other than Abraham Lincoln, to be directly involved in a military battle. In an effort to rally his troops, the diminutive president took two dueling pistols and set off for the front lines in the Battle of Washington. Rather than rallying them, he would soon have to join his troops in a massive retreat as the American forces were routed.[61] As British troops entered the Capitol, Dolley

Madison is credited with saving the portrait of George Washington in the midst of the chaos of a mad dash to evade capture. With the White House in ashes, the Madisons would return a few days later and have to live at the Octagon House while the president's residence was rebuilt. Although some have labeled the War of 1812 as the Second War of Independence, a lot of the war's battles were against Native American tribes aided by the British. After the burning of Washington City, the British forces gathered and sailed down to New Orleans, where they would lose to a motley, tattered, indigent army consisting of volunteers, slaves, freed blacks, Native Americans, and almost one thousand French pirates all under the command of General Andrew Jackson.[62] Once he learned of the imminent British attack by a superior force of eight thousand veterans of the Napoleonic Wars, Jackson issued martial law in New Orleans and ordered every able-bodied man to defend the Crescent City. Jackson gathered slightly more than one-half of the men he was up against, a patchwork of about 4,500 men, and prevented the British from controlling the waterways of the whole interior of the country. The irony is that fifteen days before the Battle of New Orleans, a peace treaty had already been negotiated with the British on December 24, 1814—even without resolving the impressment issue. But the decisive rout of British troops in New Orleans **raised morale and put the Madison administration in a good light.** New England states that had considered seceding from the Union and the Federalist Party suddenly seemed unpatriotic to the rest of the nation, and led to the collapse and dissolution of the Anglophile party. Madison would leave office in a good light, decimating the Federalists and opening the door for his friend James Monroe to succeed him.

Although I cannot say for sure, I think this apparition resembles James Madison; what say you? (Use Google images—James Madison to make a comparison.)

Madison retired to Montpelier, where all the visitors, hangers-on, and freeloaders took advantage of the Madisons' generosity, increasing the family's burgeoning debt. If that were not bad enough, Dolley's son from her first marriage, Payne Todd, was a womanizing, gambling alcoholic who would constantly come to his stepfather and mother to bail him out of gambling debts and even jail. He would even go as far as to steal paintings, furniture, and Madison's private papers from Montpelier to pay for his nefarious activities.[63] It is estimated that Madison paid some $40,000.00 during his lifetime to help his prodigal stepson. Madison would succeed his friend Thomas Jefferson as rector of the university that Jefferson founded in 1826. Madison's final act as a public servant came three years later as a delegate to help rewrite the Virginia Constitution. He also supported the gradual abolition of slavery and the repatriation of slaves and freed blacks to Africa, and he formed the American Colonization Society as a vehicle to garner support for his ideas.[64]

The small, frail, sickly Father of the Constitution outlived all members of the Virginia dynasty. During his last days in the summer of 1836, at the age of eighty-five and confined to his room with rheumatism and liver dysfunction, his family and the rest of the nation hoped that Madison's frail body would hold out to July 4 to die on the same day as the second, third, and fifth presidents. Madison's doctors even offered him stimulants to make that happen, but the aged political scientist refused and breathed his last on June 28, 1836, just six days before the sixtieth anniversary of the nation that he helped found.

A BROODING JAMES MADISON, OR PERHAPS BAD BOY PAYNE TODD

The ghost of James Madison has been seen at his desk in Montpelier, and those who have seen him describe him as brooding. I think Madison was aware that he had overspent—in the White House, after his presidency entertaining guests, and on his incorrigible stepson. If you look on the White House website, Payne Todd has been labeled the Bad Boy of the White House,[65] and he earned it. I have to wonder if his ghost is one of the faces that I found at Montpelier. I was dismayed to discover that most of the windows have a reflective tint, which distorts any apparitions that appear—but more often than not, the reflection of the sky washes out any apparition. The only place I was able to capture any faces was in the transom windows around the front and rear doors. I found another possibility for some of the faces in the windows: the protected land of Montpelier has the largest collection of Civil War campsites in the country; the Confederate army constructed the campsites here after its defeat at Gettysburg, staying through the winter of 1863–64.[66] Historians maintain that more soldiers died in camp than in battle due to the lack of clean water and the fact that thousands of men were using the land around their campsite as a toilet. I captured three men that had beards and appeared to be Civil War era; perhaps they perished on the grounds of Montpelier during the time they were encamped here. I found a strange-looking apparition that resembled a child's head lying down, with dark circles around the eyes. The last five faces are clean-shaven with longer hair—typical seventeenth-century hairstyle. Although the last face is a bit long, it does have a resemblance to a younger James Madison; what do you think? I can only wonder if one of the other faces is "bad boy" Payne Todd . . .

MONTICELLO, HOME OF PRESIDENT THOMAS JEFFERSON

The Paradox of Slavery, Sex, and Equality

Monticello, a neoclassical architectural masterpiece, was the brainchild of the third president of the United States, but it wasn't just a mansion on a hill. It was a small, self-sufficient city that grew its own food, built its own furniture and structures—including the first and second versions of the manor house, forged its own implements, and had all the drama any novelist could ever hope for, juxtaposed against the idealism of the man who presided over it all. Thomas Jefferson was born into wealth on April 13, 1743, and he later inherited one of the largest tobacco plantations in Virginia. Included in his inheritance was a nearby hilltop (to his father's manor home—Shadwell) that was his favorite boyhood playground: Monticello—Italian for "little mountain."[67] One of his resolutions as a boy was to build a home on his little mountain, and one year after he became a practicing lawyer, he began to flatten the mountaintop in preparation for building his future home. While most landowners chose stock designs readily available in architectural books, Jefferson chose to design his own home. He included architecture as one of his many interests, and he was well read on the subject—so much so that he was more than capable of designing his future abode. Monticello 1.0 was a two-story, eight-room house with a neoclassical influence. The new home was ready for the woman he would make his wife: twenty-three-year-old Martha W. Skelton, widowed daughter from another wealthy,

prominent Virginia family. They had six children at Monticello, but only two lived to be adults[68] (keep this in mind when you read about the ghost[s] in the playroom/nursery at the manor house). Martha would die in childbirth in 1782, making Thomas promise not to marry again so that their children would not have to live with a stepmother. (Martha had a less-than-happy experience with her stepmother as a child and did not want her children to go through the same bias should Jefferson remarry.) Still devastated by the loss of his wife, in 1784 Jefferson accepted the offer to be the ambassador to France, and he moved to Paris.

Two things happened during Jefferson's stay in France; one would profoundly change the appearance of Monticello, and the other would profoundly change the rest of his life. Jefferson, always with an eye out for classical architecture, discovered a Parisian home with features he was determined to incorporate into his home—most notably the colonnades and a domed roof. Jefferson would return to America to design and build Monticello 2.0, going from eight to forty-three rooms in the entire structure and from two to three stories, and becoming the first home in the country built with a domed roof (and a UNESCO World Heritage Site since 1987). Between the reconstruction of his manor house and his massive collection of European art, books, and souvenirs from his travels; Native American

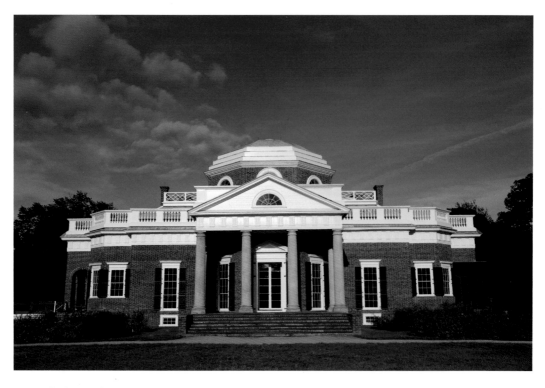

Monticello, home of President Thomas Jefferson, is a building that is truly an innovative and unique design—all the while Jefferson's peers built rectangular Georgian homes with little imagination or creativity

artifacts; and natural specimens, Jefferson also collected a massive amount of debt that would haunt him in his retirement and would result in the sale of his beloved Monticello after his death. His grandson Jeff Randolph had to assume the remainder of his debt.[69]

The other profound thing that would change Jefferson during his stay in France is that he began a lifelong affair with a woman whom he would not marry, staying true to his promise to his wife. Jefferson kept the affair under wraps for as long as he could, but a newspaper writer who did not like Jefferson outed him to the public (James T. Callender, in September 1802).[70] Although a lot has been made about Thomas Jefferson's relationship with a slave woman named Sally Hemings, there are several things about his affair that a lot of people do not know. Sally was a part of

his wife's inheritance when her father died, but most do not know that Sally was his wife's half sister (Martha and Sally had the same father)! She was only one-quarter African, and her appearance has been described as white. The only written description of Sally Hemings, written by Isaac Granger Jefferson, an enslaved blacksmith, was that she was "mighty near white . . . very handsome, long straight hair down her back."[71] So when she came to Paris to live with Jefferson, she may have resembled a younger version of his wife, Martha. Sally was still a teenager (fourteen years old) when the forty-three-year-old Jefferson began an affair that would result in six children. Slavery was illegal in France at the time, so technically she was a free woman and did not have to go back to the United States with Jefferson. She evidently negotiated with him to ensure that her progeny with him

This rather young face appeared in the front of the house in an adjacent windowpane to the older bearded man in the next photo.

would be given their freedom if she did return to Virginia. Although the relationship was denied for many years, DNA evidence of the descendants from Hemings, along with the recent discovery of Sally Hemings's secret hidden room in the South Wing of Monticello—adjacent to Thomas Jefferson's bedroom—provides proof beyond a reasonable doubt that Jefferson was carnally connected to Hemings.[72]

Thomas Jefferson was the author of the Declaration of Independence, wrote the statute of Virginia for religious freedom, served as the governor of Virginia and the third president of the United States, and was the father of the University of Virginia. These were just a few of his accomplishments, but like all men and women, Jefferson was an idealist who did not quite meet up to his ideals—but then, who does? So the man who idealistically wrote

I think these two bearded apparitions are the same ghost sporting a slightly different look when appearing in different windows.

"All men are created equal," and who opposed the institution of slavery early on in his life, lived a life that could not have been sustained without the forced bondage of, on average, about 130 slaves at Monticello. The only slaves he would set free at his death were his children to Sally Hemings (he did not even free Sally; Jefferson's daughter would do that). Jefferson, his wife, and his children lived and died on this little mountaintop, but so did many of the enslaved people who kept the place going. The Jeffersons, as well as the enslaved people, will make up the paranormal story of Monticello too. But we are leaving one other family out that needs credit for helping to preserve Jefferson's legacy as well as his *essay to architecture*:

The year was 1834, just eight years after Jefferson's death, and Monticello was a dilapidated, almost empty house whose grounds were overgrown with weeds and young saplings trying to take back the mountaintop. A career navy man, Uriah P. Levy, immediately saw the value of the founding father's manor house to posterity and bought the house and 218 acres, with the plan to restore it. He hired an overseer to both supervise and care for Monticello. Levy would even guide tourists through the house and grounds and was eventually able to purchase 2,700 additional acres of the Jefferson plantation. Levy rose to the rank of commodore in the United States Navy, and when he died in 1862, he wanted the estate to be used as a school for orphans of naval officers. The United States government was named as the administrator, but since the country was embroiled in the Civil War, the Confederate government seized the property and sold it. Nineteen years later, after the war ended, as well as after a long and convoluted period of

Another young phantom from Monticello's past:

litigation, Commodore Levy's nephew, Jefferson M. Levy, became Monticello's sole owner. The man who was hired as the overseer by Levy had taken less-than-stellar care of Jefferson's abode during and after the Civil War: Monticello was a working farm, but cattle were actually stabled in the house, and grain was stored there as well! In 1889 Jefferson Levy found Thomas L. Rhodes, a man who would work with him to restore the property to its eighteenth-century splendor, including the locating and purchasing of Jefferson's furniture and adding 300 more acres of the original plantation. Levy tried but failed to get the federal government to purchase Monticello in 1914; he would remain the steward of the estate for nine more years. In 1923 the Thomas Jefferson Foundation was formed in New York to purchase, preserve, and preside over the estate of the third president of the United States;[73] as is so often the case, ordinary citizens stepped in when government failed to do the right thing.

I'm not sure if I have an explanation for this apparition; the body is very muscular, almost like a modern bodybuilder, and he has what appears to be a chrome helmet. Any ideas?

THE DISEMBODIED WHISTLER

Does Thomas Jefferson's ghost haunt his beloved *little mountain*? One can find the answer from the people who work there or from those who came to experience Monticello for themselves. Visitors hear disembodied whistling while walking about the grounds of Monticello and are stunned to learn that they may have just heard the ghost of the third president. Jefferson would often walk about his mansion and gardens, and when he was deep in thought he would whistle. A man in period clothing matching Jefferson's description has approached other visitors and asked them what they are doing on the property. In other cases, the old man will offer help or comfort to those who need it, such as the troubled little boy in the graveyard.

One man remembers his paranormal experience as a boy visiting Monticello. One fall weekend he toured the mansion and grounds with his family and slipped away unnoticed while his parents were in the garden. He went down to the Jefferson Cemetery, which was surrounded by a wrought-iron fence and a locked gate. Seeing no other way in, he hurt himself squeezing through the bars—so much so that he did not want to escape the same way. So he began calling for help, hoping his parents would hear him, but no one came to his aid. He turned around to notice an older man dressed in eighteenth-century clothing approaching him, and he sat down on one of the gravestones. He began to ask questions about the boy's school, family, and friends in a gentle voice, and the boy calmed down. While talking, the old man looked up and suddenly said, "You're going to be okay now; here comes your mother!" The boy turned around in time to see his mother running down the hill, calling out his name frantically. The boy knew he was in trouble, so he turned back to the old man to ask him what he should do, but the old man had vanished.

While not nearly as compelling as the previous story, there are several stories related by tourists. A woman on tour inside the playroom/nursery at Monticello felt the mouth, teeth, and warm air exhaled as an unseen wraith bit her shoulder. Although she thought it was her husband joking around, he was not close enough to be the guilty party—perhaps a mischievous child ghost, one of Jefferson's children? A couple, while in Jefferson's study, felt a force that tried to enter them or pass through them. They felt very anxious and frightened; they moved to the back of the room and the entity followed them. They paced back and forth, and both never felt anything like that before. Another time, a woman in the same room felt a piece of her hair being lifted up, and tried to blame it on her husband, until she realized that he was on the wrong side of her to have done it. Of course, no other person was near enough to have tugged on her hair. In the early 1990s, an employee and a curator worked late into the night, and they felt like they were being watched. To add to the drama, they heard doors slamming on the third floor—with full knowledge that no one else was in house! Former employees would see lights and hear music from the caretaker's cottage, but as soon as they would open the window to hear the music better, it would stop and the lights would go out, which is similar to the experience of tourists walking by the Raleigh Tavern in Williamsburg . . . and Jefferson frequented that place.

As for my own paranormal experiences at Monticello, I cannot say that I was bitten,

or that my hair was pulled, or that the old man Jefferson came up to me and asked what I was doing on his property or to offer comfort or sage advice, but I came away with a plethora of photos that demonstrate that this place is highly active. Although I cannot be sure, one photo reminded me of a younger Jefferson, or perhaps one of his relatives. But in one evening I was able to walk away with what takes several or more visits at other haunted locations. I think that after the long period of neglect and dilapidation, the ghosts of Monticello's past are happy to see all the people and activity around the place where they lived, worked, and died. Perhaps that's why Jefferson is still whistling . . .

MOUNT VERNON, HOME OF PRESIDENT GEORGE WASHINGTON

The Excruciatingly Painful Death of Washington: The Reason His Brooding Ghost Remains?

Mount Vernon—the home of the man who led the way to independence from English rule (or should I use the byword of the American Revolution: *tyranny*?) and our first commander in chief—sits high on a hill with a bucolic view of the Potomac River from the front piazza (a large, two-story front porch spanning the length of the house, although in some parts of the country it just means a front porch), for those who would like to pause for a moment and take in the view that made Washington want to spend the last years of his life on this now-hallowed ground. Don't you mean the *former* home, you say? No, because according to those who were able to spend a night in his bedchamber, as well as some of those who work there, he still occupies Mount Vernon. But first I must give you a little history about Mount Vernon, so that when I reference certain names, you know who they are.

Augustine Washington, George's father, purchased the 5,000-acre estate in 1726 from his sister Mildred—she inherited it from her father. Augustine built a modest one-and-a-half-story house on the hilltop overlooking the Potomac River in 1734. They moved there in 1735 with three-year-old George in tow. In 1740 George's father turned the plantation over to his older son Lawrence, who moved there in 1743 when their father died. Lawrence renamed the Little Hunting Creek Plantation

in honor of a man he served under in the British navy: Admiral Edward Vernon. Eleven-year-old George would continue to live there with his older half brother Lawrence's family for part of his youth. Augustine left very little in inheritance for George (giving the lion's share to his older brothers), so he became a surveyor at a very early age and, at the age of seventeen, was appointed surveyor for Culpeper County (1749). Lawrence died in 1752, and his daughter (who inherited Mount Vernon) died just two years later, leaving twenty-year-old George in charge of the Washington estate. Lawrence's wife, who remarried, had a life interest in the estate, so it was not fully his. George's sister-in-law (Lawrence's wife) died in 1761, and at that point George had full possession of Mount Vernon.[74] To clarify: Mount Vernon ownership went from George's father to his older half brother, to his niece, to his sister-in-law, and finally to him. So my point was not to drag you through a convoluted litany of owners, but to let you know that this was not an easy transfer from father to son, and that a lot of Washingtons lived and died on this property, which I'm sure adds to the paranormal factor.

In 1754 George began leasing Mount Vernon from his sister-in-law Anne, and he renovated and expanded the house in 1758, raising the roof to two and a half stories high

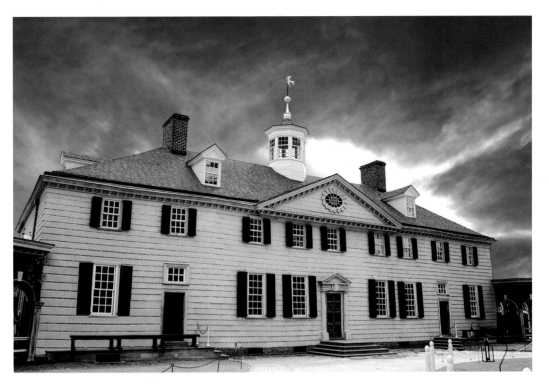

The day I visited Mount Vernon, Home of President George Washington, the weather alternated between storm clouds and blue sky with billowing white cumulus clouds. I was able to capture the back of the mansion free of tourists while they all gathered on the front portico.

in anticipation of his future marital status. On a trip to Williamsburg in March 1758, George made a detour to the home of Martha Dandridge Custis, a wealthy young widow with two children. Just nine days later he made a second visit to see the twenty-six-year-old widow, and then the couple began making wedding arrangements. Granted, they may have known each other prior to this, because Martha lived in Williamsburg with her previous husband, and George frequented Williamsburg because of his role in the First Virginia Regiment (he had risen to the rank of colonel but would resign right before his marriage). Come on—a marriage proposal on your second meeting, just nine days after the first? It sounds more like a mutually beneficial arrangement rather than all my love eternal! Here's what Martha brought to the table: she owned nearly 300 slaves and had more than 17,500 acres of land—worth more than £40,000 (about two million dollars in 2020), not to mention the annual profits brought in by these assets, her plantation home in New Kent County called the White House, a brick mansion in Williamsburg called Six Chimneys, and other rental houses and properties.[75] (George, by contrast, had just 2,000 acres and a one-and-a-half-story farmhouse, and he was still leasing this from his sister-in-law.) To put it quite simply, Martha wanted a father for her two children, as well as someone capable of managing her vast estate holdings, and the tall, dashing young hero of the French and Indian War, who seemed to fit the bill, wanted to marry up. It's no wonder then that George immediately set out to improve the one-and-a-half-story farmhouse, so that he could make it something that a wealthy widow would live in, considering that she was dividing her time

This profoundly sad face was the first I captured at the Washington manor, with this second face in an adjacent windowpane.

between two plantation homes, one of which was a brick mansion with six chimneys and one of Virginia's most elaborate gardens in the surrounding four-acre tract of land, known as Custis Square.[76]

Whatever Washington's reasons for marrying, history seems to portray him as a good husband and stepfather, but there may have been an event that happened in his early manhood that jaded Washington about love and marriage. I say *may* because this story cannot be substantiated by more than one source. Just a few miles southeast of Williamsburg stands an eighteenth-century plantation home called Carter's Grove, and it has a room inside that the nineteenth-century owner of the home gave the moniker the Refusal Room. According to the story, two young men, who would be future presidents of the United States, actually proposed marriage (not at the same time) to young, beautiful women whom they had fallen in love with—and were turned down in that room. To this day, there is a ghost that resides there that will tear up any fresh flowers that are left in the room—perhaps a bit of anger over some lost love? One of the men turned down was George Washington, and the other was Thomas Jefferson. A young, infatuated Washington is said to have asked for the hand of Sally Cary in marriage, and she turned him down. The reason why is not part of the story, but one can only wonder if Washington wasn't wealthy enough and wasn't part of the social class that Ms. Cary would consider as worthy of marrying. Did Washington, despite Sally Cary's refusal, carry a torch for her his whole life? I cannot

A pair of African American faces probably part of the enslaved work force at Mount Vernon.

say for sure, but he wrote Sally Cary Fairfax later in life, after she became a widow, that the years he had spent in her company were "the happiest years of my life."[77] You be the judge—was there a subliminal message in that line?

George married Martha Dandridge Custis in 1759, and the couple moved to the newly improved Mount Vernon when the work was finished. In 1774, despite rumblings of rebellion, war, and independence, Washington began to add the north and south wings, the cupola, and the piazza to create the structure you can tour today. From 1759 until 1775, Washington became the "gentleman farmer" for the most part, while serving time as a burgess for the county of Fairfax; however, his newly created country called him back into service as commander in chief of the American

"Continental" army for the next eight years. His mission complete, in 1783 he resigned his commission and headed back to Mount Vernon to resume the life that he loved, but it lasted only a few years, since he was called back into service as a representative for the Constitutional Convention in 1787. Advocating a strong central government rather than a bickering bunch of independent states, he served as the president of the convention. With the Constitution ratified by all the states, Washington was overwhelmingly elected president in 1789 and served two terms, refusing a third term to return in 1797 to Mount Vernon for what would be only two years of retirement from public life before his death in 1799. His beloved home would pass to two heirs, Bushrod Washington and then John Augustine Washington Jr., who was authorized by will to sell it to the US government. The

The light streaking to the glowing point in the eye is part of the intrigue of this face captured at the back of the Mount Vernon manse.

Another rather angry face with the hairstyle from the eighteenth century—perhaps a relative of Washington?

irony is that no one in the government had the foresight to buy the property—they refused! Ann Pamela Cunningham organized the Mount Vernon Ladies' Association of the Union in 1853, raising around $200,000 and purchasing Washington's house and 200 acres of the estate five years later. At the time of purchase, the house was in desperate need of restoration (check out the photo online), and Cunningham was instrumental in creating America's first historical attraction, fully restored and open to the public in 1860 with an annual average of one million visitors, and more than eighty-five million since 1860. The irony is that the government that this man fought for and advocated, and which elected him president, could not see the value in preserving Washington's home.

One more thing before discussing all the paranormal aspects of Mount Vernon—I think that you should know the intriguing story of how Washington died, which may be why he still haunts his bedchamber. On a cold December morning, Washington went out on horseback to oversee farming projects, and like many Virginia winter days the precipitation shifted from snow to ice pellets to rain, and the ever-diligent gentleman farmer remained outdoors from late morning till 3:00 p.m. while his clothing became soaked in the cold rain. Always punctual, Washington chose to remain in his damp clothes for dinner rather than being late. The next morning, despite a sore throat and three inches of freshly fallen snow, Washington went back out into the cold to select trees for removal, and throughout the day his throat condition became more irritated and inflamed. He woke up in the middle of the night, ravaged by an inflamed throat, and the next morning they sent for a doctor because the general was having a hard time breathing.

This phantom face, taken at the front of the manse, has a wide-eyed look of fright. I wonder what ghosts are afraid of . . .

Eighteenth-century medicine would in some ways seem barbaric to our current understanding of how the body works and how the immune system fights pathogens, so when you learn what happened next, keep that in mind. Washington asked the overseer at Mount Vernon to bleed him, and a half pint of blood was removed. Three doctors would eventually arrive and bleed Washington three more times, removing forty percent of his total blood volume.[78] I know what you're thinking—why on earth would they remove so much blood? Because Washington was slowly suffocating from the swelling in his throat, and the doctors felt that if they removed enough blood, they would reduce the swelling and his throat would open up enough to get adequate amounts of oxygen to his lungs. In another archaic theory, doctors thought that if you created a "counterirritation" or inflammation, you could draw out the dangerous fluids that they called "humors" from the original site of swelling. So they first applied a painful treatment of "Spanish fly" to Washington's throat, again with the hopes of decreasing the swelling inside by drawing the fluids to the skin's surface. A second doctor gave Washington something that would make him vomit "with a vengeance."[79] Finally, when all the bloodletting and vomiting did not work, they began to put the painful Spanish fly solution on Washington's feet, legs, and arms in a last-ditch effort to draw the swelling away from his throat. Can you imagine slowly suffocating to death while doctors bleed you to death, force you to vomit violently, and apply a substance to your throat, arms, and legs that causes painful, burning blisters and inflammation? Just two hours later the first president of the United States drew his last breath—one hopes that his windpipe did not close and he did not suffocate to death. One could look at these treatments for Washington's condition as barbaric, but if you look honestly at all the harmful side effects of today's pharmaceutical drugs, couldn't you say the same thing about modern medicine?

Washington's love for Mount Vernon and his rather sudden and unexpected demise (both he and Martha were looking forward to the turn of the century, just seventeen days away when he died) may be two possible reasons why his presence has been felt and detected in his old homestead. Reports of paranormal activity began after Washington's death, with many accounts coming from members of the Mount Vernon Ladies Association, who often slept at the Washington homestead. Sometimes they would sleep in the same bed that the general died in, as Mrs. William Beale and her friend did; I thought it interesting that the two women were awakened in the middle of the night by the sputtering of their candle before it went out.[80] During Washington's last night in the

bed, he awoke in the middle of the night, trying to catch his breath—I wonder if Washington reliving that moment is what caused the candle to sputter and the women to wake up.

Josiah Quincy III, a politician from Boston, stayed the night at Mount Vernon while Bushrod Washington, the nephew who inherited the Washington plantation, was living there. Bushrod allowed the Boston politician to stay in the general's bedroom, and mentioned as he was leaving the room "the rumor that an interview with Washington had been granted to some former occupants," referring to those who had slept in the bedroom before him.[1] Josiah told his son that he saw Washington's ghost that night.

While skeptics may doubt the validity of stories told of people "feeling the brooding presence of George Washington in his bedroom," it's not so easy to deny when electronic equipment picks up the invisible motion of a paranormal presence in both the stable and Washington's bedroom—on a regular basis. A head guard who worked at the old plantation from the 1980s into the 1990s would be notified when an alarm went off in the stable, and then a short time later the alarm would go off in Washington's bedchamber. Each time this happened, guards would be sent to check out each place—finding nothing. They deduced that the time between when the stable alarm went off and the alarm went off in Washington's bedroom was about the amount of time it would take to remove a saddle from a horse, put it up for the night, and walk from the stable to the mansion's bedroom![82]

The people who work at Mount Vernon have seen several other ghosts, and sometimes, like in my photographs, people see just a partial apparition. An interpreter witnessed just the feet and the bottom of the skirt of a young girl

This man and woman (were they a couple?) were very near the face of fear in the previous photo, and yet these two do not seem to be alarmed.

in an eighteenth-century dress. Another interpreter saw a woman in an eighteenth-century dress on the stairway, carrying a flower arrangement in a large punch bowl. Although the girl and the woman remain unknown, one ghost that has since been identified has made an appearance. An interpreter heard someone in the room behind her (who should not have been there), and she turned around to see a man in early-twentieth-century clothing (the giveaway for the time period was that the man's sleeves were rolled up and secured with garters, something that you do not see anymore). There was a noisy school group in the mansion, and once he had the interpreter's attention, the irate phantom shouted at her, "What the hell is going on?" She explained that she was trying to quiet them down, and the ghost promptly disappeared. The annoyed apparition was later identified as the former director of Mount Vernon (for about fifty years), Harrison H. Dodge, who died in the late 1930s while still the director—evidently he still thinks he is . . .

Unfortunately I could not find any apparitions that resembled Washington at Mount Vernon; however, I thought I might include an apparition that I captured in Colonial Williamsburg at Christiana Campbell's Tavern, Washington's favorite place to eat when he went to Virginia's capital as a member of the Virginia militia or as a member of the Virginia House of Burgesses. In his journals he recorded that he ate there ninety-one times, more than at any other tavern! I cannot say that the photo is definitely Washington, but I think there is an uncanny resemblance—what do you think?

As for the faces at Mount Vernon, I don't see that close of a resemblance to the first president in any of them, but I do have an intriguing story about one of the faces that I captured. After I had toured the mansion, I began to look into some of the outbuildings to the right of it as I came around from the front piazza. In one of the windows I noticed three women smiling as they watched one of them crafting something when I took their photo. When I looked at the photo, I could see the two women on the left and one to the far right, but standing just off center to the right—a man in eighteenth-century clothing was not looking down at what the women were watching, but was staring right at me. At his shoulder were two other disembodied heads, likewise looking at me as if the women weren't there and they were focused on what I was doing. The largest and clearest of the apparitions had a profound look of sadness that I can still see with my mind's eye. Perhaps when you visit you will capture some of the same apparitions with your camera's eye . . .

This is the most intriguing, compelling photo out of the whole Mount Vernon collection. Several real people gather at the window watching an interpreter do or make something (their faces are blacked out because I do not have permission to use their likenesses). In the background stands an African American ghost, ignoring the activity right in front of him as he intently watches me. On his left side you can see the partial face of a woman, also watching me . . .

Here is the zoomed in, cropped photo of the phantom female face from the previous photo gazing at me, with another face or two concealed in her hair.

Likewise here is the cropped close-up of the African American man from that same photo. I can only wonder what these women would have done had they seen this ghost standing over them . . .

Finally here is a photo from my previous book that I think resembles George Washington at his favorite place to dine in Williamsburg: Christiana Campbell's. In his journals, Washington documented that he ate there ninety-one times! (The face, as so often is the case, seems to be elongated—perhaps the distortion of eighteenth-century glass?)

COHOKE LIGHT

The Headless Switchman and the Confederate Death Train

Virginia's most talked-about and most seen paranormal event has perhaps faded from the public's consciousness in the past several decades: the Cohoke Light (some people not from the area will refer to it as the West Point Light, named for the closest town). A remote railroad crossing outside the town of West Point has been the site of a paranormal light that has been witnessed by thousands of people for more than one hundred fifty years. Observers, especially teenagers looking for something exciting to do (there's not a whole lot of things for adolescents to do in West Point), would stop by on the weekends just to catch a glimpse of the Cohoke Light. Teenagers from as far west as Richmond and as far east as Virginia Beach, and young enlisted men from all over the country (stationed at one of the many military bases in the area), would come to the remote crossing, hoping to catch a glimpse of the *other side*. In fact, at the height of the site's popularity, former sheriff Jim Wolford claimed to have seen cars from every state in the United States. "There were so many people there, they burned the store down (by the tracks) and a house." Teenagers would bring alcohol to party with and guns to shoot at the Cohoke Light. (The road that intersects the railroad crossing is really called the Mount Olive Cohoke Road, but I guess that's a bit too much to say.) This road actually crosses the tracks in two different places—if you continue on the road, it will cross back over the tracks about a half mile down on your right (if you came from the town of West Point), and the part of the tracks in between the two crossings of the Mount Olive Cohoke Road is where the ghost light is seen. Some eyewitnesses describe the light as orange in color, others see it as a bright blue color (one compared it to the light given off by a welding arc), and still others (myself included) have seen it change colors.

There are some intriguing legends that explain the Cohoke Light: the first and most accepted explanation has to do with a railroad employee (some say a conductor; others say a brakeman). In one version of the legend, a train conductor was walking along the *side* of the tracks at night with a lantern. A train passed by, and a loose chain hanging off the side of the caboose extended out from the momentum of the moving train with enough length and force to decapitate the conductor. The second version has a railroad brakeman (also with a lantern) trying to uncouple two train cars at the site; the train lurched forward, knocking the man down on the tracks, where his head was removed by the wheels of the still-moving train. Since the horrific accident, people have seen the stricken man with the lantern walking the tracks, searching for his missing head. Some have seen the man without his head; others have seen him with his head—on his shoulders, not carrying it. I was fortunate to capture a figure walking along the tracks holding what seems to be a lantern—in full possession of his head!

The Cohoke Light is the headlight from a phantom Civil War era train that appears over a section of railroad track near West Point, Virginia. The light appears without the train, sometimes stationary (which is how I saw and photographed it) and sometimes moving down the tracks (trains do not operate at night over this section of tracks).

The second legend of the Cohoke Light began during the 1860s: a Confederate train loaded with wounded soldiers was bound for West Point—and it disappeared! I know, trains don't just disappear, and the accepted (albeit unconfirmed) explanation is that the Union forces must have captured and destroyed it. Nevertheless, the paranormal light is thought to be the headlamp from the missing train as it makes its way through this small section of track, with a destination somewhere in the twilight zone. Some claim to have seen the whole train, while others have seen only the light, and still others have seen the light and only heard the sound of a train.

According to the legends recounted by so many online accounts and several ghost books, I tried to do some research to see if there is a historical record of a Confederate train wreck. Although there is very little information about it, I discovered that there

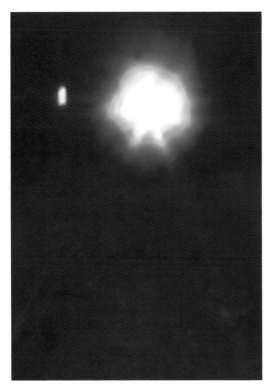

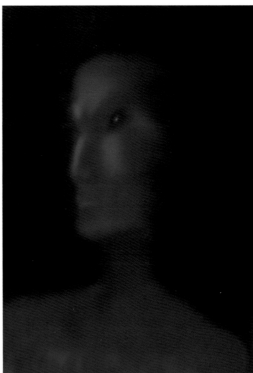

Here is a close-up of the light, which fluctuated with slight color changes the night I saw it, and next to it is what may possibly be the switchman's lantern. (The light is not as high off the tracks as a standard locomotive—for whatever reason.)

A serial killer? I was warned by a psychic not to go down the tracks in this direction . . .

really was a Confederate train wreck at the Cohoke Crossing. The Battle of Cold Harbor (not a port for ships, but a rural crossroads named for two nearby Cold Harbor taverns, which provided its customers a place to sleep—*harbor*, but did not serve hot meals—*cold*) took place in what is today known as Mechanicsville, just ten miles northeast of Richmond. The brunt of the battle took place on June 3, 1864, and was a lopsided major victory for the Confederate army—its last. In the victory, the rebel wounded numbered 3,380. Some of the wounded were taken to Richmond and placed on a train bound for West Point—I could not find an exact number. These men were supposed to convalesce and heal until they were well enough to be placed back into the ranks. When the train reached

the point of the Mount Olive Cohoke Road crossing, a railroad switchman was supposed to move a lever that would redirect the train to a different track, where it could continue on to West Point.[83] The man fell asleep on the job and was awakened by the roar of the steam engine—too late to throw the switch. Frantic, the man jumped out of his slumbering position, grabbed his red lantern, and began swinging it back and forth in an attempt to get the engineer to stop. The mighty locomotive, unable to stop, jumped the tracks, causing a massive wreck that not only killed everyone aboard but also decapitated the switchman responsible for the accident. Several photographs would later indicate that a lot of men died there, and that they have not passed on . . .

An "orb blizzard" appeared immediately after the Cohoke Light disappeared, almost as if the hundreds of orbs that had coalesced to form the light had just splintered apart!

Before going there, I discovered that there are a few rules to observe if you want to view the light, and of course they vary according to each eyewitness. Some former observers say that you can only see the light on a cloudy night—the light does not show up when the sky is clear. Some say that you must park your car on the tracks and shut the engine off for the light to come. Still others say that you cannot speak when you see the light, or it will fade away and disappear. Although I cannot find a reliable source to verify this, I was told that trains travel these tracks only during the daytime as they move to and from the West Point Paper Mill, the source of any foul odors that you may encounter while in the area—depending on the wind direction.

Many people who have seen the light say that if you get out of the car and walk down the tracks, the light will go out. But if you walk down far enough, the light will reappear behind you at the opposite end of the tracks. I can personally verify this part of the legend, and I have photographs to show each version of the light. The part that confuses me is that I could see the first version of the light with my naked eyes; it had both color and motion to it and was rather hypnotic in nature. But after traveling down the railroad tracks to get closer to the source of light, I turned and took a photo in the opposite direction. This time the camera picked up a bright white light that I could not see, leaving me to wonder if it was something altogether different.

INSIGHTS & PERSONAL NARRATIVE

Because the crossing is so remote (there are farms and cornfields nearby, but not much else), I went in the daylight to scope out the crossing. I was warned by my reluctant psychic

A pile of phantom bones lie nearby, as if this serial killer is proud to show off all the lives he has taken.

to stay away from the left side of the crossing— she had a bad feeling from the entity that dwelt down to the left about 100 yards, and the photographic results (from my first night there) seem to confirm her fears!

My first night I was unable to see the light—but it was a clear, starry night. I did capture a very faint apparition—a full-bodied classic white—along the tracks several hundred yards away. The problem was that it was so far down the tracks and so faint that a skeptic could easily dismiss it as an anomaly. I needed a return visit to find something that was larger, clearer, and more convincing. Because I could not find anything substantial in the direction of the Cohoke Light, I decided to go to the left to try to capture something (Do you remember the warning I got to stay away from that side of the tracks?); what I found was every bit as intriguing as the mysterious light—save for the psychic's assessment that it was something "bad," I had no explanation. There was a rather scary-looking creature coming out of the ground in front of a tree next to the tracks, and what appeared to be a hologram of a pile of bones nearby, complete with a skull and pieces of a skull, as well as the face of the sociopath who may have been responsible. Was this the scene of a mass murder—or perhaps the collected victims of a serial killer?

Before I went the second time to the crossing, I was told that the only way to see the light is to park your car in the middle of

Here are some really distressed faces floating to the side of the tracks; are they all reliving the derailment?

the tracks. What unnerved me about this new "requirement" was that the first night I was there, a large late-model pickup truck came speeding down the road, flying over the crossing at somewhere between 40 and 50 miles per hour, bouncing hard as it hit the rails of the track. So the second time I went, I pulled up on the tracks and stopped, and as if on cue I looked down to the right to see that the Cohoke Light was already on and animated, changing colors on its periphery in a kind of stationary yet circular movement—as if it knew that I was there to photograph it! I cannot express to you how excited I was to see this supernatural light show pulsating over the steel rails like the giant headlight of an invisible, immobile locomotive! I left the engine running and had the person with me get behind the wheel as I got out to photograph the "light." I warned him to watch in the mirror for anyone in a

One of the wispy white ghosts hovering over the tracks after the light disappeared.

A couple of phantom faces lying on the side of the track; maybe they were thrown from the train when it derailed.

speeding truck as I rushed to set up my camera. I was able to capture only one photo of the pulsating paranormal light before it suddenly disappeared, as if it had conspired to pose for one and only one photo before departing. To the lower left of the Cohoke Light, I captured another small light, something I believe to be the switchman's lantern. In my next photograph the light was missing, but in its place there were what seemed like hundreds of orbs spread over the track, as if the Cohoke Light just fragmented into a myriad of smaller pieces (the orbs). Do all these orbs coalesce to form this pulsating, color-fluctuating sphere of light? I have ample proof that ghosts travel together in mists, so I can't help but think that they are also capable of pooling their electromagnetic power to create this pulsating paranormal light.

We waited in vain for the light to return for another fifteen to twenty minutes (I was later informed that the car engine must be shut off before the light will come any closer and pass through the car) before deciding to park the car on the side of the tracks and walk in the direction that the light first appeared. As we walked several hundred yards toward the light, one person in my entourage who has psychic inclinations began to feel a "heaviness" on his chest and a sense that we were surrounded, urging me to stop and take a photo (he is a young man in his twenties who has no heart troubles). When I did take a series of photos, I discovered that ghosts surrounded us, with a classic white floating right across the middle of the tracks just ahead and a dark figure to the left of it. He also informed us that this small army of ghosts was struggling with each other to be seen by the living. Judging from the photos that showed numerous orbs surrounding us, I would say that the riders of the lost Confederate train were all right there with us, along with the phantom railroad switchman, all lost somewhere in a dimension that we cannot see or feel, and all struggling to let the living know that they are there. What do you think: Did this large group of ghosts consolidate their power into the Cohoke Light to create this phenomenon in an effort to reach out to the living?

I think this is the phantom switchman, with a glowing lantern and something else that's glowing. Contrary to all of the legends, he's not looking for his head, it's still on his shoulders. Perhaps he's looking for forgiveness, because he's responsible for all of those men dying on the train . . .

Epilogue

What I've Learned about Ghosts

As my paranormal odyssey continues, I continue to observe, record, and learn. A question I have is about a ghost's ability to re-create sights, sounds, and smells: when a ghost does this, there are usually only one or two people who experience the event. For example, the ghosts at the Raleigh Tavern re-create the sounds of a party with music and the "sweet" smell of tobacco smoke from the eighteenth century. At the Abingdon Church, I experienced the scent of lavender when no flowers were present. The ghosts at the Peyton Randolph House re-create sights and sounds: the apparition of an angry man dressed in eighteenth-century clothing with the sound of heavy footsteps, as well as the crashing sound of something falling or breaking glass. My question to my readers—since this experience usually happens to just one or two people: Do the ghosts actually re-create these sensory experiences, or is it some sort of telepathic communication where just the ideas of these sensory experiences are transmitted to our brains? I had another experience that may give this theory more validity. While taking photos of the Goodwin Building in Williamsburg, I could smell the distinct scent of cigarettes, and it wasn't the sweet smell of eighteenth-century tobacco, but the harsher smell of a modern cigarette. Here's the rub: there wasn't anyone near me, there was no smoke visible, and yet I could smell the cigarettes as if someone was standing next to me smoking. Because of the absence of a visible trace of smoke, did I really smell it?

Or was it just a sensory message transmitted to my brain? If they are really capable of doing this, why not do this in front of a large group of people? The audience is certainly available in Colonial Williamsburg . . .

I recently had an encounter very similar to what happened at the Cole Digges House after a recent move to a new house (if you recall, I had a house fire and lost everything). I was sleeping and dreaming that I was driving a car down the road when an opaque material enveloped my upper body, mostly around my head, and I could no longer breathe. I could not draw air in or push it out; it may have lasted half a minute to a minute before I woke up, my arms still flailing to remove the "material" as I sat up and gasped for air. I have never had an experience like that in my life, and I know that it was paranormal in nature. No, I don't think it was an attachment from the Cole Digges House, because it's been several years since I've been there. But the ghost of an old man has been seen at my house by several people, so that makes me highly suspicious. I do not have sleep apnea or a heart condition, and I am in excellent health. Those who have seen this apparition describe him as in his late sixties or seventies, bald, and, from the looks of his clothing, from the late nineteenth century. The fact that I've experienced this after writing about it is profound! Is he trying to get me to leave this house? I've discovered that ghosts are capable of frightening things; if suffocating the living is not bad enough, consider this.

The good: is this something angelic that appeared over a hotel in Williamsburg, or is it just a random grouping of geo-light apparitions?

The bad: is this something demonic that appeared inside one of the places that I photographed?

Colonial Williamsburg that features my photos from my first two books, shown on a large-screen computer tablet. I mention this as a background to relate that now, almost every time I'm in front of Williamsburg's most haunted, the Peyton Randolph House, the ghosts mess with my computer. Sometimes they will advance the slides, sometimes they will just shut off the PowerPoint program, and sometimes they will drain the battery. In case you don't recall or haven't read my first two books in this series, here are two other examples: the first is in regard to my own experience in front of the Dean House, and the other is a documented experience of a William and Mary student doing a film project in the haunted Tucker Hall. The first experience was with a ghost that got inside an iPhone that my sister was using to take a photo of the Elkanah Dean House. As she aimed the iPhone at the house, all you could see in the viewfinder was the face of a man in black and white—but you could see nothing standing in front of the lens. He was actually smiling as if posing for the picture. How was the ghost able to figure out how to get its image inside the camera? The second experience involved two William and Mary students converting and burning a film to DVD. The ghost was able to insert photos of classmates' faces, as well as random film footage from the internet, onto a DVD—right after they had checked their film file to make sure it was precisely what they had created. The computer technology that they used was not even in existence when this ghost passed on, yet it was able to master the technology as well as navigate the internet to change the film. How? Are they able to master it on their own, or do they access our thoughts to learn? Are they capable of mastering technology in just a few seconds, the way that ghost accessed the iPhone? What kind of an IQ do they have to be able to do that?

Another thing I learned about ghosts, which seems rather frightening when you think about it, is that they are capable of starting fires. At the Cole Digges House in Yorktown, the ghost actually started a fire, burning the paper, kindling, and logs placed in the fireplace the night before by the woman who lived there. Likewise, the ghost manager of the King's Arm Tavern relights the candles in rooms where they have all been blown out. The ghosts at the Governor's Palace also play with fire, lighting candles and then blowing them out when security enters the building. It all sounds innocuous and, yes, playful when heard within the context of these three stories, but what if ghosts set fire to buildings? Are ghosts responsible for burning down any homes or buildings?

Let me start my last observation with a question: Do some (or all) ghosts have this incredible ability to master technology they've never used? I run a walking ghost tour in

The ugly: Okay, I know—it's not as if the previous photo was not ugly too (or that this is not bad). This creature, whatever you would like to call it, was photographed on Jamestown Island, where well over 500 people lost their lives. Care to guess its role there?

The ugly, part 2; or should I just say alien?

I mentioned several times throughout this book that the moniker "most haunted" is highly subjective and cannot be fairly assessed unless someone has visited every haunted site in Virginia. My criteria for this book: online reputation, word of mouth, and what places had the most intriguing and compelling background or ghost stories. After being so successful at Mount Vernon, Monticello, and Highland, I decided to feature the homes of the Virginia presidents. I would like to have added about fifteen more chapters, but it wasn't possible for the publisher without making the book ridiculously expensive. I was not able to photograph President Zachary Taylor's home for this book—he was one of the eight Virginia-born presidents, but his home is privately owned. I had one profound experience that I was able to include in this book at Abingdon Church: the scent of lavender after catching a glimpse of a fleeing female phantom—in late fall, and after the first frost, no less—meaning no fresh flowers around. But another paranormal experience not included in this book still gives me chills: a visit to Crawford Road, one of the most haunted roads in America. Although I captured only one photo worthy for the book, what I heard there will stay with me for eternity. The prevailing ghost legacy that goes with this haunted backcountry road is about a young bride who chose to hang herself from a small bridge that crosses over the road rather than go ahead with a marriage ceremony to someone she did not love; however, when I took a team there, we heard something that gave us the impression of something totally different. It sounded like a woman screaming as she was running; we all heard her scream three times, and the last scream sounded as if she was caught. Could

the message she tried to convey indicate that she did not commit suicide but was hunted down and lynched?

My journey continues, as I try both to find and develop new and better technology to eliminate all doubt that the paranormal world exists. As I finish this book, I already have ten chapters to a book from haunted places in different parts of the country. Basically I'm going to homes, buildings, and places that have been featured on paranormal television shows such as *Ghost Adventures*, *Ghost Hunters*, *The Dead Files*, and *Kindred Spirits* and getting the photographs they did not. I started with Edgewood Plantation, which would have also fit nicely into this book, investigated by Ghost Hunters, and I have gone to several places in Virginia, Nevada, Arizona, and Pennsylvania and plan to go to about twenty more (or however many I can fit into the book). I also plan to write a book explaining all the details of how I photograph the paranormal, so that if you so desire, you can go out and get the same kind of results that I've discovered. So until then, stay tuned!

ENDNOTES

1. Warren M. Billings, *Jamestown and the Founding of the Nation* (Gettysburg, PA: Thomas, 1990).

2. All of the historical information for the Thomas Nelson House was taken from the Colonial National Historic Park Virginia/Yorktown Battlefield website: www.nps.gov/york/index.htm.

3. L. B. Taylor Jr., *The Ghosts of Williamsburg . . . and Nearby Environs* (Williamsburg, VA: L. B. Taylor Jr., 1983), 67–68.

4. L. B. Taylor Jr., *The Ghosts of Virginia*, vol. 5 (Williamsburg, VA: L. B. Taylor Jr., 2000), 356–57.

5. All of the historical information for the Cole Digges House was taken from the Colonial National Historic Park Virginia/Yorktown Battlefield website: www.nps.gov/york/index.htm.

6. Daniel W. Barefoot, *Spirits of '76: Ghost Stories of the American Revolution* (Winston-Salem, NC: John F. Blair, 2009), 237.

7 All of the historical information for the buildings in Yorktown Moore House was taken from the Colonial National Historic Park Virginia/Yorktown Battlefield website: www.nps.gov/york/index.htm.

8. Debra Boyce and Jean Kirkham, *History of Grace Church 1697–Present* (Yorktown, VA: Grace Episcopal Church, 2015), www.gracechurchyorktown.org/history (accessed August 21, 2015).

9. Historical information sources include National Park Service plaques, brochures, and interpreters.

10. George Washington, *Washington Papers*, October 1781, https://founders.archives.gov/documents/Washington/01-03-02-0007-0006.

11. Krista Tippet, *On Being*, American Public Media, March 7, 2013, www.onbeing.org/program/the-losses-and-laughter-we-grow-into/transcript/5062 (accessed July 12, 2015).

12. Lightning Facts and Statistics, www.weatherimagery.com/blog/lightning-facts/ (accessed July 12, 2015).

13. L. B. Taylor, *The Ghosts of Williamsburg . . . and Nearby Environs* (Williamsburg, VA: L. B. Taylor, 1983), 12.

14. National Park Service, "Berkeley," www.nps.gov/nr/travel/jamesriver/text.htm#bek (accessed July 12, 2015).

15. Brian K. Burton, "Seven Days' Battles," *Encyclopedia Virginia*, January 25, 2012, www.encyclopediavirginia.org/seven_days_battles (accessed July 12, 2015).

16. William Freehling, "William Harrison: Life before the Presidency," UVA Miller Center, 2019, https://millercenter.org/president/harrison/life-before-the-presidency (accessed May 23, 2019).

17. William Freehling, "William Harrison: Campaigns and Elections," UVA Miller Center, 2019, https://millercenter.org/president/harrison/campaigns-and-elections (accessed May 23, 2019).

18. William Freehling, *John Tyler: Life in Brief*, UVA Miller Center, https://millercenter.org/president/tyler/life-in-brief (accessed May 21, 2019).

19. William Freehling, *John Tyler: Life in Brief,* UVA Miller Center, https://millercenter.org/president/tyler/life-in-brief (accessed May 21, 2019).

20. Ibid.

21. William Freehling, *John Tyler: Life in Brief,* UVA Miller Center, https://millercenter.org/president/tyler/life-in-brief (accessed May 21, 2019); and Frank Freidel and Hugh Sidey, "10 John Tyler," *The Presidents of the United States of America*, 2006, www.whitehouse.gov/about-the-white-house/presidents/john-tyler/ (accessed May 21, 2019).

22. Sherwood Forest, Home of President John Tyler, 2002, www.sherwoodforest.org/ (accessed May 21, 2019).

23. L. B. Taylor Jr., "The Gray Lady at Sherwood Forest," in *The Ghosts of Williamsburg . . . and Nearby Environs*, 36–43, www.sherwoodforest.org/Ghosts.html (book and website accessed May 21, 2019).

24. Ibid.

25. T. L. Long and M. H. Quitt, "Biography: William Byrd (1674–1744)," in *Encyclopedia Virginia* (January 6, 2016), www.EncyclopediaVirginia.org/Byrd_William_1674-1744 (accessed August 13, 2015).

26. E. G. Evans, "William Byrd (1728–1777)," in *Encyclopedia Virginia* (November 4, 2014), www.EncyclopediaVirginia.org/Byrd_William_1728-1777 (accessed August 13, 2015).

27. Shirley's History: Eleven Generations of Family History, 2016, www.shirleyplantation.com/history/ (accessed May 23, 2019).

28. L. B. Taylor Jr., *Ghosts of Williamsburg . . . and Nearby Environs*, 7–11.

29. Stacy Graham, "Aunt Pratt's Haunted Portrait—Shirley Plantation January 24, 2015," http://theresashauntedhistoryofthetri-state.blogspot.com/2015/01/aunt-pratts-haunted-portrait-shirley.html (accessed May 23, 2019).

30. James Joseph McDonald, *Life in Old Virginia* (Norfolk, VA: Old Virginia Publishing, 1907).

31. Rosewell Foundation, *The History of Rosewell*, www.rosewell.org/the-history—timeline.html (accessed November 7, 2015).

32. James Joseph McDonald, *Life in Old Virginia* (Norfolk, VA: Old Virginia Publishing, 1907); and Rosewell Foundation, "The History of Rosewell," www.rosewell.org/the-history—timeline.html (accessed November 7, 2015).

33. Diocese of Virginia, *Our History*, 2009–2016, www.abingdonchurch.org/Site-Map/About-Us/History/Our-Church-Building/ (accessed August 11, 2015).

34. E. Allen Coffey, "Our History," St. Peter's Episcopal Church, 2015, http://stpetersnewkent.org/About_Us_Mission_and_Ministries/History/ (accessed August 23, 2015).

35. Jasmine Beatty, "National Historic Landmark Nomination," National Park Service, March 23, 2011, www.nps.gov/nhl/news/LC/spring2011/StPetersNoticeVersion.pdf (accessed August 27, 2015).

36. Kristen Erickson, "Dark Energy, Dark Matter," *NASA Science*, June 5, 2015, http://science.nasa.gov/astrophysics/focus-areas/what-is-dark-energy/ (accessed August 30, 2015).

37. "Early Parish History, Aquia Episcopal Church," 2019, https://aquiachurch.org/about/history/early-parish-history/ (accessed April 3, 2019).

38. "Decline & Revival after Independence, Aquia Episcopal Church," 2019, https://aquiachurch.org/about/history/early-parish-history/ (accessed April 3, 2019).

39. Andrew Lawler, "Fort Monroe's Lasting Place in History," *Smithsonian Magazine*, July 4, 2011, www.smithsonianmag.com/history/fort-monroes-lasting-place-in-history-25923793/?no-ist (accessed December 2, 2015).

40. Jacqueline M. Hames, "The Haunting of Fort Monroe," US Army website, October 28, 2011, www.army.mil/article/27725/The_haunting_of_Fort_Monroe/ (accessed December 10, 2015).

41. William Seale, "The Other White House," *White House History* 25 (Spring 2009), www.whitehousehistory.org/the-other-white-house (accessed November 7, 2015).

42. Carl Sferrazza Anthony, "First Lady Biography: Mary Lincoln," National First Ladies' Library and Historic Site, Canton, OH; and "First Lady Biography: Mary Lincoln," National First Ladies' Library, www.firstladies.org/biographies/firstladies.aspx?biography=17 (accessed November 12, 2015).

43. Charles A. Stansfield, *Haunted Presidents: Ghosts in the Lives of the Chief Executives* (Mechanicsburg, PA: Stackpole Books, 2010).

44. Alicia Cheng, "This Is What Democracy Looked Like," *New Yorker*, November 5, 2018, www.newyorker.com/culture/culture-desk/this-is-what-democracy-looked-like (accessed February 7, 2018).

45. Natasha Geiling, "The (Still) Mysterious Death of Edgar Allan Poe," *Smithsonian Magazine*, October 7, 2014, https://smithsonianmag.com/history/still-mysterious-death-edgar-allan-poe-180952936 (accessed February 7, 2018).

46. Christopher P. Semtner, "13 Haunting Facts about Edgar Allan Poe's Death," *Biography*, October 5, 2014, www.biography.com/news/edgar-allan-poe-death-facts (accessed February 7, 2019).

47. History of the Poe Museum, www.poemuseum.org/history-of-the-museum (accessed February 7, 2018).

48. Natasha Geiling, "The (Still) Mysterious Death of Edgar Allan Poe," *Smithsonian Magazine*, October 7, 2014, https://smithsonianmag.com/history/still-mysterious-death-edgar-allan-poe-180952936 (accessed February 7, 2018).

49. Woodrow Wilson Birthplace, www.nps.gov/nr/travel/VAmainstreet/woo.htm (accessed May 11, 2019).

50. "Hourly History, Woodrow Wilson, a Life from Beginning to End," 2016, www.hourlyhistory.com/free-history-ebooks/woodrow-wilson/ (accessed May 11, 2019); and Editors of History.com, "Woodrow Wilson," April 15, 2019, www.history.com/topics/us-presidents/woodrow-wilson (accessed May 11, 2019).

51. Editors of History.com, "Woodrow Wilson," April 15, 2019, www.history.com/topics/us-presidents/woodrow-wilson (accessed May 11, 2019).

52. Christine Ledbetter, "Woodrow Wilson's Birthplace: A 4,000-Square-Foot Manse," *Washington Post*, October 14, 2016, www.washingtonpost.com/entertainment/museums/woodrow-wilsons-birthplace-a-4000-square-foot-manse/2016/10/13/baf9a244-8259-11e6-8327-f141a7beb626_story.html?utm_term=.0740f02f6f4e (accessed May 11, 2019).

53. Sarah Pruitt, "Major Discovery at James Monroe's Historic Virginia Home," December 4, 2018, www.history.com/news/major-discovery-at-james-monroes-historic-virginia-home (accessed April 30, 2019).

54. Samuel Flagg Bemis, "James Monroe, President of United States," *Encyclopedia Britannica*, April 24, 2019, www.britannica.com/biography/James-Monroe (accessed May 14, 2019); and Daniel Preston, "James Monroe: Life before the Presidency," UVA Miller Center, https://millercenter.org/president/monroe/life-before-the-presidency (accessed May 14, 2019).

55. Evan Andrews, "10 Things You May Not Know about James Madison," September 1, 2018, www.history.com/news/10-things-you-may-not-know-about-james-madison (accessed May 13, 2019).

56. J. C. A. Stagg, "James Madison: Life before the Presidency," UVA Miller Center, 2019, https://millercenter.org/president/madison/life-before-the-presidency (accessed May 13, 2019).

57. Evan Andrews, "10 Things You May Not Know about James Madison," September 1, 2018, www.history.com/news/10-things-you-may-not-know-about-james-madison (accessed May 13, 2019).

58. J. C. A. Stagg, "James Madison: Life in Brief," UVA Miller Center, 2019, https://millercenter.org/president/madison/life-in-brief (accessed May 13, 2019).

59. V. Lamkin, "The Ghost of Dolley Madison," July 10, 2011, https://seeksghosts.blogspot.com/2011/07/ghost-of-dolley-madison.html (accessed May 13, 2019).

60. Editors of History.com, "War of 1812," May 16, 2019, www.history.com/topics/war-of-1812/war-of-1812 (accessed May 13, 2019).

61. Evan Andrews, "10 Things You May Not Know About James Madison," September 1, 2018, www.history.com/news/10-things-you-may-not-know-about-james-madison (accessed May 13, 2019).

62. Editors of History.com, "War of 1812," May 16, 2019, www.history.com/topics/war-of-1812/war-of-1812 (accessed May 13, 2019).

63. Walt Harrington, "Ghosts of Montpelier," *American History Magazine*, May 4, 2018, www.historynet.com/ghosts-of-montpelier.htm (accessed May 13, 2019).

64. J. C. A. Stagg, "James Madison: Life after the Presidency," UVA Miller Center, 2019, https://millercenter.org/president/madison/life-after-the-presidency (accessed May 13, 2019).

65. William Seale, "The Bad Boy: Payne Todd," *White House History* 36 (Winter 2014), www.whitehousehistory.org/the-bad-boy (accessed May 13, 2019).

66. Jonathan Vatner, "In Virginia, Touring Lesser-Known Civil War Sites," April 29, 2011, www.nytimes.com/2011/05/01/travel/01journeys-civilwar.html (accessed May 13, 2019).

67. "Brief Biography of Jefferson," Monticello website, www.monticello.org/thomas-jefferson/brief-biography-of-jefferson/ (accessed March 30, 2019).

68. Editors of History.com, "Monticello," A&E Television Networks, August 21, 2018, www.history.com/topics/landmarks/monticello (accessed March 30, 2019).

69. Gaye Wilson, "Monticello Was among the Prizes in a Lottery for a Ruined Jefferson's Relief," *Colonial Williamsburg Journal* 32 (Winter 2010): 62–67, www.history.org/foundation/journal/winter10/jefferson.cfm (accessed March 30, 2019).

70. "Thomas Jefferson and Sally Hemings: A Brief Account," Monticello website, www.monticello.org/thomas-jefferson/jefferson-slavery/thomas-jefferson-and-sally-hemings-a-brief-account/ (accessed March 30, 2019).

71. "Monica Huntington, Discovery at Monticello Plantation Sheds Light on Thomas Jefferson Mystery," *Direct Expose*, March 11, 2018, www.directexpose.com/monticello-plantation-thomas-jefferson-mystery/ (accessed March 30, 2019).

72. Ibid.

73. "The Levy Family and Monticello," Monticello website, www.monticello.org/thomas-jefferson/a-day-in-the-life-of-jefferson/all-my-wishes-end-at-monticello/the-levy-family-and-monticello/ (accessed March 30, 2019).

74. Editors of Encyclopedia Britannica, "Mount Vernon," *Encyclopedia Britannica*, www.britannica.com/topic/Mount-Vernon-historical-site-Virginia (accessed March 4, 2019).

75. Martha Custis to Robert Cary and Company, 1758, in *"Worthy Partner": The Papers of Martha Washington,* ed. Joseph E. Fields (Westport, CT: Greenwood, 1994), 25–26, www.mountvernon.org/george-washington/martha-washington/george-marthas-courtship/ (accessed March 4, 2019).

76. Mary A. Stephenson, *Custis Square Historical Report, Block 4, Lot 1–8*, October 1959, https://research.history.org/DigitalLibrary/view/index.cfm?doc=ResearchReports%5CRR1070.xml (accessed March 4, 2019).

77. Parke Rouse, "Washington Often Visited Williamsburg," *Daily Press*, November 1, 1992, www.dailypress.com/news/dp-xpm-19921101-1992-11-01-9211020180-story.html (accessed March 4, 2019).

78. "The Excruciating Final Hours of President George Washington," Public Broadcasting System, December 14, 2014, www.pbs.org/newshour/health/dec-14-1799-excruciating-final-hours-president-george-washington (accessed March 4, 2019).

79. Ibid.

80. "Washington's Ghost Haunts Mount Vernon," Ghost Stories, George Washington's Mount Vernon website, www.mountvernon.org/the-estate-gardens/ghost-stories/ (accessed March 4, 2019).

81. Great George's Ghost: Josiah Quincy III and His Fright Night at Mount Vernon, https://www.mountvernon.org/george-washington/facts/great-georges-ghost/ (accessed March 4, 2019).

82. "Washington's Ghost Haunts Mount Vernon," Ghost Stories, George Washington's Mount Vernon website, https://www.mountvernon.org/the-estate-gardens/ghost-stories/ (accessed March 4, 2019).

83. York River State Park, "Ghost Stories–Ghost Train of West Point," *Virginia Outdoors*, October 12, 2010, www.virginiaoutdoors.com/article/more/1119 (accessed November 10, 2015).